Maurice Prendergast

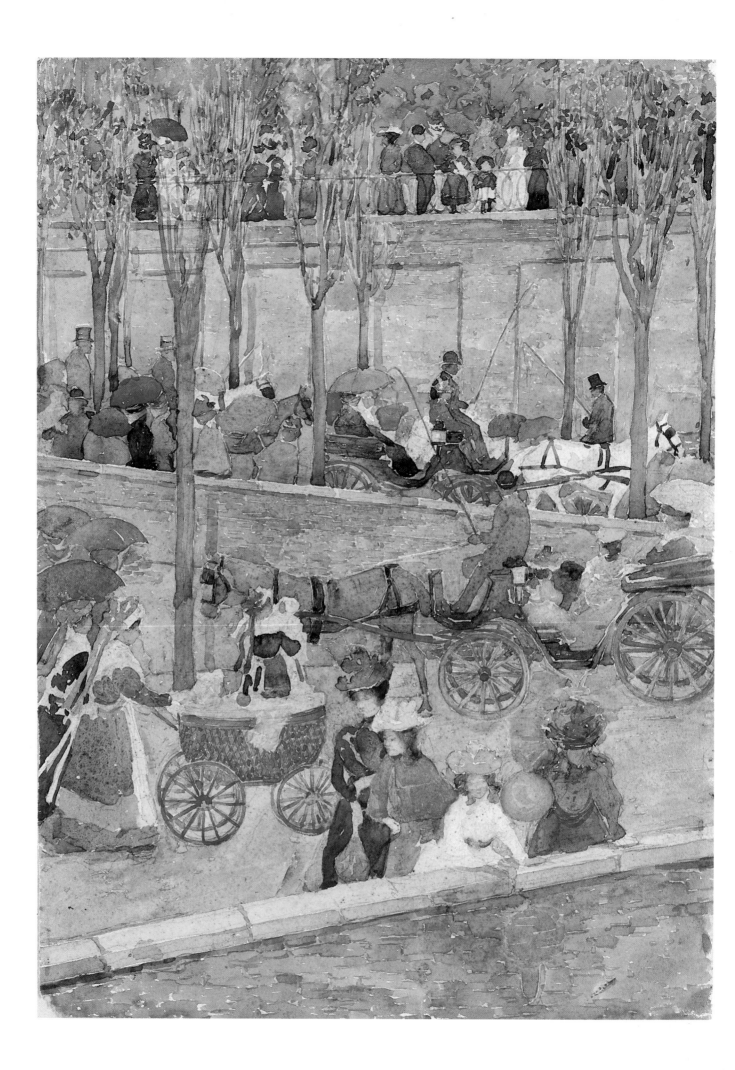

Nancy Mowll Mathews

Maurice Prendergast

Prestel

In Association with Williams College Museum of Art

This exhibition has been organized by the Williams College Museum of Art, Williamstown, Massachusetts. The exhibition is made possible by a generous grant from The Henry Luce Foundation, Inc., and by additional support from the National Endowment for the Arts.

Exhibition Itinerary:
Whitney Museum of American Art, New York
May 31, 1990—September 2, 1990;
Williams College Museum of Art, Williamstown, Massachusetts
October 6, 1990—December 16, 1990;
Los Angeles County Museum of Art
February 21, 1991—April 22, 1991;
The Phillips Collection, Washington, D. C.
May 18, 1991—August 25, 1991.

Cover:
Maurice Prendergast, Rocky Shore, Nantasket, ca. 1896–97, (s. cat. 16, p. 61)

Frontispiece:
Maurice Prendergast, Afternoon, Pincian Hill, ca. 1898–99, (s. cat. 31, p. 76)

Prestel-Verlag
Mandlstrasse 26
D-8000 Munich 40
Federal Republic of Germany

Distributed in continental Europe and Japan by Prestel-Verlag, Verleger-dienst München GmbH & Co KG, Gutenbergstrasse 1, D-8031 Gilching, Federal Republic of Germany

Distributed in the USA and Canada by te Neues Publishing Company, 15 East 76th Street, New York, NY 10021, USA

Distributed in the United Kingdom, Ireland, and all other countries by Thames & Hudson Limited, 30-34 Bloomsbury Street, London WC1 B3 QP, England

Library of Congress Cataloging-in-Publication Data

Mathews, Nancy Mowll.
Maurice Prendergast / Nancy Mowll Mathews.
p. cm.
To accompany an exhibition at the Whitney Museum of American Art, New York, May 31, 1990-Sept. 2, 1990 and at other museums.
Includes bibliographical references.
ISBN 3-7913-0966-8. – ISBN 3-7913-1073-9 (pbk.)
1. Prendergast, Maurice Brazil, 1858-1924 – Exhibitions.
1. Williams College. Museum of Art. 11. Whitney Museum of American Art. 111. Title.
ND237.P85A4 1990
760'.092 – dc20 90-33501
CIP

Composition by Fertigsatz GmbH, Munich
Lithography by Brend'amour Simhart GmbH & Co., Munich
Printing by Karl Wenschow—Franzis Druck GmbH, Munich
Binding by R. Oldenbourg, Munich
Printed in the Federal Republic of Germany

ISBN 3-7913-1073-9 (softcover edition, not available to the trade)
ISBN 3-7913-0966-8 (hardcover edition)

Table of Contents

Foreword

In 1935 four watercolors by Maurice Prendergast were shown in a group exhibition at the Lawrence Art Museum (the first name for the Williams College Museum of Art) at Williams College, and soon thereafter, in 1941, Karl Weston, chairman of the Williams College art department and director of the museum, acquired a Maurice Prendergast watercolor, *Landscape, New Hampshire*, for the permanent collection. Thus began a long and fruitful relationship between the Williams College Museum of Art (WCMA) and the Prendergasts that continues to this day.

Through the generosity of Mrs. Charles Prendergast and the Eugénie Prendergast Foundation, WCMA has established itself as the primary center for scholarship on the brothers Charles and Maurice Prendergast and as a significant resource for the study of American art of that period. The Museum can boast almost two hundred works by these brothers in the permanent collection and has recently co-published a catalogue raisonné* of their work. Over six years of scholarly research provided the basis for the catalogue raisonné and for the organization of this exhibition, so it is with pride and celebration that WCMA presents this first definitive retrospective exhibition of Maurice Prendergast's work. It is fair to say that none of this would have been possible without the encouragement and support of Mrs. Prendergast and her Foundation. On behalf of the Trustees of Williams College and the staff of WCMA, I would like to express our profound gratitude for all that she has done to help establish WCMA's prominence in this area.

In addition to this longstanding support, we have been most fortunate to have received a generous grant from The Henry Luce Foundation for the preparation of this exhibition and catalogue. We are proud and grateful to be the recipient of a grant from this distinguished foundation, known for its enlightened sponsorship of American art and scholarship. And in the form of public funds, the National Endowment for the Arts has also contributed toward this effort and deserves our continuing recognition of its significance. At this

particularly embattled moment in the NEA's history, it is critical to remember that the NEA is not only responsible for helping to realize contemporary and perhaps controversial projects, but is equally responsible for the encouragement of historical and scholarly projects. Such a combination of public and private support is the key to the future of funding for the arts; one serves to reinforce the other in building an even stronger base. We acknowledge with much appreciation the assistance of these two organizations.

Nancy Mowll Mathews, Prendergast Curator at Williams College Museum of Art, has not only diligently overseen every aspect of this exhibition and the accompanying catalogue, but has been responsible since 1988 for directing the final stages of the catalogue raisonné, as well as all ongoing Prendergast collection exhibitions, scholarship, and research at WCMA. It has been especially reassuring for me as the new Director of WCMA, entering in the middle of this massive undertaking, to know that such a complex and important component of the Museum's program has been in her capable hands. To Nancy Mathews I owe my sincere thanks.

A special note of thanks is also due to Thomas Krens, director of the Solomon R. Guggenheim Foundation and former Director of the Williams College Museum of Art, for the central role he played in bringing about this exhibition and establishing the Museum's warm relationship with Mrs. Prendergast and the Eugénie Prendergast Foundation.

One of the earliest posthumous exhibitions of Maurice Prendergast's work took place in 1934 at the Whitney Museum of American Art, a longtime champion of American art and of Maurice Prendergast. It is therefore especially appropriate that *Maurice Prendergast* will open there before it begins a national tour. We are delighted to be able to share this exhibition with the Whitney, the Los Angeles County Museum of Art, and The Phillips Collection in Washington, D. C.. We have appreciated the cooperative and collegial spirit that has informed our arrangements with our colleagues at all three of these institutions; it has contributed significantly toward the atmosphere of good will that has prevailed throughout the organization of the exhibition.

No exhibition of this scope is possible without the generosity of lenders and the hard work of the entire Museum staff. To the lenders let me say how much we appreciate your willingness to part with these beautiful and fragile works of art for even a short length of time; we know it is a sacrifice.

* Carol Clark, Nancy Mowll Mathews, and Gwendolyn Owens, *Maurice Brazil Prendergast, Charles Prendergast: A Catalogue Raisonné* (Williamstown, Massachusetts: Williams College Museum of Art, and Munich: Prestel-Verlag, 1990).

Together with Nancy Mowll Mathews, we would like to express our gratitude to the WCMA staff for all each of them has done to make this exhibition and catalogue such a richly deserved success. And finally, it should not be forgotten that a college museum exists within the context of a college; this one is no exception. The guidance and encouragement that Williams College has provided in the form of its trustees, the president, Francis C. Oakley, and the provost, Gordon C. Winston, have proven invaluable. The Museum is proud of its long history as a teaching institution and looks back fondly to its early days, when even then the art of the Prendergasts was regarded as something special. Fifty-five years later, this exhibition is the culmination of that first involvement.

Linda Shearer
Director
Williams College Museum of Art

Acknowledgments

Maurice Prendergast's generosity and openmindedness won him loyal friends and enthusiastic admirers during his lifetime; his artistic legacy has won for him equally loyal friends and interpreters after his death. The realization of a major exhibition of Maurice Prendergast's art has depended mightily on the good will of these friends, who now assume the form of scholars, collectors, and museum curators.

First and foremost is Mrs. Charles Prendergast, who has been second only to her husband in dedication to the art of Maurice Prendergast. Although she met and married Charles after Maurice's death, she shared with her husband the responsibility of caring for, exhibiting, and sharing information about Maurice Prendergast; and after Charles's death in 1948, she carried on alone. Her support of the Maurice and Charles Prendergast Systematic Catalogue Project, which resulted in *Maurice Brazil Prendergast, Charles Prendergast: A Catalogue Raisonné* (Munich and Williamstown, 1990), has made possible the exhaustive research upon which this exhibition is based. She has also been a generous donor of works of art to the Williams College Museum of Art (which form part of this exhibition) as well as being a gracious lender to the exhibition from her own collection. The Eugénie Prendergast Foundation board members, including Joseph T. Butler, John W. Boyd, and Dr. and Mrs. Harold Genvert, have also been invaluable as advisors in instituting the Prendergast programs at the Williams College Museum of Art.

The Prendergast Systematic Catalogue Project staff, whose team research since 1983 has established the body of knowledge which informs this exhibition and catalogue, deserve acknowledgment for their indirect contributions. My co-authors of the Prendergast catalogue raisonné, Carol Clark (Prendergast Executive Fellow, 1984-87) and Gwendolyn Owens (Prendergast Fellow, 1986-87, and Executive Fellow, 1988), devoted years to the accumulation of the extensive files that make up the Prendergast study center and archive at the Williams College Museum of Art. My own participation in the project (Prendergast Fellow, 1984-87, and Prendergast Curator and Project Director, 1988 to the present) is meshed with theirs. Charles Parkhurst (Project Director, 1983-87) and Milton W. Brown (Prendergast Senior Fellow, 1983-88) gave invaluable advice and guidance. The contributors to the catalogue raisonné, Carol Derby, Dominic Madormo, Cecily Langdale, Patricia Ivinski, Marion Goethals, Anthony Gengarelly, and Ross Anderson, have also added to knowledge about the Prendergasts.

The lenders to the exhibition (listed elsewhere in this volume) are all to be thanked for their willingness to lend objects that steadily increase in value and fragility, and special thanks to those who have agreed to lend to all four of the venues. Both private collectors and public institutions have allowed me to survey their art works, and have opened homes and storage areas to my inspection. Special thanks go to Nicki Thiras, Addison Gallery of American Art; Cheryl Saunders, The Carnegie Museum of Art; E. Jane Connell, Columbus Museum of Art; Jane Glaubinger, The Cleveland Museum of Art; Franklin Kelly, formerly of The Corcoran Museum of Art; Nancy Rivard Shaw and James Tottis, The Detroit Institute of Arts; Doreen Bolger, formerly of The Metropolitan Museum of Art; Sue Welsh Reed, Museum of Fine Arts, Boston; Carlotta Owens, National Gallery of Art; Eliza Rathbone, The Phillips Collection; and Scott Atkinson, Terra Museum of American Art, for their assistance. The Whitney Museum of American Art has been particularly generous and helpful, and I would like to acknowledge Jennifer Russell among others at the Whitney for her support in this project.

We are grateful to The Henry Luce Foundation, Inc., for providing major funding for the exhibition, and to the National Endowment for the Arts for furnishing additional support. The generosity of these agencies has brought this exhibition into being. We would particularly like to thank Mary Jane Crook of The Henry Luce Foundation for her encouragement and efforts on our behalf.

The staff of the Williams College Museum of Art deserves more acknowledgment than it is possible to give. This extraordinarily conscientious and hardworking group of people is responsible for the high quality of programming that has brought the Museum to national prominence. In addition to those listed elsewhere in this volume, I would like to thank Francis Oakley, President of Williams College, and Thomas Krens, Director of the Solomon R. Guggenheim Foundation and former Director of the Williams College Museum of Art, for their key roles in making this exhibition come about. Of my own project staff, I would like to recognize Ann Greenwood, Molly Donovon, Diana Nunley, Darsie Alexander, Robert Lach; and former staff members, Elizabeth Durkin and Jackie Barr. They have been masters of all the bewildering details of such an undertaking.

Nancy Mowll Mathews
Prendergast Curator

I

La Belle Epoque

Observations of Modern Life

(1891-1906)

By the time Maurice Prendergast reached Paris he was thirty-two and had already been making a living for eighteen years. Although his parents were of middle-class origins (his father had owned a grocery store and his mother was the daughter of a doctor[1]), they had fallen on hard times. They left St. John's, Newfoundland, where Maurice and his brother Charles were born in 1858 and 1863 respectively, and settled in Boston to be near Mrs. Prendergast's family. The boys completed the minimum of eight years of public education at Rice Grammar School in Boston, and then went out to work at the age of fourteen.

But in spite of the elder Prendergasts' inability to give their sons a privileged upbringing, they must have instilled in Maurice and Charles a profound respect for the finer things of life since both gravitated toward books, pictures, and antiques. By 1879 Maurice began listing himself as a "designer," that is, graphic designer or commercial artist,[2] in the *Boston City Directory*. From 1886 until 1890 he listed his business address as that of the firm of Peter Gill, designer of "show cards" (hand-painted signs and advertisements).[3] Beyond this we know very little of his life before he went to Paris, except that he seems to have taken a trip to Wales and elsewhere in Britain in 1886.[4]

But it is not hard to reconstruct the environment that a young man of artistic interests would have enjoyed in Boston during the 1880s. While Prendergast may not have shared the cameraderie with other artists that comes from attending art school,[5] it is unlikely that he would have been isolated since many of his fellow designers also aspired to the fine arts. This path already had been taken in Boston by artists such as Winslow Homer and Childe Hassam, both of whom achieved national prominence, and, in Prendergast's circle, by Hermann Dudley Murphy, Horace Burdick, George Hallowell, and Dodge Macknight. From their workplaces downtown they were within easy reach of the proliferating art exhibitions that could be found throughout the city. Exhibitions of contemporary American and European art were sponsored by the artists' associations such as St. Botolph's Club and the Boston Art Club, as well as by art galleries such as Doll & Richards. French modernism appeared as early as 1883[6] and by 1892 the first exhibition of Monet's work to be held in the United States took place in Boston.[7]

A strong link between Boston and Paris—the legacy of William Morris Hunt (1824-1879)—persisted to the turn of the century. Hunt had been in France in the 1850s and was swept up in the excitement of the new freer painting of naturalism and the Barbizon movement, which he introduced to his classes back home in the 1860s and 1870s. As the 1880s progressed and a more academic system taught at the Boston Museum School and the Cowles Art School took hold, ever increasing numbers of art students were drawn to Paris, where they congregated at the academies of Julian and Colarossi. European styles were also made attractive to Bostonians in the person of John Singer Sargent, who became a major influence on young Bostonians after his visits to the city in 1887 and 1890. One promising painter, Dennis Bunker, went to England to work with Sargent during the summer of 1888. Another link to contemporary European art was forged by Lilla Cabot Perry, who became a close friend of Monet at Giverny in 1889 and thereafter was a promoter of his work back home.

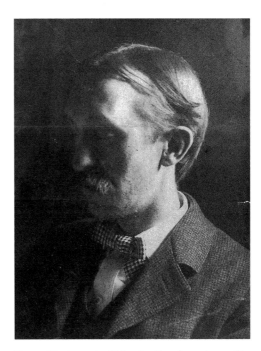

Fig. 1. Photograph of Maurice Prendergast, ca. 1880 (6¼ x 4½ in.), Williams College Museum of Art, Prendergast Archive

For Prendergast, the most inspiring example may have been Childe Hassam, who was close to Maurice's age (one year younger) and also working as a commercial artist until 1882, when he decided to become a painter. From 1883 to 1889 Hassam traveled abroad and sent back paintings to be exhibited and sold in Boston. His success was such that he did not return home to Boston but to New York, where he continued his upward climb to national recognition. The cosmopolitan impressionist style and subject matter that Hassam adopted in 1887 made even the streets of Boston and New York look like Parisian boulevards, and appealed greatly to the prospering American art community—both collectors and artists like Prendergast—with its promise of foreign ease and sophistication.

It is no small wonder that Prendergast's first major series of paintings (the Parisian scenes, cat. nos. 1, 2, 5) show him following in Hassam's footsteps as a "view painter." By early 1891 Prendergast had accomplished his own conversion from commercial artist to painter by departing for Europe, like Hassam had seven years before. Prendergast joined the stream of American art students sailing to Paris in order to study in the academies of Julian and Colarossi; a few watercolors attest to his diligence in class (fig. 2). Apparently he was less prepared for the instruction than other Americans; he had never drawn from the nude, but he was determined to master the academic system nonetheless.[8]

In spite of his efforts in class, it is obvious that Prendergast's four years in France were devoted more to making studies of the city and the coastal resorts (cat. nos. 1–5) than they were to the kind of painting that might establish him in the mainstream of academic painting. He did not exhibit in the Salon as had fellow Bostonians such as Hassam, Hopkinson, Macknight, and Murphy, and there is no evidence that he ever attempted to.

Fig. 3. Maurice Prendergast, Illustration, *The Studio*, Vol. I, 1893, p. 188, Photomechanical transfer of pencil drawing on paper (11³/₄ x 8¹/₂ in.; page), Erroneously attributed to Michael Dignam

Instead, recognition came in less formal ways that encouraged his natural inclination toward the more experimental sketchy style that can be seen in the great number of small works that have survived from this trip. Prendergast, for instance, took pride in once having sold a painting while he was painting it: "He was sketching on one of the boulevards when a Frenchman stopped to look at his work and asked him how soon it would be finished. When the sketch was done, the Frenchman reappeared and paid for it and carried it away."[9] This unknown work was just one of many that Prendergast sold or traded while still in Paris[10]—before he entered an exhibition of any kind. It was clear to him that with this kind of spontaneous interest in his work, he had a marketable style.

In another incident, sketches of his were taken from his studio and ended up being reproduced in *The Studio* under another artist's name. In spite of being cheated of the proper credit, Prendergast could only have been pleased that his drawings (fig. 3), which were recommended to *The Studio* by Whistler, had been chosen for publication.[11]

In style, the *Studio* sketches are very close to oils of this same period such as *Evening Shower, Paris* (cat. no. 1). The subject of a woman walking down a boulevard lined with lights was popularized in Boston by Hassam, but could be seen in the work of any number of French artists from Jean Béraud to Pierre Bonnard. In this case, Prendergast leans toward the more radical end of the spectrum and betrays a knowledge of the drawing style of Toulouse-Lautrec and Bonnard whose work could be seen in posters and other mass publications in Paris (fig. 4).

Prendergast also had a personal connection to these circles in his friend Charles Conder, an English artist who had come to Paris in 1890. Conder painted Jeanne Avril and La Goulue at the Moulin Rouge and was himself painted there by Toulouse-Lautrec in the early 1890s.[12] From the associations

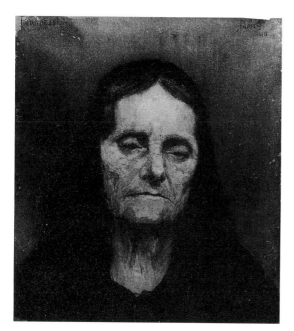

Fig. 2. Maurice Prendergast, *Old Woman, Paris*, 1891, Watercolor and pencil on paper (10⁵/₈ x 9³/₈ in.), Williams College Museum of Art, Gift of Mrs. Charles Prendergast (86.18.1)

Prendergast made in Paris during these four years, it is evident that, like Conder and their mutual Canadian friend James W. Morrice, he gravitated toward the more progressive fringe of the Parisian art establishment. Morrice settled in Paris before 1890 and later became a close friend of Clive Bell and Matisse. He also knew Robert Henri in Paris (starting in 1895, after Prendergast's departure) and may have been one of the links that drew Henri and Prendergast together in New York after 1901.[13]

While there are echoes of the Nabis in Prendergast's *Sketches in Paris* (cat. no. 2), which feature vignettes of children playing in parks such as the Luxembourg Gardens not far from the Académie Julian at 31, rue de Dragon, these sketches also suggest the influence of Whistler, the most prominent American living in Paris during Prendergast's stay there. Whistler's studio on rue Notre-Dame-des-Champs, overlooking the Luxembourg Gardens, became a gathering place for Americans in Paris after 1892. Although many more celebrated artists such as Degas, Toulouse-Lautrec, and Beardsley visited Whistler, it is certainly possible that Prendergast and his friends might have occasionally gained entrée. Prendergast's friends from Boston who were also studying in Paris at the time—George Noyes, Charles Hovey Pepper, and Hermann Dudley Murphy—were all passionate about "our grand master."[14] It was in this studio that Whistler worked on his lithographs, such as *Nursemaids, "Les Bonnes du Luxembourg"* (1894; fig. 5), which were echoed in Prendergast's park scenes. Whistler's influence can also be seen in the gray delicate mood of Prendergast's *Along the Seine* (cat. no. 3) and *Dieppe* (cat. no. 4).

With the coming of summer the American art students in Paris typically headed for the countryside and formed col-

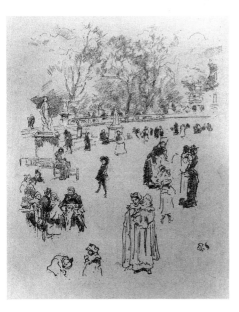

Fig. 5. James McNeill Whistler, *Nursemaids, "Les Bonnes du Luxembourg"*, 1894, Lithograph (12³/₄ x 8³/₄ in.), Williams College Museum of Art, Estate of Jane T. Richie (85.24.56)

onies that dotted the Normandy and Brittany coasts as well areas along the Seine and pockets of Holland. Prendergast was a lifelong habitué of seaside resorts, but once acquainted with certain areas of coastline, he seldom strayed farther away. Unlike Homer, who traveled to beaches in the Bahamas, Bermuda, and Florida in addition to New England and New Jersey, Prendergast was content with the New England coast, to which he returned year after year. He followed the same pattern in France: once he became familiar with certain beaches from St. Malo to Dieppe, he went back during every subsequent trip.

In the early 1890s he often traveled with Morrice, and the two of them would produce small oils and watercolors of a Whistlerian romanticism, showing deserted beaches or melancholy figures gazing out to sea (*Le Treport*, fig. 6, and *Dieppe*, cat. no. 4). Although in the watercolors he would occasionally use brilliant touches of color, the oils, such as *Dieppe*, tend to be muted and distant. Very little direct influence of the Impressionists can be detected in these early beach scenes, even though their work was readily seen in Paris in the years Prendergast was there.[15]

The contrast between Prendergast's looser more exuberant scenes of the city and his muted studies of the coastal areas suggests that he saw the landscape motif in a more traditional way than he saw the scenes of modern urban life. It is likely that in the city he was surrounded by and inspired by more radical art, whereas during his trips to the seaside, he was truly "on vacation" and slipped back into traditional formulas. Interestingly enough, it was the coastal views that he offered for exhibition when he returned to Boston in 1895.[16]

But these calm romantic depictions of unchanging nature suddenly gave way to an interpretation of the beach scene that had seldom been formulated in either European or American art. Beginning in the first year after Prendergast's return from Europe, he devised a synthesis of the two different approaches (urban und rural) that had previously divided his work. This can be seen in the subjects that show urban life *at its juncture* with nature. For instance, in the versions of *South*

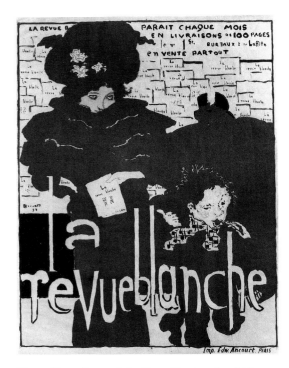

Fig. 4. Pierre Bonnard, *La Revue Blanche*, 1894, Lithograph (31¹/₂ x 24³/₈ in.), Williams College Museum of Art, Museum Purchase (58.16)

Boston Pier (cat. nos. 6, 7), Prendergast shows a pier—one of the Boston concourses that projects into the sea—beckoning the city dwellers to cross the line from a man-made environment to a natural one. The characteristics of the city remain, as we saw them defined earlier in *Evening Shower, Paris*: the active walk of the "Parisienne" which sends her clothing flying, the exuberance of children, and the pattern of the city lights. They have simply been lifted from their gray urban setting and placed in the midst of sun, wind, and sea.

The beach, on the other hand, had become in Prendergast's art as urban as the city; and Prendergast again recorded the juncture of man-made and natural environments. In *Revere Beach* (cat. no. 8), it is crowded not only with people, but with a warren of buildings as congested as Boston itself. Architectural structures have even spread out into the waves, as in *Children on a Raft* (cat. no. 9) and *Float at Low Tide, Revere Beach* (cat. no. 10) where the large raft is almost like a small town square where as many people as possible have congregated.

Prendergast's new interpretation of the beach would not have been possible without his absorption in Paris of the notion of the "heroism of modern life" which had pervaded radical French art since the 1860s. As T. J. Clark recently interpreted it, "modern life" for painters was thought of as subjects that mixed classes and class values and, in doing so, equated the modern with the "marginal."[17] This could be seen particularly in the work of Manet and the Impressionists in which marginal members of society—prostitutes, the petit bourgeois, and the new suburbanites—help create the "spectacle" of the city. By the 1890s, when Prendergast was in Paris, he could have seen an even more extreme example of this through his friend Conder, the habitué of the Moulin Rouge with its volatile mixture of classes and morals, or in the work of Seurat, such as *La Grande Jatte,* which was highly visible after the young artist's sudden death in 1891. The aspect that caught Prendergast's eye was the portrayal of the less refined segment of society as dynamic and fashionable so that it acquired a beauty that blurred class distinctions.[18]

Fig. 6. Maurice Prendergast, *Le Treport,* 1892, Watercolor and pencil on paper (7³/₄ x 8³/₄ in.), Williams College Museum of Art, Gift of Mrs. Charles Prendergast (85.21.4)

When Prendergast returned from Paris in late 1894, public attention was focused on the crisis in Boston resorts—those closest to the city, Revere Beach and Nantasket, had been allowed to sink to new lows of overcrowded conditions and immorality, particularly in the uncontrolled sale and consumption of liquor. These resorts had been bypassed for decades by the upper-class Bostonians on their way to Nahant, Marblehead, Salem, or farther north to Maine. But the laying of track for a new electric railway in the 1880s made Revere Beach and Nantasket suddenly accessible to the rapidly expanding working-class population of the city. Unregulated growth soon produced conditions too squalid to be tolerated, and, in 1894, the old shanties were torn down for more spacious and safer public buildings.[19] For the next few years, Revere Beach was a model working-class resort, and Prendergast, aware of the attention focused on it (and Nantasket, which would undergo a similar clean-up in the later 1890s), capitalized on the diverse reactions the public had to this particular site.

In Prendergast's *Revere Beach* (cat. no. 8), dated 1896, we see in the background the new pavilions erected to sell food, rent bathing costumes, and provide entertainment to the holiday crowd. In front, the "Sunday-dressed" family (backs turned to the sea) picks its way along the wet sands toward the commercial attractions. The working-class identity of Revere Beach would have been well known to Bostonians, and the resort's previous disgraceful reputation still fresh in the viewer's mind. However, Prendergast mitigates the negative by showing off the attractiveness of the people in their fresh and fashionable clothes, and reminds the viewer that the resort has turned over a new leaf. The result is a mixture of responses to the subject matter as the shifting elements of class and fashion are taken into consideration.

There is a mixture of "high" and "low" in Prendergast's style just as there is in his subject matter. The upward sweep of the spatial construction, the intensity of the color, and the charm of the detail are all masterful; but the quickness of Prendergast's stroke often results in imperfect renditions of the figure that appeared crude to some critics at the time. The intriguing blend of crudeness and refinement in both style and subject matter accounts for the success of these works when they were first shown and for their continuing appeal. In his scenes of Revere and Nantasket beaches, Prendergast arrived at his first mature style—one based on the French "painting of modern life," but translated into a Boston idiom.

By the end of 1896 Prendergast had begun exhibiting these beach scenes not only in Boston at the Boston Art Club and the Jordan Art Gallery, but also at the New York Water Color Club, the Pennsylvania Academy of the Fine Arts in Philadelphia, and the Art Institute of Chicago. His notices were uniformly enthusiastic and, within two years of his return from Paris, he had made a successful transition to the fine arts. A glowing review in the *Sunday Journal* in the spring of 1897 is worth repeating in full:

The works by Maurice B. Prendergast, both at the Art Club and Jordan Art Gallery, are the "rage of the town," and well they may be so reckoned.

Prendergast, when a student in Paris, was the most popular man in his class, and his fellows always bought everything he painted, paying from twenty-five francs upward for his sketches.

Since his return to Boston he has been unable to keep pace with the demand, and now our modern Dumas shouts to the public, "We have a Meryon among us." One of his pictures at the Jordan Gallery has sold, and others will follow.

Prendergast was a fellow student at Julian's with Murphy and Hopkinson, both strong men, as their works in the Jordan Gallery bear witness. The young men seem to be carrying off all the art honors of late.[20]

In spite of the reviewer's claim that "he has been unable to keep pace with the demand," Prendergast supplemented his income from painting by designing posters, book covers, and book illustrations for publishing companies in Boston during the first few years after his return from Paris. Indeed, he did much of this work in 1895, when he probably most needed the money. In that year he did various kinds of design work (poster, book cover, or illustrations) for four books, *Foreman Jennie, On the Point, The Shadow of a Crime,* and *My Lady Nicotine,* and one poster for a series of books, *Round Table Library.* The most ambitious of these was *My Lady Nicotine,* for which he designed the cover (fig. 7) and 138 illustrations and decorations (for example, fig. 8).

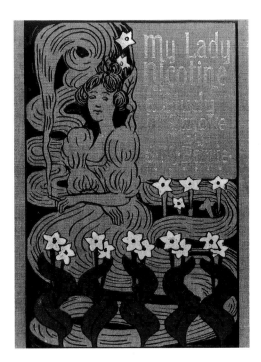

Fig. 7. Maurice Prendergast, Cover design for *My Lady Nicotine: A Study in Smoke* by James M. Barrie (Boston: L. C. Page and Company, 1896), Commercial transfer of drawing via metal die, embossed on hard cover ($7^1/_2$ x $5^1/_4$ in.), Department of Printing and Graphic Arts, The Houghton Library, Harvard University

Fig. 8. Maurice Prendergast, Illustration from *My Lady Nicotine: A Study in Smoke* by James M. Barrie (Boston: Joseph Knight Company, 1896 [1895]), Photomechanical transfer of ink drawing and watercolor on paper (7 x 5 in.; page), Williams College Museum of Art, Prendergast Archive

Although Prendergast had been a commercial artist for over ten years, he does not seem to have done this kind of work before.[21] His dabbling in applied graphic art should be seen, therefore, as an outgrowth of the general craze for posters and the art of the book that swept Boston as it had European and other American art centers in the 1890s. New journals and publishing houses proliferated in Boston, and Prendergast, perhaps through his friend Murphy (who had been an illustrator before they both went to Paris), became extensively involved. However, he did not continue his work in applied graphics beyond the numerous projects of 1895 and a final one in 1897, *Muriella or Le Selve*; and this may support the idea that Prendergast did this kind of work only while he was establishing himself as a painter.

At the same time, he began practicing another form of graphic art which was to hold his interest for several years—the art of monotype (see chapter four). These color prints, like the posters he had been designing, were linked to the widespread interest in Japanese printmaking and design that had taken hold in Boston at the same time as the book and poster movement. Prendergast and all his friends collected Japanese prints, and one friend in particular, Charles Hovey Pepper, had become so enamoured of them in Paris that he later traveled to Japan to study them and afterwards published a book on Japanese prints.[22] In Boston Ernest Fenellosa, scholar, curator, and collector, had been responsible for the start of an extensive collection of Oriental art at the Museum of Fine Arts, and Arthur Wesley Dow, a friend of Prendergast's, was his assistant. Color prints inspired by the Japanese were tried by all of the artists in these circles.

However, Japanese prints were even more influential on theories of design that pervaded not only color prints but all forms of painting. Japanese influence, of course, was nothing new in European and American painting; it had been acknowledged since the 1860s. However, in the late 1890s, the design qualities of Japanese prints became codified in the form of Dow's extremely influential book, *Composition,* published in 1899. Dow had been teaching art since about 1890, and in 1895 began dividing his time between Boston and New York to teach at the Pratt Insitute. For his new book he compiled

methods he had devised over the years to teach "composition" rather than "drawing," and at the core of his approach was the study of the large flat areas of color artistically arranged in Japanese prints. Much of his belief in this form of design was shared by Prendergast and the group in Boston.

Prendergast's color prints show the Japanese design principles most vividly, but his watercolors and paintings of this time were also deeply affected. Compared to the paintings he did in France, the beach scenes (cat. nos. 8-19) are very consciously "composed." In the two watercolors of the Revere Beach raft, *Children on a Raft* and *Float at Low Tide, Revere Beach,* the poles of the raft, as well as their reflections in the water, act as very distinct vertical dividers that intersect with horizontal bands in water, beach, and horizon to form a grid upon which all other elements of the composition are carefully placed. The grid-like pattern can also be seen in horizontal works like *Evening on a Pleasure Boat* (cat. no. 18). Furthermore, the high horizon line that Prendergast uses throughout this period serves to flatten the surface, and in works like *Summer Visitors* (cat. no. 12) and *Low Tide, Nantasket* (cat. no. 14) he allows diagonals to zigzag from foreground to background.

The tendency to see the paper as a flat surface upon which large shapes are arranged was new in Prendergast's work and can be linked to the theoretical discussion on composition then current in Boston art circles, particularly among those influenced by Dow. Critics were well aware of this tendency and often cited Prendergast's "Japanese effects." One critic went on to link them to the "poster" style: "One feels that such effects are decorative rather than realistic, and the drawing that accompanies them favors that suggestion. This is pleasant, in moderation, but one would be sorry to have poster landscapes exclusively."[23]

During the mid-1890s, Prendergast lived with his brother Charles and their father (their mother had died in 1883) at

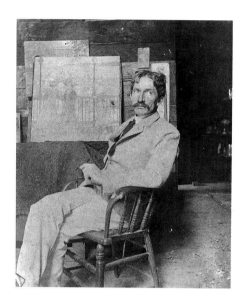

Fig. 10. Photograph of Charles Prendergast, ca. 1900-03 (4⅝ x 3⅝ in.), Williams College Museum of Art, Prendergast Archive

several different addresses in Boston, and then moved to suburban Winchester in 1898. Charles Prendergast had been a partner in a firm that made decorative woodwork for private homes, but in 1897 was apparently persuaded to branch out on his own as a framemaker.[24] The style of living of this household of three Prendergast men was modest, but increasingly more comfortable, especially when they moved into a house in Winchester after a series of city apartments. But in spite of their limited means, they established themselves among the well-educated and often very well-off, including Hermann Dudley Murphy, Mr. and Mrs. Oliver Williams, and Charles Hovey Pepper—all of whom lived either in Winchester or in nearby Concord. The brothers soon began to meet very wealthy people and establish a pattern of cordial relationships with patrons that would continue for the rest of their careers.

By all accounts the Prendergast brothers were charming, attractive people (figs. 9, 10). Both were slight of build; Maurice was five feet six inches tall and had gray hair by the age of forty. A friend who knew them somewhat later said, "They were odd and wonderful people, Mr. Maurice and Charlie. They always looked so clean and jaunty. There was something Peter Pan about both of them, [they] never quite grew up."[25] In spite of their youthful air, however, they were serious about art, and the lasting friendships they formed were with those who shared their passion.

Maurice became visible enough at this time to attract the attention of Sarah Choate Sears, an artist, photographer, and, with her husband, a leading patron of the arts in Boston. Prendergast and Sears may have known each other through their frequent exhibitions in Boston, or, possibly through Charles's work as a framemaker, which brought him many commissions from wealthy people. The result was that Sears apparently offered to finance a second trip to Europe for Prendergast;[26] by midsummer 1898 he was sailing for Italy. Sears is not known to have helped any other artists in this way, but, in a related act of generosity, she had begun to help art students through an annual cash prize she established at the Boston Museum School in 1891. Sears's friendship with Sargent and Mary Cassatt, and her small but important col-

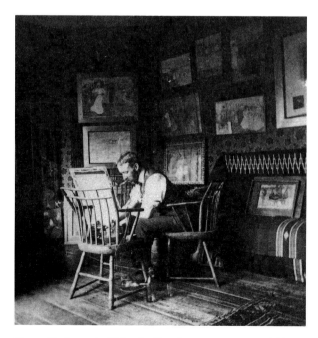

Fig. 9. Photograph of Maurice Prendergast, ca. 1900-03 (2¼ x 2¼ in.), Williams College Museum of Art, Prendergast Archive

lection of recent paintings by them and the French Impressionists, makes her appreciation of Prendergast especially significant. Several important watercolors from Prendergast's trip subsequently entered Sears's collection, including *St. Mark's Square, Venice (The Clock Tower)* (cat. no. 23).

Prendergast's decision to go to Italy rather than back to Paris was an unusual one in light of the artistic interests he had displayed up to this point. Neither his subjects (fashionable street life and coastal resorts), nor his style (contemporary French brushwork, Japanese and poster design), would lend itself easily to Florence, Rome, and Venice, where the ancient and the exotic took precedence over modern life. Even while in Paris Prendergast had previously shown little interest in the study of classical or Renaissance art. However, influential artists such as Hassam, Sargent, and Whistler had already painted there, and his friends Murphy and Pepper had been to Italy within the last few years. As he emerged as a successful painter in the mid-1890s, it is likely that Prendergast learned to appreciate the value of a trip to Italy more than he had at first and welcomed the acquaintance with older art that it offered.

Once in Italy, Prendergast made the most of his opportunity. Although no letters or documents survive to allow us to reconstruct the trip in detail, the basic outlines are these: he sailed soon after obtaining his passport on June 29, 1898; traveled to Venice, Padua, Florence, Siena, Assisi, Orvieto, Rome, Naples, and Capri;[27] and returned late in 1899.[28] He executed mainly watercolors while he was there,[29] sixteen of which he sent back for exhibition at the Boston Art Club and later at the gallery of J. Eastman Chase. The rest he carried home with him, and, within a few months of his return, he had exhibited them at the Art Institute of Chicago and the Macbeth Gallery in New York. The Italian watercolors capped ten years of steady growth and recognition and allowed Prendergast to enter the new century with confidence.

By far the most extraordinary aspect of the Italian watercolors is Prendergast's use of detailed architectural structures as decorative backdrops for the parade of human life seen throughout the tourist's Italy at the turn of the century. Unlike Ruskin, Sargent, or Whistler, Prendergast did not glorify the past by focusing exclusively on ancient monuments or picturesque natives. Instead, he made it plain in his pictures that he had come as a tourist and aimed to capture the excitement of tourist haunts. As with his beach scenes, he presents a beautiful setting and then populates it with figures that are as lively and interesting as the sights confronting them.

But since this charming crowd of people had appeared before in Prendergast's work, the real novelty is in the architectural design. There are a few views of Paris and Boston (*La Porte St. Denis,* Collection of Ned L. Pines, *Catalogue Raisonné,* no. 542, and *Rainy Day in Boston,* whereabouts unknown, *Catalogue Raisonné,* no. 598) from the 1890s that show an early mastery of urban architecture, but for the most part Prendergast concentrated on park and beach scenes. Why Prendergast turned to architectural compositions when he went to Italy may be explained simply by his attraction to the beauty of these ancient cities. While he loved looking at the

Fig. 11. F. Hopkinson Smith, "An Old Watergate," Illustration from F. Hopkinson Smith, *Venice of Today* (New York: The Henry T. Thomas Company, 1896), opposite p. 46 (11 3/4 x 6 11/16 in.; image), courtesy of Sawyer Library, Williams College

paintings in the great Italian museums, he spent as much time, if not more, exploring the architectural wonders he discovered at each new site.[30]

Venice was the city that held his attention for the greater part of the trip; he apparently went there first to take advantage of the remaining summer weather in 1898, and then went back to Venice the following spring after wintering in Rome, Naples, and Capri. He seems to have stayed there for the next six months, until he sailed for home. Venice's reputation as a city for artists was well established by the 1890s. Not only were Venetian views common fare in Boston exhibitions, but the artist's experience of canals and piazzas was what every tourist hoped to simulate. The proliferation of books on Venice, illustrated with artists' sketches of the formal and informal sites of the city, trained the tourist's eye to see it as an artist would. In one popular book, *The Queen of the Adriatic,* the author traverses the canals with an artist beside her, "The most delicious of days is that when in the cool morning we take to our gondola, with our artist and his traps...."[31] Most of the views of Venice produced for this tourist market, such as F. H. Smith's illustration from *Venice of Today* (fig. 11), were derived from Whistler's misty paintings and delicate etchings. They made the city seem insubstantial and fragmentary, as if it were a kaleidoscope of glimpses from a gondola rather than a series of well-defined views.

Prendergast's interpretation of Venice is oddly inconsistent with this popular style. While he, too, is captivated by the shimmer of light and the low "gondola" viewpoint in many of his canal scenes, he deliberately rejects the Whistlerian compositional device of starting from the center and letting the forms around the edges trail off. Instead, his Venetian scenes were even more carefully "composed" than were his previous beach scenes. He continued to use his favorite grid

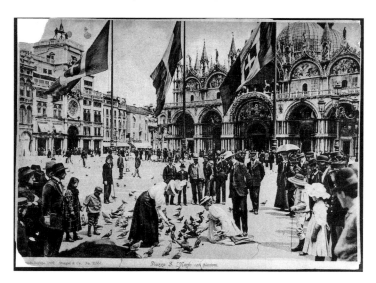

Fig. 12. *Piazza San Marco con piccioni*, 1897, Photograph (7⁵/₈ x 10⁷/₈ in.), Williams College Museum of Art, Prendergast Archive

device, often making a series of three flagpoles the vertical lines of the grid (cats. nos. 20-22). The other dominant lines of the composition tend to come from the architecture, which gives each work a completeness not often found in contemporary paintings of Venice.

Once again, Prendergast may have gotten the idea of putting architecture at the service of composition from Arthur Wesley Dow. Another of Dow's exercises was to have students analyze medieval and early Renaissance architecture. "Students made drawings or tracings from photographs of especially admired monuments, such as the Florence Duomo and Campanile, so they could better understand the harmonic proportions Dow likened to 'visual music.'"[32] Dow himself had made a study trip to Italy in 1896, ending with Venice's Gothic palaces.

Dow's exercise not only introduces the idea of using architecture for compositional purposes, but it also shows how pervasive was the use of photographs in the creative process in Prendergast's circle. In the case discussed above, the photographs were used for their abstract design qualities, but other qualities of nineteenth-century photographs also inevitably influenced how the architecture itself was perceived when the artist finally stood in front of the real thing. The monumental panoramic view of the building, the strong contrast of light and dark, and the wealth of surface detail are all typical qualities of photography that shaped the painter's perception.

Prendergast's watercolors of this period invite speculation about his use of photography. From as early as the mid-1890s to about 1901, the most structured and detailed of his works, such as *Float at Low Tide* (cat. no. 10) and *The Mall, Central Park* (cat. no. 35), in addition to many of his Italian pictures, suggest a photographic source. Indeed, photographs from his own collection, such as a large postcard of St. Mark's Square (fig. 12), could have served as a guide for the architectural background of *St. Mark's, Venice* (cat. no. 21), or even for the shapes of some of the flags of the unfinished watercolor *Venice* (cat. no. 22). Unfinished works like *Venice* show that Prendergast first sketched in major lines of the compositional grid

and then began to fill in smaller shapes, such as the flags, which would be the points of interest. His understanding of the composition was entirely two-dimensional—a series of colored puzzle pieces filled in one by one—as if working from a two-dimensional model (a photograph) rather than the three-dimensional world.

The fact that Prendergast executed the paintings on the site,[33] however, contradicts the idea that he was merely working from photographs; and indeed no photograph has been identified that was the exclusive source of a Prendergast painting. He evidently used the photograph as a guide for the outlines of the architecture and for occasional groups of figures, but he put the ingredients together to fit an overall response he had to the site itself. Furthermore, the photograph was not simply a crutch which allowed Prendergast to paint the scene with more certainty, but, true to Dow's teaching, it allowed him to achieve greater abstraction and balance of the two-dimensional with three-dimensional effects. In spite of the precision Prendergast achieved in these works, they are not static, rather they sparkle with color and lively patterns. Contemporary critics saw the relationship of these works to photographs as positive; one writer in *International Studio* compared them to a set of recently published photographic views of Venice: "These photographs are valuable documentary evidence worthy of consideration and Mr. Prendergast's sketches in the domain of color are of equal value."[34]

When not painting architecture, Prendergast's Venetian watercolors are looser and more purely decorative. In works like *Fiesta-Venice-S. Pietro in Volta* (cat. no. 25) and *Festa del Redentore* (cat. no. 29), he turns to the other great attraction of Venice (besides its picturesque urban structure)—festivals. *Fiesta-Venice* may simply illustrate one of the many parish festivals that were marked by colorful banners and processions through the streets, but *Festa del Redentore* captures the most important city-wide holiday of the year. Prendergast, gathering his information from descriptions in such books as *The Queen of the Adriatic* would have known that this festival marks the city's deliverance from the plague of 1576 and is celebrated on the third Sunday in July. All day there are processions and a carnival atmosphere; at night, it is the custom to hire a "supper gondola." "These are brilliantly lighted with lamps, and so beautifully dressed with green branches and wreaths that they seem like living bowers. The tables are well filled, and the boats crowded with joyous holiday-seekers, whose laughs and jests, intermingled with the sound of mandolins and songs, are most contagious in their merriment."[35] Prendergast's depiction of the gondolas at night, his first known night scene, is a vivid recreation of just such a passage.

Elsewhere in Italy Prendergast adjusted to the unique compositions to be found at each stop. He painted the hillside at Assisi (cat. no. 30), the island views of Capri, the paved courtyards of Siena, and the flower stalls of Florence. In Rome he visited the Borghese Gardens, the Spanish Steps, and the Pincian Hill, where he came upon a society in which the daily promenade was as colorful as a Venetian procession.

In his watercolor versions (cat. nos. 31, 32) of the zigzag roadway traversed by people of diverse classes and occupations, we sense in Prendergast a renewal of interest in the painting of modern life.

Prendergast came home from Italy to find that his affairs had been well tended. Sarah Sears had arranged for his Venetian works to be shown in Boston (see p. 17); Hermann Dudley Murphy kept Maurice's new paintings in his studio in the Grundmann Building in Boston and arranged for them to have a joint exhibition at the Art Institute of Chicago a month after Maurice's return;[36] and finally, Charles Prendergast had responded positively to a letter from William Macbeth, the New York dealer, requesting some paintings by Maurice to show in his gallery.[37] Maurice, at the age of forty-two, went back to Winchester to live with his brother and father in a house crowded with books, art reproductions, and ten years' worth of paintings (figs. 9, 10).

Prendergast's depictions of architectural monuments in Venice seem to have instilled in at least one patron the idea that he could do the same kind of work in Boston, and he was soon commissioned to paint the old "Bartol" church (*West Church, Boston*, cat. no. 33).[38] He did a series of views of the building itself (which was being used temporarily as a library) as well as the fountain and grounds. Of all the city views he was to do on American soil, these came closest to the architectural masterpieces of the Venice series.

The exhibition given to Prendergast by the Macbeth Gallery in New York opened a new chapter in the artist's career. While he may have had some contact with the New York art world in the 1890s,[39] from 1900 on he was in the city regularly and developed a lasting circle of friends there that included artists, critics, and dealers. He may even have been tempted to move there in the early 1900s as did the Philadelphia artists—Robert Henri, William Glackens, John Sloan, George Luks, and Everett Shinn— but his ties to Boston held him back. Nevertheless, his attention was increasingly turned to the events and ideas of the growing radical art movements that were beginning to take hold in New York, but not in

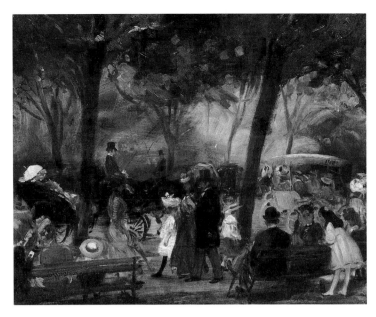

Fig. 14. William Glackens, *The Drive, Central Park,* 1904, Oil on canvas (25³/₄ x 32 in.), The Cleveland Museum of Art, Purchase from the J. H. Wade Fund (39.524)

Boston. The Boston artists in his circle were often sympathetic to these trends. For instance, Dow taught young artists like Max Weber at the Pratt Institute and the Art Students League; Pepper was friendly with Henri, Luks, and Marsden Hartley; and Sears knew Stieglitz and was a member of the Photo-Secession. But no one from Boston went to the lengths that Prendergast did to participate in the new movements.

His first contact in New York may have been Arthur B. Davies, who has been credited with having arranged Prendergast's one-man show at Macbeth in 1900.[40] He and Prendergast certainly became very good friends, collaborating and exhibiting together for the next two decades. Davies, in turn, may have introduced Prendergast to Henri, Glackens, and Luks, all of whom Davies got to know when they moved to New York by 1900. In addition to this group, Prendergast knew such artists as Albert Sterner and Van D. Perrine, who were not radical artists but nevertheless were interested in the contemporary art scene.

From 1900 to 1906 Prendergast seems to have spent part of every year in New York. He painted watercolors of the city sights: Madison Square, the East River, and countless scenes of Central Park. It is interesting that the oils during this period, which tend to be rather dark and thickly painted in a modified Ash Can School manner, were *not* of the city but of beaches and seaside parks, such as *Salem Willows* (fig. 13). In New York Prendergast preferred a light-filled watercolor technique, even when painting city streets, as in *Madison Square* (cat. no. 34).

His scenes of carriages drawn through Central Park (cat. nos. 36–38) form a series very much like his Pincian Hill watercolors from 1899. They parallel paintings by other members of his New York circle, such as Glackens's *The Drive—Central Park* (1904; fig. 14) and may in fact have influenced his friends' park scenes. While Prendergast did not

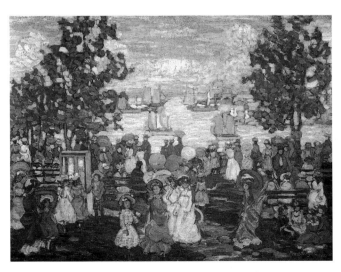

Fig. 13. Maurice Prendergast, *Salem Willows,* 1904, Oil on canvas (26 x 34 in.), © Daniel J. Terra Collection, Terra Museum of American Art, Chicago (21.1984)

share the harsher view of New York held by Luks or even Sloan, he quite genuinely believed (as they did) in the "common people" as important subjects (as in his earlier depictions of Revere Beach, see above), and he could second Luks in at least the second half of his refrain, "Guts, Guts, Life, Life! that's my technique."[41]

The banner in *Madison Square* advertises the Pan-American Exposition held in Buffalo in 1901 and may be a subtle reference to the fact that Prendergast had four works in the art exhibition of the Pan-American and was awarded a Bronze Medal by the exhibition jury. This was to be the only prize he would win until 1923, just before his death. Furthermore, he entered works in fourteen exhibitions that year, more than any other year until 1923. With an enthusiastic New York dealer and a new circle of friends, he reached new heights in his career.

It was during the early years of the century that he was closest to the Henri circle in style and philosophy. His explorations of New York were as avid as theirs; the city attracted him as Boston had not. He also shared their interest in children at play, depicting swings (*The East River,* cat. no. 43), sailboat ponds, and May Pole dances (*May Day, Central Park,* cat. nos. 41, 42). He made an effort to see sights such as a parade in Prospect Park, Brooklyn, that Macbeth told him about: "I received your considerate post card and got out to Prospect Park in good time and was lucky enough to see the prossession [sic] from the grand stand. It was a great sight— thousands of little children marching past with their banners and flags waving."[42]

But when Prendergast first got an opportunity to exhibit with this group at the National Arts Club in 1904, he did not submit the New York watercolors, but entered seven oil studies of beach scenes, all titled *Promenade on the Seashore.* While these studies of sea and clouds (for example, fig. 15) contrasted with the portrait and figure studies shown by Henri, Luks, Glackens, Sloan, and Davies, Prendergast was not considered an outsider. In fact, the critic for the *New York Evening Sun* put him next to Henri in stature: "[this is] what will infallibly happen at this exhibition, namely, that Mr.

Fig. 16. Arthur B. Davies, *Dancing Children,* 1902, Oil on canvas, (26 x 42¹/₈ in.), The Brooklyn Museum, Bequest of Lillie P. Bliss (31.274)

Henri and Mr. Prendergast will be better received than the rest, because by some extraordinary accident they have gained a secure footing in the big annual shows of the recognized institutions and the disciples of those institutions have learned to tolerate them."[43] Prendergast at this point was considered as important and influential in New York as Henri.

In the next few years Prendergast remained identified with the New York realists. Even as he began to lose interest in their subject matter, he continued to sympathize with their struggles against the closed-minded jurors who ruled large exhibitions in New York. He wrote indignantly to a friend in Boston about how the jury at the Society of American Artists had laughed at a portrait by Luks, and in spite of one juror's valiant speech in its favor, voted it down.[44] Although successful, Prendergast, who had not exhibited in the Paris Salon or become a member of the important American art associations like the Society of American Artists or the National Academy of Design, was renegade in spirit and was attracted to artists whose ideas were exciting and original, regardless of their style.

After the 1904 exhibition at the National Arts Club, Prendergast diverged even more in style from the urban realism of the Henri circle. He maintained close ties with Davies, however, and the works carried out closer to 1905, including the studies of surf (*Surf, Cohasset,* cat. no. 44, and *Surf, Nantasket,* cat. no. 45) and the related watercolor, *April Snow, Salem* (cat. no. 46), are more fanciful in style than strictly descriptive. Davies, who was known for using mythological and imaginative subjects, had an exhibition in Boston in 1905[45] which intrigued Prendergast, and many of Davies's works from the early part of the decade (fig. 16) have the same decorative quality as *April Snow.*

Prendergast by 1906 was still a painter of modern life, but he was reaching the limits of this theoretical framework. His oil studies of the seashore from 1904 were investigations of color far more than they were observations of modern life, and, for the first time, Prendergast was praised for his brushstroke, color, and composition without a mention of his subject matter.[46] After fifteen years of chronicling high and low society of La Belle Epoque, Prendergast, at the age of forty-eight, was ready for a change.

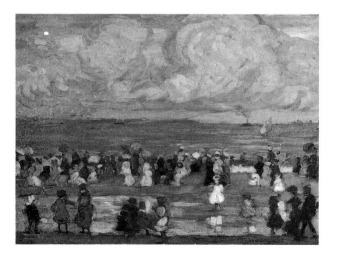

Fig. 15. Maurice Prendergast, *By the Seashore,* ca. 1902-04, Oil on panel (11³/₄ x 16 in.), Mitchell Museum, John R. and Eleanor R. Mitchell Foundation (1973.1.47)

Notes

1. Charles Prendergast described his father's business as a "trading post," but he is listed as "grocer" in the *Newfoundland Directory*. His mother was the fourth daughter of H. M. Germaine, M. D. of Boston. In an interview with Hamilton Basso, Charles said that his father, Maurice Prendergast, traveled frequently on business to Boston, where he met Mary Malvina Germaine, married her, and brought her back to St. John's. Hamilton Basso, "A Glimpse of Heaven—II," *New Yorker* 22 (August 3, 1946), p. 28.

2. John Sloan, for instance, had a business card which identified him as "a designer who did lettering and advertising sketches." Van Wyck Brooks, *John Sloan: A Painter's Life* (New York: E. P. Dutton & Co., Inc., 1955), p. 29.

3. Ellen M. Glavin, "Maurice Prendergast: The Boston Experience," *Art & Antiques* 5 (July-August 1982), p. 67.

4. Basso II, p. 28. Two watercolors by Prendergast that depict scenes in Wales are dated 1886 (*Catalogue Raisonné*, nos. 509 and 510), and a sketchbook from about the same time (*Catalogue Raisonné*, no. 1475) contains addresses in North Wales.

5. The *Dictionary of American Biography* (1963) states that Prendergast attended the Starr King School and drew from the cast in the evening classes. This, however, is the only reference to Prendergast's studying art in Boston and has not been corroborated by any other source.

6. Works by Manet, Monet, Courbet, and Corot were included in the "Foreign Exhibition" at the International Exhibition for Art and Industry in the fall of 1883.

7. Carol Troyon, *The Boston Tradition: American Paintings from the Museum of Fine Arts, Boston*, exhibition catalogue (Boston: Museum of Fine Arts, 1980), p. 36.

8. Van Wyck Brooks, "Anecdotes of Maurice Prendergast," *Magazine of Art* 31, no. 10 (October 1938), p. 565.

9. *Ibid.*, pp. 565-566.

10. His friends James Morrice and "a young English sculptor named Stark" both acquired a number of Prendergast's watercolors at this time. Stark's watercolors stayed in the familiy until the early 1960s. For Morrice, see Cecily Langdale, *Charles Conder, Robert Henri, James Morrice, Maurice Prendergast,* exhibition catalogue (New York: Davis & Long Co., 1975), p. [4].

11. The story is found in Brooks, "Anecdotes," p. 566.

12. Langdale, p. [7].

13. For the relationship between Prendergast and Morrice, see Langdale, p. [3], and Nicole Cloutier, *James Wilson Morrice 1865-1924*, exhibition catalogue (Montreal: The Montreal Museum of Fine Arts, 1986), p. 21.

14. Murphy gave Maurice Prendergast a copy of Whistler's *The Gentle Art of Making Enemies* (New York: John W. Lovell Co., 1890), with the following inscription:
 My dear old Prendy,
 A merry Christmas to you and Charlie and your father & may our grand master's words afford you [as much] amusement as they do your friend.
 HDM [monogram]
 Prendergast Archive, Williams College Museum of Art.

15. At the Galeries Durand-Ruel alone, Prendergast might have seen exhibitions of Mary Cassatt (1891), Renoir (1892), and Gauguin (1893) among other Impressionist and Post-Impressionist exhibitions. In June 1891 Durand-Ruel held an exhibition of American artists, including Chase, Eakins, Hassam, Robinson, Twachtman, and others.

16. He exhibited a *Fishing Boats — Treport, France* in the 52nd exhibition of the Boston Art Club, April 6-27, 1895 and two watercolors of Tréport in the "Jordan Gallery Third Exhibition of Works by New England Artists," May 9-30, 1896.

17. T. J. Clark, *The Painting of Modern Life: Paris in the Art of Manet and His Followers* (Princeton: Princeton University Press, 1984), p. 259.

18. See Clark, pp. 261-267, for critical reaction to Seurat's mixture of classes in *Dimanche après-midi à l'île de La Grande Jatte* at the time when it was first exhibited (1886).

19. A history of the North Shore can be found in Joseph E. Garland, *Boston's Gold Coast: The North Shore, 1890-1929* (Boston: Little, Brown and Company, 1981), pp. 6-33, *passim*.

20. Reprinted in the catalogue of the "Artist's Exhibition and Sale," Gallery of C. O. Elliett, Malden, Massachusetts, April 21-May 4, 1897.

21. The critic who reviewed *My Lady Nicotine* for the *New York Evening Sun*, while very laudatory, suggests that Prendergast is just learning the craft, "If a few of these [the illustrations] are a little crude, and lack something of technical skill, it is because Mr. Prendergast has not, perhaps, as yet thoroughly mastered his medium" "New Books," January 2, 1896, p. 5.

22. Charles Hovey Pepper, *Japanese Prints* (Boston: Walter Kimball and Company, n. d. [1905]).

23. Arthur Chamberlain, "Boston Notes," *Art Interchange,* 150, no. 4 (April 1898), p. 88.

24. Basso II, p. 28. According to the story Charles told, both his brother and Hermann Dudley Murphy urged him to become a framemaker.

25. Fred Brady, "Anonymous Friend Reveals Prendergast's Love of Life," *Boston Herald,* Sunday, November 27, 1960. The anonymous friend was Daphne Dunbar, a young art student and friend of the Prendergasts in Boston during the teens.

26. William M. Milliken, "Maurice Prendergast, American Artist," *The Arts* 9 (April 1926), p. 182.

27. This itinerary is based on sites identified in the watercolors and information given by Charles Hovey Pepper, "Is Drawing to Disappear in Artistic Individuality?" *The World To-Day* 19, no. 1 (July 1910), p. 719.

28. A letter from Hermann Dudley Murphy to William Macbeth, December 1, 1899 informs Macbeth that Prendergast has just returned (Archives of American Art, Macbeth Gallery Papers).

29. There are sixteen monotypes and one oil panel associated with the Italian watercolors of 1898-99, but, unlike the watercolors, there is no evidence that they were actually done in Italy and not after his return home.

30. Pepper, *The World To-Day*, p. 719: "Much of [Prendergast's] time was also spent in studying the architecture of the city's old palaces and churches."

31. Clara Erskine Clement [Waters], *The Queen of the Adriatic or Venice, Mediæval and Modern* (Boston: Estes and Lauriat, 1893), p. 15.

32. Frederick C. Moffat, *Arthur Wesley Dow (1857-1922)*, exhibition catalogue (Washington: Smithsonian Institution Press, 1977), p. 82.

33. A story was told about *St. Mark's Square, Venice (The Clock Tower)* (cat. no. 23) that confirms the fact that Maurice painted outdoors in front of his subject:
 "[Prendergast] had a commision in Venice to paint the old clocktower. He went there two or three times for preliminary sketches. Each time, as he began to work, a little boy who was passing stopped to watch him. The little boy stood motionless and silent until he closed his box and went away. The next day, there was the boy again, waiting for him, following all his movements. Prendergast was frantic. He packed up his box and walked over to Florian's, and he kept peeping round the corner to see if the boy was there. Not a soul in sight! He went back and unfolded his stool. Presto! There was the boy again; he seemed to have sprung from the ground. There he stood watching and never said a word." Brooks, "Anecdotes," pp. 567-568.

34. Charles H. Caffin, "American Studio Talk," *International Studio* 9, no. 34, Supplement (December 1899), pp. VII-VIII.

35. Clement [Waters], pp. 74-75.

36. H. D. Murphy to William Macbeth, [Nov.? 1899] (AAA, Macbeth Gallery Papers).

37. Charles Prendergast to William Macbeth, September 29, 1899 (AAA, Macbeth Gallery Papers).

38. Milliken, p. 182.

39. At the very least, he exhibited with the New York Water Color Club from 1896 on, and was well received there. He very likely traveled to New York for these exhibitions.

40. Bennard B. Perlman, *The Immortal Eight* (New York: Exposition Press, 1962), p. 169. However, from correspondence between Prendergast, Murphy, and Macbeth, it seems that Macbeth had approached Prendergast first about handling "two or three" works on commission (Murphy to Macbeth, [October] 1899, AAA, Macbeth Gallery Papers), but it was Prendergast who asked Macbeth to "please let me know if you give single exhibitions in your galleries" (MBP to Macbeth, January 10, 1900, AAA, Macbeth Gallery Papers). The "single" exhibition seems to have been agreed to quickly, with Prendergast shipping his works to New York at the end of February for a March 9 opening.

41. Perlman, p. 128.

42. MBP to Macbeth, June 5, 1904 (AAA, Macbeth Gallery Papers).

43. "A Significant Group of Paintings," *New York Evening Sun*, January 23, 1904, p. 4.

44. MBP to Esther Williams, April 27, 1904 (AAA, Williams Papers).

45. MBP to Esther Williams, March 6, 1905 (AAA, Williams Papers): "Do run up and see Davies' exhibition. I would like to have your opinion on them . . . it is the first time I have seen them in a collective exhibition and they interest me although I have [heard] adverse criticism from two people whose opinions I value highly."

46. "His spotty little pictures reveal a sense for color schemes that is very uncommon . . . it is rare to find any one with such a delicate feeling for the relations of colors and so true a sense for composition." Charles deKay, "Six Impressionists: Startling Work by Red Hot American Painters," *New York Times*, January 20, 1904, p. 9.

II

Early Modernism

Studies in Color and Form

(1907–1913)

By 1907 Henri had established himself as the leader of the progressive artists in New York and his deeply felt realism as the style to be emulated. But even as he ascended to prominence, news about more exciting styles from abroad had been trickling into New York and Boston. In 1908 Prendergast, Henri's friend and ally, unwittingly assisted in the downfall of Henri's realist style when he showed a series of paintings fresh from his trip to France in the exhibition of The Eight. This exhibition, which was to be the triumph of "American" art, also turned out to be a vehicle for the dissemination of the new French modernist styles.

Prendergast's restlessness in the early years of the decade prompted him to make several changes in his work. He left suburban Winchester for a studio in downtown Boston and began to concentrate on oil paintings, a medium taken more seriously than watercolor by the art world. And, as noted above (p. 20), he introduced a greater degree of imaginative transformation of the subject matter that had appeared "mannered" to critics used to his previous straightforward naturalism.[1] These changes may in part reflect the fact that success feeds ambition, and Prendergast was anxious to prove that he was more than a mere painter of watercolor views. He may also have been sensitive to the expectations of the larger art world, to whom he was now well known. Prendergast may have heard rumblings among artists and critics along the lines of a review he got in a Chicago paper in 1905 which praised his work but urged him to move on: "This painter is so blithe, he sees so vividly the playful surfaces of life, that any criticism seems too austere; yet he is doing exactly the same kind of things with which he began a few years ago. He should widen his range, lest his style harden."[2]

In May of 1907 Prendergast departed for France. His objective was simple: he wanted to return and paint the coastal resorts in Normandy and Brittany that he had come to know so well fifteen years before. According to a letter to his brother, his immediate plans were to stay at Le Havre (where his ship would dock) and paint in that area if the weather were good; if not, he would go to Paris to see the exhibitions.[3] As it happened, the weather was not favorable, and Prendergast ended up in Paris seeing art that changed his life. In his next letter to Charles came a flood of thoughts and feelings:

I have just seen the Champs de Mars [Société Nationale des Beaux-Arts] exhibition and it was worth travelling 100,000 miles to see and to spend all [the] money one could afford. When I landed at Harve I got quite homesick and regretted coming over but one [day] at the Champ de Mars made me feel like an artist again. One thing [that] made a great impression on me were the beautiful colors which they got, and in wonderful taste—all have that, whatever color they are. There is a beautiful quality of grey in them. And I tell you I was kept busy between looking at the frames and the pictures. I got in at eight in the morning and I happened to look at my watch and it was four o'clock in the afternoon. I forgot [hunger?], I forgot I was in Paris, I was so absorbed. Of course there is a lot of rot and so many and many charming and delightful, so much, so much in my own temperament. I never got such a shake-up and it made me feel glad I have that quality. And there are so many others [it] made Paris feel so homelike. It is the real home of the artist. There is no thinking of yourself like alas—Boston. . . .

This Champ de Mars is a staggerer for me, it is a blow on the chest. And it has set me in a profound thought and a hell of [a] lot of thinking

You have no Idea what a novelty it is for me to see all those stunning little artistic things on exhibition.

You ought to see the Luxembourg Garden now, it is in full swing—the Band playing and the children romping about and women talking, sewing, and embroidering. I see pictures in every direction, and I am dam glad I did [not] stay at Harve.[4]

From the strength of his reaction, it is clear that Boston and New York provided inadequate stimulation for him. Even the Champs de Mars, the most conservative of the three annual Paris exhibitions, contained enough innovation to open Prendergast's eyes.

Prendergast was indeed fortunate in the exhibitions in Paris that year; besides the Champs de Mars which excited him so much, he got to see an exhibition of Cézanne's watercolors[5] and the Cézanne retrospective in the Salon d'Automne.[6] Because he was obviously hungry for all the art Paris could offer, we can asume that nothing that was exhibited publicly[7] escaped his attention. In his letters home he mentions a wide range of artists by name: Chardin, Fragonard, Cézanne, Berthe Morisot, Eva Gonzales, Félix Vallotton, Vuillard, and

his old friend, Morrice. In addition, he was especially taken with the most radical artists who were shown at the Salon d'Automne:

> I am delighted with the younger Bohemian crowd, they outrage. Even the Byzantine and our North American Indians with their brilliant colors would not be in the same class with them. Valloton Felix is one of the younger men and Vuillard. [Vallotton] paints on cardboard which by the way seems to be popular among them. Vuillard is a rare exception, he paints interiors, quaint and old Fashioned with the most delightful greys. All those exhibitions worked me up so much that I had to run up and down the Boulevards to work off steam.
>
> Then there is another crowd here, the Independents, who Paul Adam says paints for noterity. Can you imagine a picture which is called Maternity, the Mother Surrounded by her children, an interior. The Mother has a brick red face and arms with a prussian blue dress, the baby has a vermillion face with a green dress and the other children in ratio. The furniture is indian red, the whole backed with a cadmium yellow wall. The faces are outlined in black black eye brows, black shadows, etc. The effect is startling, but there is something I like about them. I wish we had some [of] it in Boston or New York. Our exhibitions are so monotonous.[8]

These are the letters of someone who is delighted with everything, and the newer the better! He started his visit to Paris being strongly affected by the offerings of the Champs de Mars; he finished it full of praise of art on the opposite end of the scale at the Salon d'Automne. In between, and dominating all the modern art in Paris that year, was Cézanne, whose art touched Prendergast deeply.

Of all the American artists working or studying in Paris in 1907, Prendergast was the first to bring the new ideas back to the American art scene. He played this key role for several reasons. First, for an established artist, he was unusually open-minded and able to appreciate what he had seen. Others of his age and respectability, like William Glackens (who had been in Paris the summer before), were not as responsive to the new art as Prendergast and the younger artists tended to be. And second, unlike the younger artists, Prendergast was influential and sufficiently connected in progressive circles back home that people immediately took note of what he said. When he spoke of Cézanne and the Fauves, he had the attention of such teachers and journalists as Robert Henri and Charles Fitzgerald, critic for the *New York Sun*. And finally, Prendergast returned to the United States before the others. He was in France only for five months, returning, paintings in hand, in November 1907. Others who were in Paris in 1907—like Eduard Steichen, Max Weber, John Marin, Alfred Maurer, Patrick Henry Bruce, Arthur B. Carles, Abraham Walkowitz, and Walter Pach—all stayed in Europe for at least another year. Alfred Stieglitz, who was also in

Fig. 17. Gertrude Kasebier, *Portrait of Maurice Prendergast,* ca. 1907, Photograph, platinum print (8³/₈ x 6¹/₂ in.), Delaware Art Museum, Gift of Helen Farr Sloan (78-589.18)

Paris in the summer of 1907, did not begin showing contemporary French art at his 291 Gallery until the following year (Rodin in January, Matisse in April) and did not show his first American modernist (Maurer) until the spring of 1909.

Furthermore, less than four months after his return, Prendergast was able to show his latest paintings in the exhibition of The Eight, an exhibition that attracted an inordinate amount of attention and traveled to ten cities across the country. Prendergast was in a prime position to transmit the contemporary art styles he had just seen in Paris.

What, then, did he transmit? First, and perhaps most importantly, he communicated his enthusiasm for the new art he had just seen to anyone in New York and Boston who would listen. As soon as he returned, he preached the gospel of Cézanne to his New York friends—Glackens, Shinn, Sloan, Henri, and the critic Fitzgerald.[9] He shared his enthusiasm with Charles Hovey Pepper in Boston; possibly through his influence, Sarah Sears eventually owned two Cézannes and a Matisse. Walter Pach, who had been a pupil of Henri in 1906 and who wrote the first major article on Cézanne in English (1908), had become a friend of Prendergast by 1909 and gave him credit for being "the first American to appreciate Cézanne."[10]

In his Paris sketchbook, Prendergast drew some of the paintings he saw in the exhibitions there, including Matisse's *Le Luxe, I* (1907; fig. 18). These drawings would have been the first reproductions of such paintings to enter the United States, and Prendergast could have used them to describe to his friends some of the more radical works. When Stieglitz held the first American exhibition of Matisse's drawings, paintings, and prints in April 1908, the artists in Prendergast's circle would already have had some idea of his style.

Prendergast's paintings from France (cat. nos. 47-65), while far from duplicating the styles he saw in Paris, gave

American viewers their first glimpse of the extremes to which the French had gone. Prendergast's paintings are not consistent in style, nor do they equally reflect identifiable French sources, but they all share what Prendergast called "a new impulse" (see below). The body of work falls into three stylistic groups: the Paris series (both watercolors and oils), the St. Malo watercolors, and the St. Malo oils. Within each group one can see a slightly different facet of Parisian modernism and a slightly different method Prendergast used to assimilate it into his own style.

The Paris watercolors and oil panels (cat. nos. 47–52) are closest to the work he was doing before he came to France. They are not based on bright primary colors à la neo-impressionism, as is *St. Malo No. 2* (cat. no. 54), but are blue, gray, and tan (see *Notre Dame, Paris*, cat. no. 47, and *Band Concert*, cat. no. 49, especially). This muted blue-gray palette was one that he had adopted before his Paris trip (see *April Snow, Salem*, cat. no. 46), and his appreciation of it in the exhibitions in Paris (see quotation, p. 23) was a way of affirming his own style in the face of so many new trends. After he had seen the Champs de Mars Salon, but before the Cézanne opened, he wrote to Charles, "it [the exhibition] gave me the impression I was working all right."[11]

But as satisfied as Prendergast was that his pre-Paris work was on the right track, he immediately started to change once he began painting in Paris. Comparing *Notre Dame, Paris* (cat. no. 47) to *April Snow, Salem* (cat. no. 46), for example, it is obvious that in the Paris picture Prendergast has fragmented his form so that the clouds and the foreground shadows are broken up to create abstract shapes. Prendergast, always conscious of "composition" (see p. 16, top) now creates compositional unity by weaving the lines of the background and foreground motifs together (such as the trees and the architecture in *Band Concert*, cat. no. 49); this confuses the spatial relationships but results in a new type of harmony.

It is possible that Prendergast, while keeping the distinctive hallmarks of his own style (urban views, decorative figures),

adopted some of the radical qualities of Cézanne that he admired in the watercolor exhibition. In his letter to Mrs. Williams just before he left in October, he wrote:

> I have been extremely fortunate in regard to the exhibitions, not only in the spring with the Salons but Chardins, Fragonard, etc. and the delightful fall exhibitions which last during the month of October. They have all Paul Cezannes [at the Salon d'Automne]... Cezanne gets the most wonderful color, a dusty kind of a grey. And he had a water color exhibition late in the spring which was to me perfectly marvelous. He left everything to the imagination. They were great for their symplicity [sic] and suggestive qualities. . . .
>
> I have not done any thing important, that is, any thing large—mostly all sketches. But I got what I came over for, a new impulse. I was somewhat bewildered when I first got over here, but I think Cezanne will influence me more than the others. I think so now.

The St. Malo watercolors (cat. nos. 53–59), on the other hand, show a direct relationship to the colorful neo-impressionist style practiced ca. 1901–05 by the Fauves, particularly Signac and others like Henry Cross. Prendergast missed seeing such works in the Salon des Indépendants that year (the exhibition closed on April 30) before he left for St. Malo in early July, but some echo of the style was undoubtedly in the Champs de Mars Salon and in other art to be seen in Paris in June. This style was also very well published by 1907,[12] and Prendergast very likely knew of it already, if only from black and white reproductions.

Prendergast took home his Paris paintings and his watercolors from St. Malo and entered them in exhibitions across the country. In 1908 alone he showed his French pictures in New York, Boston, Maine, Washington, Philadelphia, Pittsburgh, Toledo, Cincinnati, Detroit, Chicago, and Portland, Oregon. But by far the greatest exposure came in the exhibition of The Eight which started in New York in February 1908 and ended over a year later in Newark, New Jersey (April–May 1909).

Of the seventeen titles of Prendergast works listed in the catalogue of the exhibition of The Eight, most still remain unidentified. However, through labels on the backs of some works,[13] it is now possible to suggest the type of work that was shown, if not the actual objects. The eight works called *Study, St. Malo* were small oil panels (such as cat. nos. 61–65), while the larger paintings of St. Malo listed by title in the catalogue were more like his *Lighthouse at St. Malo* (cat. no. 60). Although there may have been one or two earlier works in the show, it was these St. Malo studies and paintings that were uniformly noticed and commented on.

In the exhibition of The Eight, Prendergast showed neither his Cézannesque Paris watercolors nor his neo-impressionist St. Malo watercolors, but instead he exhibited oils of St. Malo which were in yet another style. In comparison, the St. Malo paintings are less "neo-impressionist" in that they are not

Fig. 18. Maurice Prendergast, Pencil drawing after Matisse's *Le Luxe I,* "Sketchbook #38," 1907 (6¹/₂ x 4¹/₄ in.), Museum of Fine Arts, Boston, Gift of Mrs. Charles Prendergast in honor of Perry T. Rathbone (1972.1128)

done in primary colors using a pointillist technique. Instead, they are more atmospheric, painted with rather large dabs and strokes of paint. The studies are obviously unfinished, but even in finished paintings such as *Lighthouse at St. Malo*, Prendergast exploits broken and incomplete form. To the modern eye, they do not resemble any of the then current Parisian styles closely enough to pin down concrete sources, but it is likely that they are a mixture of neo-impressionist and Cézannesque elements that have been translated into a vocabulary of Prendergast's own. They are the most abstract of Prendergast's French paintings in that they suppress his usual depiction of anecdotal figural details in favor of the elements of color and brushstroke.

It was on the basis of these paintings (cat. nos. 60-65), that most critics and viewers judged what Prendergast had learned in France. And while they may not have taught the American public about the particulars of any style being currently practiced in Paris, they most definitely communicated the freedom of color and the push toward abstraction that was a hallmark of all the modernist currents and that had left an indelible mark on Prendergast.

All viewers noticed that Prendergast's work was different from the rest of the paintings in the show, but the critical reaction to this difference tended to vary according to how knowledgeable or how accepting each critic was of French styles. On the negative end of the scale, critics called them "strange studies in pink and purple paint"[14] and "artistic tommy-rot."[15] In the middle were the critics who laughed at them without condemning them, such as Arthur Hoeber who offered this comment:

> Prendergast sends nearly a score of modest sized canvases, full of spots of color, with many people mainly on the beach at the French St. Malo, obviously a place where the sun shines in a curious manner, where color is wonderfully made manifest, where the people are careless about their drawing and construction, and where everything is a jumble of riotous pigment, such as one does not see elsewhere. Hung in a group, these canvases of Maurice Prendergast look for all the world like an explosion in a color factory.[16]

But knowledgeable critics identified them as neo-impressionist[17] and related them to Cézanne and Matisse.[18] In fact, by the time the exhibition came to Newark, the critic of the *Newark Evening News* was well versed in Prendergast's style and its derivation. He discussed the theory, expressed often in writings on modern art by 1909, that art must "represent," not "reproduce," and that Prendergast is expressing emotion in his painting, not copying mere appearances: he "sees the joyousness of . . . Nature and tries to express it with fluttering leaves, dancing waves, vibrant sunlight and groups of human beings." This theory is acknowledged as French in origin, "But do not think that Prendergast has spoken the final word with his Cézanne technique. We will hear more of it when the influence of France upon the young artists studying there now becomes better known. Prendergast has sacrificed much

in adopting it, but then, like his comrades, he has the satisfaction of being true to himself."[19]

This critic's acceptance of Prendergast's new style and its French origins represents a radical change in the way the exhibition of The Eight was perceived from beginning to end. At its opening in February 1908, a major article appeared in the *Craftsman* which summarized Henri's philosophy and emphasized the American qualities of The Eight. In an eloquent plea for freedom from the tyranny of Paris, the author listed the unique American qualities of each artist, saying that "our only hope is in a home-grown art." She hailed Prendergast as an artist who "will give them a lesson on painting . . . with such beauty and atmosphere . . . that they will recognize him as a teacher not to be found in the Latin Quarter."[20] This article, obviously written before the author had seen Prendergast's new work, shows how far Prendergast had strayed from the core principles of The Eight and how his work eventually led artists' and critics' attention away from American art and back, once again, to France.

Prendergast's position of leadership in transmitting new ideas to the American art world was short-lived. Although he retained an active interest in progressive art, his own version of modern styles was soon eclipsed by the work of Americans still abroad which Stieglitz began to exhibit in the spring of 1909. Alfred Maurer's landscape sketches (fig. 19), for instance, shown in March and April in New York, were much closer to Matisse and the Fauves than Prendergast's *Studies, St. Malo*.[21] The following spring (1910) Stieglitz showed a group of Paris-trained Americans including Carles, Dove, Marin, Maurer, Steichen, and Weber among others. In addition, he held exhibitions of Matisse in 1908, 1910, and 1912, and showed both Cézanne and Picasso in 1911.

Prendergast was never part of the Stieglitz circle, but his genuine interest in modernist art must have brought him closer to Stieglitz than is generally recognized. Along with Davies, who frequented Stieglitz's gallery and occasionally

Fig. 19. Alfred Maurer, *French Landscape,* ca. 1907, Oil on wood panel, (8³/₄ x 10³/₄ in.), Blanden Memorial Art Museum, Fort Dodge, Iowa, Gift of Dr. Albert C. Barnes (1952.15), Photograph courtesy of the Blanden Memorial Art Museum

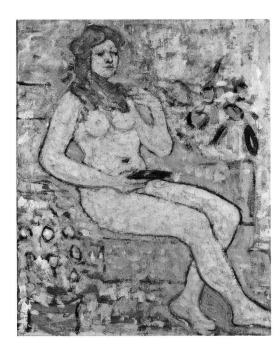

Fig. 20. Maurice Prendergast, *Red-Headed Nude,*
ca. 1910-13, Oil on canvas (24¹/₈ x 19¹/₈ in.),
Wadsworth Atheneum, Hartford, The Ella Gallup
Sumner and Mary Catlin Sumner Collection (1960.193)

bought from him,[22] Prendergast would have kept up with the exhibitions at 291 and articles in *Camera Work*. Prendergast and Stieglitz admired many of the same artists; for instance, Prendergast associated with Max Weber in New York and owned one of his paintings. In addition, Prendergast introduced Marsden Hartley (who had been painting in New Hampshire and sought out Prendergast in Boston) to Davies, Sloan, and Glackens in New York. Hartley was quickly taken up by Stieglitz and given an exhibition in May of 1909. While Hartley's style at that time was not based on actual study in Paris, his experimental canvases, derived from what he could learn about modernism in Boston and New York, appealed to both connoisseurs—Prendergast and Stieglitz.

While Prendergast's painting was on the cutting edge of modernism only briefly, he stayed consistently in the front ranks of the movement from the time of his trip to Paris in 1907 until the middle of the following decade. He continued his exploration of color and disintegration of form for a number of years, using stock figures and subjects that discourage site identification or any other anecdotal message. Both in oil, as in *Opal Sea* (cat. no. 66), and in watercolor, as in *Spring Promenade* (cat. no. 67), Prendergast applied a carefully worked out color scheme in small dabs of paint. The result is an overall open surface pattern that allows the lighter colors or paper underneath to shine through for a glowing luminous effect. His procedure, which can be seen in unfinished works, such as *Children in the Tree* (cat. no. 68), was the same as it was in earlier examples (cat. nos. 22, 37) in that he still started with the foreground focal points and filled in the background around them. But in *Children in the Tree* he has abandoned solid areas of color altogether in favor of a build-up of the composition with strokes of pure color.

At the end of the first decade of the twentieth century, Prendergast, now fifty-two, had effected a daring mid-career overhaul of his work and reputation. After establishing himself with critics and collectors as a master of watercolor scenes of modern life, he jumped into the modernist camp, where he would stay, with more or less prominence, for the rest of his career. He still lived and maintained a studio in Boston with his brother, who had become well known for his custom-made handcarved frames. They socialized with their old Boston friends—Mr. and Mrs. Oliver Williams, Charles Hovey Pepper, Horace Burdick, Carl Gordon Cutler, and Charles Hopkinson. And in New York they continued to associate with members of The Eight, especially William and Edith Glackens. The Glackens's son, Ira, remembered that "Whenever [Maurice and Charles Prendergast] appeared the news spread through the community, 'The Prendies are in town!' for they were much loved, and all their friends made haste to wine and dine them."[23] Their New York ties were so strong that Prendergast continued to be involved in the major progressive exhibitions and organizations after the exhibition of The Eight. He participated in the two large "independents," the "Exhibition of Independent Artists" in 1910 and "An Independent Exhibition of the Paintings and Drawings of Twelve Men" in 1911.

In the summer of 1911 Prendergast joined Charles in Italy. For a few months the brothers traveled together, ending up in Venice, where Maurice showed Charles the sites he remembered from his trip in 1898-99. Maurice started a number of watercolors in August and September, but was taken ill and had to have prostate surgery in the middle of October. Charles left soon after the surgery and Maurice, instead of painting Venice, spent the next two months in the hospital recuperating and reading art books. While he did manage to complete a small series of Venetian watercolors (cat. nos. 69-72), what seems to have had a more lasting impact on his future direction was his discovery, through books, of early Italian painters and art history in general. The tendency of writers on modern art to reinterpret the past in modernist terms gave Prendergast a new way of appreciating older art and opened up an avenue for his art that would occupy him for the rest of his life.

The integration of ancient and modern art, however, did not immediately assert itself in Prendergast's painting. In the years from 1910 to 1913 he devoted most of his time to further research into the lessons of Cézanne and other principles of modern style. Prendergast, like his modernist colleagues, painted still life, portraiture, and landscape according to the new theories of the relationship of art to reality.

Still life was of special concern to modernists in Europe and America. Cézanne's paintings of apples and bowls were much admired because his abstraction of form and color transformed the simple subject matter into something profound. Influential artist/theorists like Kandinsky wrote extensively on Cézanne's new handling of still life, as in this passage which was translated into English and reprinted in *Camera Work* (1912):

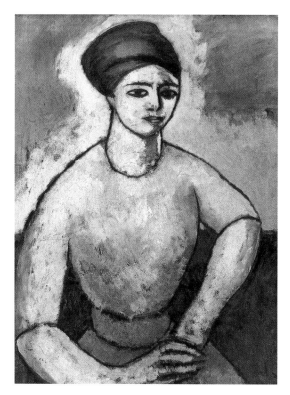

Fig. 21. Morton L. Schamberg, *Study of a Girl,* ca. 1911,
Oil on canvas (30⁷/₈ x 22⁷/₈ in.), Williams College Museum
of Art, Bequest of Lawrence H. Bloedel '23 (77.9.11)

Cézanne knew how to put a soul into a teacup, or, to
speak more correctly, he treated the cup as if it were a
living thing. He raised "nature morte" (still life) to that
height where the outer dead things become essentially
living. He treated things as he treated human beings,
because he was gifted with the power of seeing the
inner life of everything. He realizes them as color ex-
pressions, picturing them with the painter's inner note
and compelling them to shapes which, radiating an
abstract ringing harmony, are often drawn up in
mathematical forms. What he places before us is not a
human being, not an apple, not a tree, but all these
things Cézanne requires for the purpose of creating an
inner melodious painting, which is called the picture.[24]

As Kandinsky put it, the modern still life is a "color expres-
sion," in which shapes are abstract, often "mathematical."
Through this process the artist brings out the inner "soul" of
the humble object and creates something transcendent—a
painting. Prendergast's still lifes, such as *Still Life: Fruit and
Flowers* (cat. no. 73) and *Still Life* (cat. no. 74), are just such
exercises in color and form. His mosaic-like brushstrokes
regularize the surface and his outlines emphasize the geomet-
ric round and oval shapes. The color is brilliant; and Prender-
gast again uses an open pattern of strokes, layer over layer, so
that one has the sensation of seeing many depths at once, or
perhaps seeing the "inner life" of these "dead things." Still life
in this style was practiced by most of the Americans influ-
enced by Paris, including Bruce, Carles, Dove, Hartley, and
Maurer. In fact, two young Americans, Andrew Dasburg

and Morgan Russell, devoted a year (1909-10) to the study of
Cézanne's *Pommes,* lent to them by Leo Stein.[25]

A similar reconsideration of the portrait took place among
artists of modernist leanings. Not only was Cézanne influen-
tial here, but also Van Gogh and Matisse. Prendergast's *La
Rouge: Portrait of Miss Edith King* (cat. no. 75) is a highly
decorative pointillist work that resembles none of these mod-
els very closely, but is Prendergast's own mixture of the ele-
ments of modern style. His sitter is reputed to be Edith King
(1884-1975), an artist and teacher at a private school in Cam-
bridge. Maurice and Charles Prendergast were friendly with
King, her sister, and mother around 1911.[26] Prendergast
painted approximately twenty portraits in the years from
1910 to 1913, a number of which resemble King. In a curious
and suggestive parallel, Prendergast's *Redheaded Nude* (fig. 20)
assumes the same langorous seated pose as in *La Rouge.* While
it is not likely that King posed for, or even knew of, the nude
version of her portrait, Prendergast might have painted the
dual works in another attempt to reveal the "inner spirit"
hidden beneath the surface of the real world.

Only a year after his return from Venice, Prendergast had a
second opportunity to show his most advanced work in an
exhibition of national proportions—the Armory Show ("In-
ternational Exhibition of Modern Art") which opened on
February 15, 1913. In contrast to the exhibition of The Eight,
in which he was the first to show the latest Paris styles to the
American public, in the Armory Show he was far from the
cutting edge. In 1913 the European progressives themselves
were amply included, as were works by Marin, Maurer,
Joseph Stella, and Morton Schamberg (fig. 21) which echoed
the latest Fauve, cubist, and futurist advances. Compared to
these, Prendergast's decorative *Landscape with Figures* (cat.
no. 76) was several years out of date. However, compared to
even the most radical works of the other Americans, such as
Elmer MacRae's *Battleship at Newport* or Walt Kuhn's *Morning*

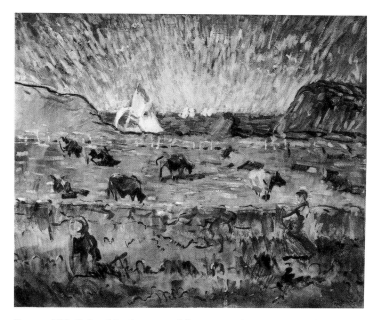

Fig. 22. Walt Kuhn, *Morning,* 1912, Oil on canvas (33 x 40 in.), Collection of
the Norton Gallery of Art, West Palm Beach, Florida (46.13)

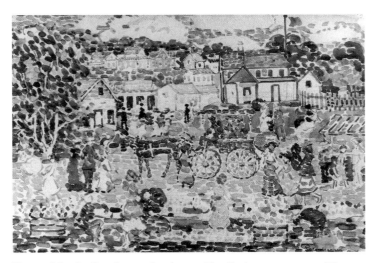

Fig. 23. Maurice Prendergast, *Landscape with a Carriage,* ca. 1912-13, Watercolor and pencil on paper (14³/₄ x 21³/₄ in.; sight), Collection of Nancy and Ira Glackens

(fig. 22), Prendergast's offerings, such as *Landscape with Figures* or *Landscape with a Carriage* (fig. 23), appeared very European and experimental in color and paint surface.

On the basis of what was seen at the Armory show, Prendergast was still considered to be in the front ranks of American modernism, even if he no longer represented the latest word from Paris. Now cubism and futurism had eclipsed Cézanne, Matisse, and fauvism as the most controversial styles, and although the latter continued to be respected, as did Prendergast, they no longer attracted attention as novelties. Prendergast apparently drew the line at cubism for himself. Some interest in geometric compositions can be seen in his sketches, and there is an occasional watercolor that stresses angular outlines (fig. 24), but unlike his friends Davies and Kuhn, Prendergast seems to have stayed away from the style. As a modernist he had reached his limit, and when asked his opinion of the Armory Show, he quipped, "Too much—O my God!—art here."[27]

In addition to the Armory Show, Prendergast participated in a number of other exhibitions in New York and Boston in 1912-13, including a one-man retrospective show at the Cosmopolitan Club (New York) about which very little is known. From titles in exhibition catalogues (including the Armory Show, in which only three of Prendergast's seven entries can be identified) and from descriptions in reviews, we can determine that Prendergast was showing large new oils, mostly of beach scenes, such as *A Dark Day* (cat. no. 77) and

Seashore (cat. no. 78). These are a natural outgrowth of his earlier experimental works, such as *Opal Sea* (cat. no. 66), only pushed to greater extremes of fragmentary form and color. The identifiable forms, particularly the figures, have a minimum of descriptive detail and tend to merge with their surroundings. Some critics, especially those who had followed Prendergast since his beginnings, balked at these excesses: "Mr. Prendergast becomes more and more mannered in his work and his two figure compositions, showing many figures against backgrounds of blue water and rocks, are executed in his most incoherent style. Some of the figures are nude and others are draped but all are equally ill drawn."[28] But other critics were supportive of his attempts to redefine reality, and believed that his paintings "gain in artistic quality the less the artist attempts naturalism."[29]

Prendergast's interest in redefining reality continued for the rest of his life. Alongside the fantasies and idylls that attracted more and more of his attention after 1913, Prendergast continued to produce watercolors and oils that were based on onsite sketches, but that were transformed by his investigation of abstract color and form. Such paintings as *Boat Landing, Dinard* (cat. no. 79), *Marblehead* (cat. no. 80), and *New England Harbor* (cat. no. 81), which span the period from the Armory Show to his last works in 1923, show how Prendergast continued to mine his first experience of modernism in Paris of 1907. This initial contact was enriched by Prendergast's practice of keeping up with the new artists, exhibitions, and writings on modern art available to him in New York and Boston, as well as by his insistence on shaping the "new impulses" to suit himself.

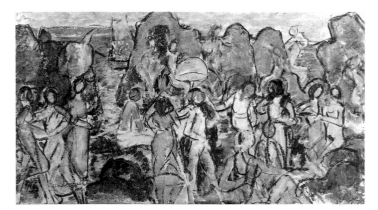

Fig. 24. Maurice Prendergast, *The Bathers,* ca. 1912-13, possibly reworked ca. 1915, Pastel, watercolor and pencil on paper (11³/₄ x 22 in.), Private Collection

Notes

1. "The Boston Art Club Exhibition," *The Collector and Art Critic Weekly Calendar,* January 22, 1906, n. p.: "Maurice Prendergast has gone beyond his tendencies into mannerisms and especially his *Willows* #145 is not as good as his *May Day* of last year's Society."

2. Newspaper clipping, unknown source [May-June 1905] (Scrapbook 21, April 1905-March 1906, no. 24, Art Institute of Chicago Archives).

3. MBP to Charles Prendergast, letter written continuously from May 19 to May 28 [voyage en route to France], Prendergast Archive, Williams

College Museum of Art. This passage is dated May 26: "going up to Paris is bothering me. It will cost me ten dollars to go up and stay a couple of days to see the Salon. I think if I see the stuff around Harvre I think [unintelligible] and if I get at once to work I will let the Salon go. I will see after I arrive."

4. MBP to Charles Prendergast, [ca. May 31, 1907], Prendergast Archive, Williams College Museum of Art. I have tried to preserve the flavor of Prendergast's writing style and thus have edited the spelling and punctuation of his letters only when necessary to improve comprehension.

5. Held at Bernheim-Jeune Gallery from June 17 to 29, this exhibition showed 79 watercolors from the Cézanne estate.

6. The Salon d'Automne of 1907 included a retrospective of 56 Cézanne paintings, mostly oils, and opened on October 1.

7. What he may have seen privately is open to speculation. His friend Morrice was well connected in radical circles in Paris and may have introduced Prendergast into artists' studios and salons. Morrice's later friendship with Matisse indicates that he had some contact with the Fauves. It is not known whether Prendergast was taken to the salon of Leo and Gertrude Stein in 1907. He may have had contact with them through Max Weber, a former student of Prendergast's friend Dow, or through others in Paris at the time including Walter Pach, Alice Schille, Gertrude Kasebier, Patrick Henry Bruce, Arthur B. Carles, and Alfred Maurer.

8. MBP to Esther Williams, October 10, 1907 (AAA, Williams Papers).

9. "In Paris he had seen an exhibition by Cézanne, then practically unknown in America, and had studied and been fascinated by that artist's work. An amusing story is told about a studio party in New York after this second return from Europe. Glackens, Shinn, Sloan, Henri, Fitzgerald, and others were there. Prendergast was talking to all, of Cézanne; and the high point of the evening was a stentorian demand, loud above the noise of conversation, 'Prendergast, who is this man, Cézanne?'" Milliken, p. 186.

10. Walter Pach, *Queer Thing, Painting* (New York: Harper & Brothers Publishing, 1938), p. 224. According to Pach, Prendergast called Cézanne "old Paul."

11. MBP to Charles Prendergast, [June 13], 1907 (Prendergast Archive, Williams College Museum of Art).

12. In addition to articles in French periodicals, Prendergast might have been familiar with neo-impressionism through such books as Paul Signac's *D'Eugène Delacroix au Néo-Impressionisme* (1899), Camille Mauclair's *L'Impressionisme—son histoire—son esthétique—ses maîtres* (1904), or Julius Meier-Graefe's two books from 1903-04, *Der Moderne Impressionismus* (which Prendergast owned) and *Entwicklungsgeschichte der modernen Kunst.*

13. *St. Malo No. 11* (cat. no. 64) and *St. Malo No. 12* (cat. no. 65) are titled as such in labels on the back written in Maurice Prendergast's hand. These numbers correspond to the numbering used in the catalogue of The Eight exhibition produced by the Pennsylvania Academy of the Fine Arts when it was shown in Philadelphia (March 1908). Prendergast's number 12 is listed as *Study, St. Malo.* Number 11 is listed as "Decorative Composition," which probably referred to another work, but Prendergast, writing the labels before shipping the paintings to Philadelphia, may have thought that all the *Studies, St. Malo* would be listed continuously in the catalogue as they had been in New York.

14. "Striking Pictures by Eight 'Rebels'," *New York Herald*, February 4, 1908, p. 9.

15. Joseph E. Chamberlin, "Two Significant Exhibitions," *New York Evening Mail,* February 4, 1908, p. 6.

16. Arthur Hoeber, "Art and Artists," *Globe and Commercial Advertiser,* February 5, 1908, p. 9.

17. James Huneker, "Eight Painters," *New York Sun*, February 9, 1908, p. 8.

18. "Exhibitions Now On," *American Art News* 6, no. 26 (April 11, 1908), p. 6.

19. "'The Eight' Stir Up Many Emotions," *Newark Evening News*, May 8, 1909, II, p. 4.

20. Giles Edgerton [Mary Fanton Roberts], "The Younger American Painters: Are They Creating a National Art?," *Craftsman* 13 (February 1908), p. 523.

21. When Maurer showed his Fauve landscapes some critics like James Huneker thought Prendergast did a better job of interpreting the new style: "We know that Prendergast of Boston can succeed in making clear his vision while working in the same bloodshot optical region." *New York Sun*, April 7, 1909, reprinted with other reviews in *Camera Work*, no. 27, July 1910, pp. 42-44, and quoted in Sheldon Reich, *Alfred H. Maurer 1868-1932*, exhibition catalogue (Washington, D.C.: National Collection of Fine Arts, 1973), p. 43.

22. Perlman, p. 209.

23. Ira Glackens, *William Glackens and The Eight* (New York: Horizon Press, 1957), p. 131.

24. Wassily Kandinsky, "Extracts from 'The Spiritual in Art,'" *Camera Work*, 39 (July 1912), p. 34.

25. Gail Levin, "Morgan Russell," in *The Advent of Modernism: Post-Impressionism and North American Art, 1900-1918* (Atlanta: High Museum of Art, 1986), p. 153.

26. Maurice wrote to Charles from Venice after his operation: "I must say the women here are very fine, they are considerate and know all about sickness and misery—beside which the King girls are hard and crude." [ca. November 13], 1911 (Prendergast Archive, Williams College Museum of Art).

27. Glackens, p. 183.

28. "Four Boston Painters," *Boston Evening Transcript*, January 8, 1913, p. 25.

29. Unknown article, *New York Evening Post,* as quoted in "Four Boston Artists," *Boston Evening Transcript*, March 31, 1913, p. 11.

III

Personal Vision

Myth, Fantasy, and the Idyll

(1914–1924)

The largest and most ambitious of Maurice Prendergast's paintings date to the last decade of his life. After six years of experimentation with formal elements and modernist principles, Prendergast introduced symbolic subject matter as a powerful mode of expression. More than anything else, his monumental female figures, his horse and riders, and his swans separate this body of work from all that went before. Neither in his earlier scenes of modern life, nor in his studies of color and form, had there been a hint that Prendergast harbored symbolist inclinations, but by 1913 he had already begun to exhibit paintings based on this new interest, and by 1915, when he had a one-man show at the Carroll Galleries in New York, symbolic subject matter dominated his canvases.

This new direction required that Prendergast learn new skills, first among them being a belated mastery of the nude female figure. While Prendergast had reputedly drawn from the nude at the Académie Julian,[1] and he had filled his sketchbooks over the years with studies of women, both nude and clothed, he had never before painted this subject. Now, in his fifties, he began to hire studio models and draw and paint the traditional poses that, in a glance, evoke past centuries of western art (fig. 25).

Prendergast's interest in the female nude no doubt stemmed from his study of Cézanne and Matisse, and had as its basis a redefinition of the figure. His earliest oil studies of nudes in the landscape, such as *Four Nudes at the Seashore* (fig. 26), reflect Matisse's similarly casual and fragmentary studies of the same subject, such as *Nude in a Wood* (fig. 27) which had been on view at Stieglitz's 291 Gallery in 1908. Critics noticed the similarity between Prendergast and Matisse: "Mr. Prendergast is becoming more impressionistic in his own whimsical and amusing way. He draws his figures almost as badly as Matisse, and is fully as ingenuous...."[2]

As time went on, however, Prendergast went beyond Matisse-like simplicity and added other ingredients to his formulation of the nude. In the early teens he added classical imagery, as in *Bathers* (cat. no. 82,) which not only shows full-figured classical "goddesses" in poses reminiscent of the Judgment of Paris, but also includes Italianate architecture in the background to complete the classical allusion. In *The Promenade* (cat. no. 83), *Beach No. 3* (cat. no. 84), *Figures in Landscape* (cat. no. 85), and *Women at Seashore* (cat. no. 86)

nude and clothed figures assume classical *contrapposto* and reclining poses in the manner of antique sculpture.

What was behind Prendergast's enthusiastic embrace of classical style and imagery? Unfortunately, no simple answer emerges from the evidence left by Prendergast, nor does this change fit easily into the accepted version of the development of American modernism. However, by piecing together a number of factors pertaining to Prendergast as an individual and to the more complex scope of modern art in the teens, we begin to understand the motivation behind Prendergast's new art.

Prendergast's second trip to Italy in 1911–12 appears to have been a turning point in his appreciation of the art of the past. While recuperating from his prostate operation in the British Cosmopolitan Hospital in Venice, he was supplied with a wealth of art books from the library of Lady Layard, widow of Sir Austen Henry Layard, author and excavator of Nineveh. Two books he recorded by title in his sketchbook,

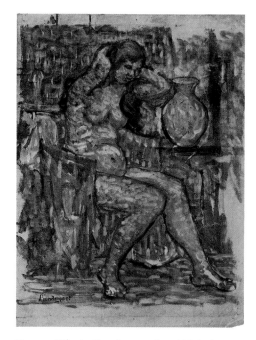

Fig. 25. Maurice Prendergast, *Seated Nude Arranging her Hair,* ca. 1910–13, Oil on canvas (26¹/₂ x 18³/₄ in.), Williams College Museum of Art, Gift of Mrs. Charles Prendergast (86.18.83)

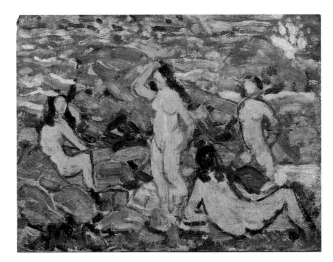

Fig. 26. Maurice Prendergast, *Four Nudes at the Seashore*, ca. 1910–13, Oil on panel (10¹/₂ x 13³/₄ in.), Williams College Museum of Art, Gift of Mrs. Charles Prendergast (84.16.9)

Painters of the School of Ferrara and *Byzantine Art and Architecture,* indicate the world of the past that Prendergast was immersed in for those few months.[3]

Prendergast's new appreciation of older art was not a repudiation of his modernism but rather an extension of it. It was common for modernist theoreticians and artists, including Matisse, to hark back to art of other periods and cultures to justify or explain expressive techniques of the modern style. Matisse, for instance, pointed to Egyptian and Greek sculpture to illustrate how one should abandon "the literal representatation . . . to reach toward a higher ideal of beauty."[4] He also voiced an appreciation of Giotto in modernist terms: "When I see the Giotto frescoes at Padua I do not trouble to recognize which scene of the life of Christ I have before me but I perceive instantly the sentiment which radiates from it and which is instinct in the composition in every line and color."[5] The connection between modernism and earlier art was also made by such influential writers in English as Roger Fry and Walter Pach, as well as by the connoisseur of Italian art, Bernard Berenson.[6]

In a related phenomenon, modernists paid homage to recent artists, such as Puvis de Chavannes and Hans van Marées, who worked in an updated "classic" style. Gauguin was appreciated for his absorption of primitive and other ancient imagery into modernist composition, and, above all, Renoir rose to unprecedented heights in the eyes of the young artists of the teens. Renoir's large, chromatically jarring bathers of the last decade of his career were heralded as a new formulation of classicism by theorists and collected avidly by such admirers as Albert C. Barnes. The proponent of the Synchromists, Willard Huntington Wright, brother of Stanton Macdonald-Wright, wrote of Renoir in 1913:

> He ranks with Rubens, Rembrandt, El Greco, Giotto, and Giorgione. He is the culminating point of the whole movement . . . his later work contains a profoundly *felt* but not *seen* power of a full and mighty comprehension of what is the basis of a work of art . . .

there is in his work, especially that of the last ten years, a tremendous emotional power which only the trained artist can appreciate. He is as great as Rubens, and has a greater plastic pictorial vision, rendered possible by modern processes. After Renoir a new tendency crept slowly into painting. To-day it dominates the efforts of all vigorous artists.[7]

Julius Meier-Graefe's 1911 monograph on Renoir emphasized this period of Renoir's painting and such illustrations as the *Baigneuses* (fig. 28) fueled interest in the nudes-in-landscape theme as practiced by Prendergast.

Along with the current admiration for Renoir, Puvis, von Marées, and Gauguin came the modern theory of "decoration," which impressed Prendergast deeply. It was Berenson who, in his *Central Italian Painters of the Renaissance* (1903), distinguished between the two basic types of painting, illustration and decoration, and held decoration to be the higher because it has "eternal, not transitory, properties."[8] Whereas decoration later came to denote mural painting in American modernist circles (see p. 36), Prendergast originally used it as early as 1908 to describe an easel painting, as evidenced by the use of the title *Decoration* for an unidentified work in the exhibition of The Eight. Prendergast used the term more and more often in the teens, including for the title of *The Picnic* (cat. no. 87) which was originally called *Decoration—Summer*. The eternal qualities of this painting, as well as its variant, *The Swans* (cat. no. 88) are readily seen in the poses and the use of Leda's symbol. Prendergast's sketchbooks from this period show recurring interest in this elegant bird, but aside from possible veiled eroticism suggested by the story of Leda (whose lover Jupiter visited her in the form of a swan) and perhaps a wry allusion to the swan boats in the Boston Public Garden, little else besides their usefulness as a symbol of the

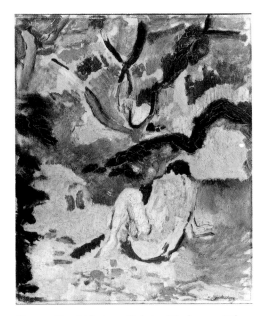

Fig. 27. Henri Matisse, *Nude in a Wood,* 1905, Oil on panel (16 x 12³/₁₆ in.), The Brooklyn Museum, Gift of George F. Of (52.150)

"eternal" can be inferred from Prendergast's frequent depictions of them.

Prendergast used classical imagery overtly in his art only up to 1915; thereafter he tended to apply classical principles to idyllic scenes of "modern" life (such as *Landscape with Figures*, cat. no. 110) in which dresses replaced the classical veils and ordinary dogs replaced the swans of his earlier "decorations." But Prendergast's excursion into the antique typifies the entire last phase of his art. Personally, this new style reflected Prendergast's deep interest in the enduring art of other periods and cultures and his own search for a monumental style that, in this time of weakening health and approaching old age, would bring him similar immortality. In the broader context of the modern art world, Prendergast found support and encouragement for his new interests both in the modernist theories that linked the old and the new arts, and in the art of the new "classicists," Renoir, Puvis, Gauguin, and others.

Whether these large classicizing canvases can legitimately be placed in the mainstream of American modernism, however, has been debated from the moment they were first presented to the public. Some critics reacted purely to the "other-worldly" idyllic qualities and proclaimed Prendergast free of any contemporary influences:

> Maurice Prendergast has lived in Boston for many years, within hailing distance of apostles of the cult of Vermeer and of late he has lived in New York within call of Cubist and Matisse imitators, yet he is just as completely himself now as he was years ago, when his paintings were welcomed by the appreciative as the flowering of a curiously direct and child-like nature.[9]

But most observers of the art world could not so cavalierly dismiss Prendergast's long-standing and well-known association with the modern movement. Thus, the critics who could not fit his new work into current trends saw him taking modernist methods in the wrong direction. Willard Huntington Wright, who praised Renoir's late bather scenes, did not accept Prendergast's similar classicizing canvases. In his book

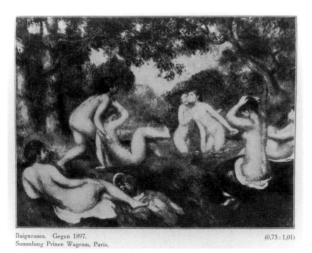

Fig. 28. Auguste Renoir, *Baigneuses,* Illustration, Julius Meier-Graefe, *Auguste Renoir* (Munich, 1911), p. 193

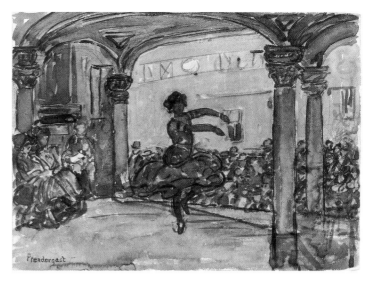

Fig. 29. Maurice Prendergast, *Cabaret,* ca. 1907, Watercolor and pencil on paper (11¹⁄₈ x 15¹⁄₄ in.), Williams College Museum of Art, Gift of Mrs. Charles Prendergast (85.21.7)

Modern Painting (1915) he included Prendergast in his chapter on "The Lesser Moderns" along with such French artists as Henri Rousseau and Félix Vallotton:

> Though using the modern methods of simplification, these men revert to a static and dead past. Their aim is to revive the most ancient manner of painting. Of all the modern decadents they are perhaps the most devitalising for they tacitly repudiate the discoveries of the new men, and strive to turn the minds of the public and of painters alike to the sterilities of antiquity.[10]

Wright's scathing dismissal of Prendergast no doubt represented the attitude of the most radical artists and critics toward Prendergast at this time. From the point of view of Wright, his brother Stanton, and the Synchromists, Prendergast was not following the correct path to fragmentation of form and a systematic color expression. Although their opinions have not been preserved, surely many other American cubists and futurists also dismissed Prendergast's grand eclecticism as irrelevant to their own research into abstracted form and a new definition of art.

However, Prendergast's work from the 1910s was not completely cast out of the progressive modernist arena. His masterful use of color, based on years of practice and assimilation of theory, his peculiar—but original—simplification of the figure, and his flattened grid-like compositions earned him a special place in modern art in the minds of the majority of contemporary artists, critics, and collectors. To honor him, they stressed that he was the quintessential designer and thus captured the essence of modernism:

> Prendergast is essentially a part of the NEW MOVEMENT which . . . has taken firm hold of New York and is becoming more and more understood. Beginning with his earliest work, mastery of design is to be discovered in every one of his paintings. Indeed in his

case design, and again design, and yet again design, is as much the "constant" as in the case of Cézanne, of whom he was one of the very earliest admirers in this country.[11]

Prendergast, in the mid-teens, was collected by the most important patrons of early modernism, including Edward Root, John Quinn, Albert Barnes, Ferdinand Howald, Edward Balken, Lillie Bliss, and Duncan Phillips. He and his brother Charles finally moved to New York in 1914, and he was immediately accorded a place of prominence in the art world there. He had been elected president of the Association of Painters and Sculptors earlier that same year, and in 1915 he reached new heights of recognition with his one-man show at the Carroll Galleries. As a friend later recalled, "A dinner was given before the opening of the show and so many pictures were sold that evening that Prendergast later [said]: 'I really felt ashamed. It didn't seem like art; it seemed more like business.' From then on, Prendergast's success was assured."[12]

While Prendergast's monumental classicizing style was his trademark in the teens, he also pursued tangential interests in oriental art, modern dance, German Expressionism, the horse-and-rider theme, children's art, fairy-tale and fantasy themes, and mural painting that make this period of his art richer and more complex than previous ones. Prendergast, in deciding to introduce evocative subject matter into his art, opened a Pandora's box and let loose imaginative hybrid creatures.

Many of the smaller works from this period reflect an interest in movement and the dance that Prendergast shared with many others in his circle, including Davies and Abraham Walkowitz. Prendergast was probably drawn to dance as

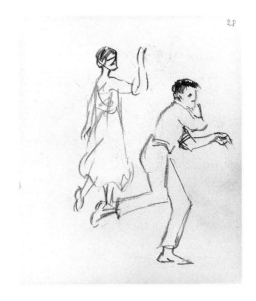

Fig. 31. Maurice Prendergast, Pencil drawing from "Paris Sketchbook," ca. 1912-15 (8$^1/_4$ x 6$^3/_4$ in.), Williams College Museum of Art, Gift of Mrs. Charles Prendergast (85.26.1)

a spectacle in much the same way that he loved resorts, amusement parks, burlesque, and even the cinema.[13] A few earlier works, such as *Carbaret* (fig. 29), attest to a long-standing interest in portraying dance movements; but it was not until the teens that Prendergast took up the subject with some frequency. Large single-sheet drawings and pages in sketchbooks record what appear to be models Prendergast hired to assume dance poses and sketches from actual performances (figs. 30, 31).

Prendergast then used dance poses in finished oils and watercolors (cat. nos. 89-92) in a number of exotic guises. The oriental style of *Sea Maidens* (cat. no. 89), the bacchic qualities of the two *Bathers* (cat. nos. 90, 91), and the ritualistic dance in *Fantasy* (cat. no. 92) all show Prendergast applying his studies of movement to the creation of an exotic or fantasy world. In these cases, Prendergast probably supplemented his studies from life with illustrations from the many art books and magazines that were his constant companions.

The ability of vigorous movements to transport the dancer to an altered state of consciousness had been a theme shared by such Fauve painters as André Derain and such German Expressionists as Emil Nolde. Prendergast's contact with their works is hard to document with any specificity, but the interest of Americans in expressionist art and doctrine in this period is well known. Kandinsky's writings were translated into English and published in this country, either in excerpted form, as in *Camera Work*, or in their entirety.[14] Prendergast's friend Marsden Hartley had been particularly drawn to German styles and expressionist philosophy and provided a link between the New York artists and Kandinsky and others such as Franz Marc. Furthermore, Stieglitz had purchased Kandinsky's *Improvisation No. 27* (fig. 32) from the Armory Show.

It is hard not to see Kandinsky's emblematic *Blaue Reiter* as a source for the horses and riders ambling through the back-

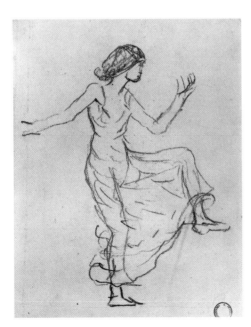

Fig. 30. Maurice Prendergast, *Dancer #3*, ca. 1912-15, Pencil on paper (12$^1/_4$ x 9$^3/_8$ in.), Williams College Museum of Art, Gift of Mrs. Charles Prendergast (85.22.4)

grounds of so many of Prendergast's canvases (cat. nos. 93–97). In particular, the series of the "blue hills," which includes both *Blue Mountains* (cat. no. 93) and *Rider Against Blue Hills* (cat. no. 94), is close to Kandinsky's *Improvisation No. 27* in that Prendergast uses large areas of pure color populated by attenuated fragmentary figures. On the other hand, paintings like *Sunset* (cat. no. 95) and *Sunset and Sea Fog* (cat. no. 96) are in Prendergast's more typical pointillist style, but the quixotic horse and rider under the disc-like sun suggest the mysticism associated with Kandinsky's philosophy.[15] In 1919 Prendergast participated in an exhibition of "Expressionists" at Babcock Galleries which included other American artists, such as George Luks and Eugene Higgins. Although not much is known about this exhibition, the unifying principle was that the artists should be motivated more by the expression of what was deeply felt than by considerations of style or technique—a vague principle, but one that critics saw readily in Prendergast's work.[16]

The triumph of "expression" over technique was a curious accomplishment for an artist who had always been interested in matters of style and composition. Although never an academic, Prendergast studied traditional techniques as well as their modernist redefinition. Yet in the mid-teens, at the same time as he introduced classicism into his work, he was simultaneously exploring its antithesis: naive, folk, and children's art.

Prendergast was generally considered to have "naive" qualities as an artist, no matter what subject or style he used.[17] Some of this may have sprung from his personality which was universally referred to as "simple," "childlike," or "other-worldly." His friend Jerome Myers recalled that, "Of all the men of genius I have known, Maurice Prendergast had the simplest manner. In conversation he showed the same naive charm that is inherent in the lovely magic of his work."[18] But it is certain that Prendergast's exploration of

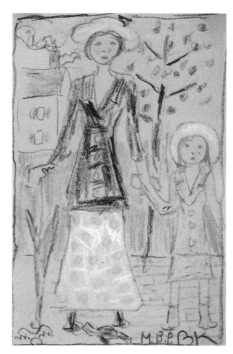

Fig. 33. Brenda Kuhn with Walt Kuhn and Maurice Prendergast, *Crayon Drawing* (9¼ x 6 in.), Comenos Fine Arts

"naive" art of all kinds in the early teens, when he was most visible as an artist, promoted this general perception of him.

Two works, *Fantasy* (cat. no. 97) and *Decorative Composition* (cat. no. 98), illustrate how the combination of simplified brushstroke, decorative patterning, and "fairy-tale" subject matter allowed Prendergast to create a childlike effect. Although no narrative content can be identified, the naive effort and storybook ingredients suggest a child's interests or viewpoint, as one critic pointed out: "Prendergast sees the world as a small boy might—an endless procession of men, women and donkeys moving through the trees by the water's edge."[19] In fact the pure decorative indulgence of these works, along with their homespun simplicity, may have provided viewers with an easy way to appreciate Prendergast when faced with his more complex classicizing oils. Another critic was more penetrating in his analysis of Prendergast's "naive" paintings and their effect on the average viewer:

> [Prendergast] is a serious and humble student of design, and marshals line and color into patterns of some intricacy and much interest ... his work has rhythm and beauty and a quaintness of humor that go far to inveigle the ordinary observer into acceptance of an extraordinary piece of craftsmanship. When he paints a "decorative composition" [cat. no. 95] with a background of waving lines and a foreground of domestic animals and a middle-distance of home-going youth with basket, he simply spells "sampler" to the middle-aged public and they delight in him. Thus they can bear it not quite to understand his bathers and very distinguished nudes.[20]

Fig. 32. Wassily Kandinsky, *Improvisation No. 27*, 1912, Oil on canvas (47⅜ x 55¼ in.), The Metropolitan Museum of Art, The Alfred Stieglitz Collection, 1949 (49.70.1)

Fig. 34. Arthur Bowen Davies, *Dances,* 1914-15, Oil on canvas
(7 ft. x 11 ft. 6 in.), © The Detroit Institute of Arts, Gift of Ralph Harman
Booth (27.158)

Indeed, as successful as Prendergast was in this genre, it is incorrect to see his naive paintings as effortless or without strong roots in current modernist theory. Interest in folk art of all kinds, from Russian folk art to Native American art, was widespread in Prendergast's circle, and can be documented as a special interest of Maurice's by his well-worn and doodled-upon copy of *Peasant Art in Russia* (1912)[21] and the appearance of a Navajo rug in early photographs of his home, as well as by his reference to "our North American Indians with their brilliant colors" in the context of modern art in Paris in 1907 (see quotation p. 24). Furthermore, he worked to achieve the "childlike" style, often using children's wax crayons, and even producing drawings in conjunction with a child—Walt Kuhn's daughter Brenda (fig. 33). Prendergast's attempts at imitating a child's hand parallel those of Paul Klee from the mid-teens, which Marsden Hartley had written to Stieglitz about[22] and which may have, in a similar way, been communicated to Prendergast.

As interested as Prendergast was in mastering the naive style in his watercolors, we are nevertheless surprised to see that he chose the same style for a wall-sized "decoration," or mural, called *Picnic* (cat. no. 99). The painting, and its companion piece, *Promenade* (cat. no. 100), were two of a series of four murals to which Prendergast contributed (along with Davies and Kuhn) in late 1914 and early 1915. Unfortunately the genesis of the project is obscure,[23] leaving us with little to explain Prendergast's choice of subject and style. We might assume, however, that since neither *Picnic* nor *Promenade* are painted in the classicizing style he normally used for large oil paintings (as is *The Picnic,* cat. no. 87), they are intentional experiments in using alternate and non-western art traditions to create modernist murals. A critic pointed out that "the feeling of open air joyousness in 'The Picnic' and 'The Promenade' . . . are the result of experiments in pure decoration, of efforts to get away from the conventional formalism which has tended to take self expression out of mural work."[24]

Prendergast's *Picnic,* especially, is far from a conventional mural. Both in subject and in style it contradicts the high rhetorical tone set by American mural painters of the previous decades. The schematic figures, trees, and other landscape elements in *Picnic* are blown up to such a scale that the

adult viewer relives the sensation of being in a child's fairy-tale world. *Promenade,* on the other hand, shares nothing with *Picnic* except its contradiction of the western mural tradition. Rather than deriving from children's art, *Promenade* is based on Byzantine mosaics and oriental tile decorations. Prendergast had recently adapted his broken brushstrokes to a regularized pattern in many decorative works, such as *The Rider* (cat. no. 101) and *Elephant* (cat. no. 102). To underline the connection with an older and more exotic decorative tradition in these colorful emblematic works, Prendergast's inscription on *Elephant* reads "tile from the Ceylon" and may indicate that he based his design on an art book illustration.

Prendergast's two murals were exhibited with Davies's *Dances* (fig. 34) and Kuhn's *Man and Sea Beach* (fig. 35) at the Montross Gallery in February of 1915. The four disparate canvases could not have seemed less like a series except for their similar large sizes. The hope that they might be hung together as permanent decorations was probably fed by the immediate purchase of the four by the collector John Quinn; however, outside of a loan the next year to the Panama-Pacific Exposition in San Francisco,[25] the murals were never to emerge from Quinn's storage during his lifetime. Thus, in the development of modernist mural painting in the mid-teens, Prendergast's role must be considered important—but brief.

The exhilaration of the middle years of the 1910s included not only this extraordinary range of artistic experiments, but a short trip to France (summer, 1914) and Prendergast's move to New York (November 1, 1914). After 1915 Prendergast's life and art became calmer, and his eclecticism abated (fig. 36). He still produced finished paintings at an amazing rate, but they were restricted to a few subject areas that Prendergast returned to again and again. His major exhibition piece continued to be the large oil with monumental figures and a landscape setting. But rather than evoking the classical past, these later works established Prendergast's personal vision of an unchanging and golden idyll.

The subject matter, basic compositional principles, and painterly qualities of these late oils vary little from canvas to canvas (cat. nos. 103-110). Consequently, the impact of each

Fig. 35. Walt Kuhn, *Man and Sea-Beach,* Illustration from *Vanity Fair,* Vol. 4, #3 (May 1915), p. 40, Courtesy *Vanity Fair.* © 1915 (renewed 1943) by The Condé Nast Publications Inc.; photograph, courtesy Tulane University Library, New Orleans, Louisiana

Fig. 36. Photograph of Maurice Prendergast, ca. 1917 (10 x 8 in.), Williams College Museum of Art, Prendergast Archive

Fig. 38. Maurice Prendergast, *The Beach*, ca. 1918-19, Illustration from exhibition catalogue, *Catalogue of the Thirteenth Annual Exhibition of Selected Paintings by American Artists and a Group of Small Selected Bronzes by American Sculptors*, Buffalo, N.Y.: The Albright Art Gallery, 24 May-8 Sept. 1919.

work relies on an internal adjustment of all the elements so that subject, composition, and color make a strong and unique statement each time. It is a tribute to Prendergast that in spite of the repetitiveness, he is largely successful. These late idylls were well received by critics and collectors, perhaps more so than the classicizing bathers of the earlier teens. Duncan Phillips became Prendergast's major patron by 1920 and Albert Barnes, Ferdinand Howald, and Lillie Bliss continued to support his efforts. While no one considered him to be in the forefront of a new movement, he was consistently shown with those who were, including Marcel Duchamp, Man Ray, John Marin, Charles Demuth, Morton Schamberg, and Joseph Stella. In 1923 his large *Landscape with Figures* (cat. no. 110) was awarded a bronze medal by the Corcoran Gallery for the William J. Clark purchase prize and thus became one of the earliest Prendergasts to enter a museum collection. The artist, with only weeks yet to live, was touched by the honor and was reputed to have said, "I'm glad they've found out I'm not crazy, anyway."[26]

Prendergast worked into the last years of his life until failing health finally caused him to stop. He tended to produce watercolors during summer trips to his favorite New England resorts (fig. 37). He would often stay with old friends like Oliver and Esther Williams or William and Edith Glackens in Annisquam or Gloucester; or he would travel with Charles to Ogunquit or Brooksville, Maine. One summer (1922 or 1923) he and Charles stayed in Arthur Dove's house in Westport, Connecticut.

During the winters, Prendergast tended to work on his oils in his studio at 50 Washington Square South. Although he continued to participate in artists' associations such as The Society of Independent Artists[27] and maintained his many friendships in art circles, he increasingly kept to his studio where he tinkered with canvases in various stages of completion. His friend Walter Pach remembered him "before his easel, 'pecking away' as Charlie Prendergast would call it, eager and exhilarated as he 'punched up' a canvas that might have seemed perfect before but in which he saw possibilities of greater depth, a hardier build, or more of light and richness."[28] Prendergast had been in the habit of "pecking away" at his canvases all his life. Indeed, decades earlier, collectors who wanted to buy paintings knew they had to act fast to get the painting before it was drastically altered or lost forever under an entirely new painting. The Boston artist Carl Cutler, when going to the Prendergasts' studio to buy a particular painting, could not find it again. Since Maurice was out, Charles explained, "Yes, I know that picture—I thought it one of his best—but it no longer exists, it is gone. Maurice began painting on it again and it just disappeared."[29]

This happened with greater frequency in the late teens, when Prendergast narrowed his focus to the large idyllic paintings. Occasionally we can reconstruct this process by comparing known paintings with old photogaphs. We seem to have such a case with both *The Cove* (cat. no. 106) and *Beach at Gloucester* (cat. no. 107). *The Cove* bears some resemblance to a lost painting titled *The Beach* which was reproduced in a 1919 exhibition catalogue (fig. 38).[30] A com-

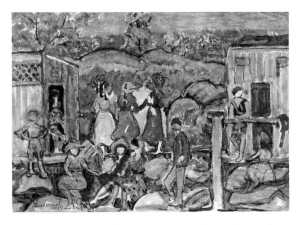

Fig. 37. Maurice Prendergast, *Annisquam*, 1919, Watercolor, pastel and pencil on paper (14 x 20 in.; sight), Collection of Mrs. Charles Prendergast

parison of the two works suggests that Prendergast had taken *The Beach* and began "pecking away," altering figures and setting, until all was changed except some of the original outlines, such as the circular hat at left center and the torso of the reclining figure at right center. There is a similar correspondence of *Beach at Gloucester* to a photograph from Prendergast's studio (fig. 39).[31] If indeed the missing works in these old photos now reside under the final paint surfaces of *The Cove* and *Beach at Gloucester*, we have solved the puzzling disappearance of what must have been important paintings, and we may also be able to explain the similar disappearance of a number of other oils photographed during Prendergast's lifetime.

Prendergast's habit of applying new paint layers over old not only caused major exhibited and photographed paintings to disappear, but it also resulted in increasingly thick and complex surfaces on paintings of this later period. Because Prendergast used dabs of paint, the earlier layers were never completely obscured, but simply became part of a dense, colored atmosphere. Many of the outlines from the earlier layers also show through, giving rise to mysteriously incomplete figures or trees. Some of these canvases may simply have been left unresolved at Prendergast's death, such as *Acadia* (cat. no. 109), but others, such as *Landscape with Figures* (cat. no. 110), were exhibited that way, indicating that Prendergast approved of the fact that parts of the painting were "in process."

The late idyllic paintings, with their visible signs of Prendergast's ceaseless attempt to improve his art, reveal an essen-

Fig. 39. Maurice Prendergast, *Unknown title*, ca. 1914–15, Photograph in Williams College Museum of Art, Prendergast Archive

tial feature of Prendergast as an artist. He came to his profession without the advantage of family connections or wealth, but with a solid background in the virtues of hard work and progressive thinking. His talent gave him the tools to succeed in commercial art and as a view painter early in his career; his innate attraction to new ideas allowed him to move on to modernist circles and to play a part in the cultural revolution of the early twentieth century. Even when he restricted himself to a single idyllic message of peace and harmony late in his life, he worked to improve the expression in each one even if it meant dispensing with what went on before. His never-ending pursuit of a new solution gave him the courage to move beyond each success and create works that continually surprise and satisfy. For this he was recognized by his contemporaries and continues to be valued by posterity.

Notes

1. Milliken reports that Prendergast drew from the nude at Julian's, but no examples of his classwork have survived. "After a while, he went to Julien's [sic] and entered the life-class there. He had never tried to draw a nude figure. When the master, Jean Paul Laurens, glanced at his first sketch, he said, 'You should go down-stairs and study from the casts.' Prendergast took this as a challenge. He made up his mind to stick to the model until he had made a good drawing, and soon he made a number that were hung in the Concours." Milliken, p. 565.

2. Downes, "Exhibition of the Water Color Club," *Boston Evening Transcript*, February 6, 1911, p. 11.

3. Sketchbook, Museum of Fine Arts, Boston, *Catalogue Raisonné*, no. 1498. The titles refer to Edmund G. Gardner, *The Painters of the School of Ferrara* (London: Duckworth & Co., 1911) and O. M. Dalton, *Byzantine Art and Archaeology* (Oxford: Clarendon Press, 1911). I am grateful to Elizabeth Durkin for identifying these titles.

4. Henri Matisse, "Notes of a Painter" (1908), in Herschel B. Chipp, *Theories of Modern Art* (Berkeley: University of California Press, 1971), p. 133.

5. Matisse, p. 135.

6. For a discussion of Berenson's mentions of Monet, Cézanne, and Matisse in his writings, see Sandra S. Phillips, "The Art Criticism of Walter Pach," *Art Bulletin* 65, no. 1 (March 1983), p. 109, especially footnotes 19, 20, and 25.

7. Wright, "Impressionism to Synchromism," *Forum*, vol. 50 (December 1913), p. 761.

8. Berenson, pp. 15–16, as discussed by Phillips, p. 109, footnote 19.

9. "Art Notes," *New York Evening Post*, February 20, 1915, part I, p. 7.

10. Wright, *Modern Painting: Its Tendency and Meaning* (New York: John Lane Company, 1915), pp. 321–322.

11. Frederick James Gregg, introduction to the exhibition catalogue, *Maurice B. Prendergast: Paintings in Oil and Watercolors*, Carroll Galleries, February 15 to March 6, 1915.

12. Joseph Coburn Smith, *Charles Hovey Pepper* (Portland, Maine: The Southworth-Anthoensen Press, 1945), p. 42.

13. Hedley H. Rhys mentions that Maurice and Charles Prendergast at one time owned cinema stock. "Maurice Prendergast: The Sources and Development of His Style" (unpublished dissertation: Harvard University, 1952), p. 4.

14. Kandinsky's *On the Spiritual in Art*, published in German in January of 1912, was excerpted in *Camera Work* in July, and published in English in 1914.

15. Hartley was particularly affected by Kandinsky's mysticism, and, if Prendergast was hearing about German Expressionist theory from Hartley, he might have believed that his horse and rider and symbolic sunset were in line with German ideas. For Hartley and Kandinsky, see William I. Homer, *Alfred Stieglitz and the American Avant-Garde* (Boston: New York Graphic Society, 1977), pp. 160–161.

16. "The case of Maurice Prendergast is on the face of it less opposed (than that of Luks) to Mr. Babcock's definition. The oils and water colors of this distinguished painter, if they possess one thing more than another,

do demonstrate that he is much more taken up with what he is striving to express than the way he does it." Frederick J. Gregg, "'Expressionists' Presented as New Class of Artists," *New York Herald*, March 9, 1919, Third Section, p. 9.

17. The critic quoted above (footnote 9) goes on to say, "Even Venice has not been 'seen before' enough to alter the originality of the work of Prendergast. He is one of the true moderns, because he is always himself, untrammeled by tradition, unspoiled by the barbarians, intent only on singing of the joy within him, gifted with the rarest of all gifts—true naiveté." "Art Notes," p. 7.

18. Myers, *Artist in Manhattan* (New York 1940), as quoted in Rhys, p. 2. See Rhys, pp. 2-4, for a number of other reminiscences of Prendergast.

19. Robert J. Cole, "Maurice Prendergast Features One Woman," *New York Evening Sun*, February 26, 1915, p. 10.

20. "Prendergast's Paintings," *New York Times*, March 4, 1915, p. 8.

21. Charles Holme, ed., *Peasant Art in Russia* (New York: "The Studio" Ltd., 1912), Prendergast Archive, Williams College Museum of Art.

22. See Homer, p. 287, footnote 100.

23. The clearest account of the mural project is in a letter from Walt Kuhn to John D. Morse, April 8, 1939 (AAA, Walt Kuhn Papers): "Soon after the completion of the [Lillie] Bliss library paintings [by Kuhn and Davies, 1914] we planned a set of four large murals, two by Prendergast, entitled respectively, 'Picnic' and 'Promenade,' one by Davies entitled 'Dances' (not Dancers) and one by myself which I called, 'Man and Sea Beach.' These were prepared and executed in the same studio under the same conditions as the Bliss murals. None of these latter four murals had been commissioned by Mr. Quinn nor any other collector, they were done simply because Davies and myself felt the urge to do them and hoped that their showing would perhaps stimulate more of the sort by ourselves and other artists. They were then exhibited in the Montross Gallery [1915] and subsequently purchased by Mr. Quinn." The conditions under which they were executed (that Kuhn refers to) were that the artists prepared sketches and the murals were actually painted by members of the Co-operative Mural Workshops. See Doreen Bolger, "Modern Mural Decoration: Prendergast & His Circle," in *The Prendergasts & The Arts & Crafts Movement* (Williamstown, Massachusetts: Williams College Museum of Art, 1989), especially pp. 55-59.

24. "The 'New Art' Applied to Decoration," *Vanity Fair* 4, no. 3 (May 1915), p. 40.

25. This was the "Post Exposition Exhibition" of the Department of Fine Arts, January 1 to May 1, 1916.

26. Milliken, p. 192.

27. Charles Prendergast was Vice President and Maurice Prendergast was on the Board of Directors from the inception of the organization in 1917.

28. Pach, p. 225.

29. Smith, p. 41.

30. The Buffalo Fine Arts Academy: The Albright Art Gallery, *Thirteenth Annual Exhibition of Selected Paintings by American Artists*, May 21 to September 8, 1919.

31. Prendergast Archive, Williams College Museum of Art.

IV

Postscript
The Monotypes

When Prendergast was in his sixties, galleries began to exhibit his earlier work in group retrospectives.[1] These exhibitions allowed the art world to rediscover not only his watercolors from the 1890s, but also his monotypes[2]—Prendergast's contribution to printmaking at the turn of the century. Because of this renewed interest, it was a monotype that became the first work by Prendergast to enter a museum collection.[3] Since then, these delicate images have become increasingly popular and are now some of the most sought-after prints of the period.

It is tempting to assume that the large number of these prints (approximately two hundred) and the spontaneity of their design are indications that Prendergast did them in a casual manner and that they were not really intended as finished works of art. Indeed, one of the few early descriptions of his process indicates that they were done as preliminary exercises "in order to see how a sketch would look in a painting."[4] This view of the monotypes is attractive because it allows us to feel as if we are discovering something private, not meant for public display.

However, it has long been stressed that Prendergast's color prints were not only a highly serious endeavor on his part, but that they were among the most visible of his exhibited works in the late 1890s and early 1900s.[5] In fact, only monotypes were shown in Prendergast's first major exhibition in Boston at Hart & Watson's gallery in December 1897. While not a solo exhibition (the show included Hermann Dudley Murphy and Charles Hopkinson), it allowed him to present more works than in any other exhibition previously; Prendergast contributed approximately one third of the show's total of fifty works.[6] The importance of the exhibition to Prendergast, Murphy, and Hopkinson can be measured by the fact that it had been mentioned twice in the *Boston Evening Transcript* simply in anticipation of its opening.[7]

Murphy and Hopkinson had returned from Europe not long before the exhibition, and in one review Murphy is credited with having "invented" the monotype process they used.[8] Apparently, the three exhibitors felt that their prints went beyond standard monotypes, becoming in effect a new form they preferred to designate as "color print" rather than monotype.[9] While scanty, this information suggests that all three were probably familiar with monotypes (which were produced in great numbers in progressive circles in the

1890s), but that Murphy brought home with him from Europe a new formula for handling color more successfully—hence the emphasis on "color prints" rather than monotypes, which tended to be thought of as monochromatic.

Regardless of Murphy's role as initiator, it was Prendergast who was deemed most skillful with the technique, and the critical success, as well as the brisk sales of the works,[10] may have provided the impetus for Prendergast to continue making and exhibiting them for the next five years. He exhibited more monotypes than watercolors at the next Boston Water Color Club annual exhibition (1898). In 1900, his major exhibitions in Chicago and New York (Macbeth Gallery) included equal numbers of prints and paintings, and in 1901 he showed a record thirty-six monotypes (as opposed to twenty-eight watercolors) in a one-man show that traveled from Detroit to Cincinnati. It is clear from this exhibition history that Prendergast considered the monotypes to be major works.

What made him abandon the process soon after 1902? We know that color prints were still on his mind as late as 1907, when he compared some of James Morrice's panels he saw in Paris to his own work: "Morrice['s] things are sloughy [sic] in their execution but he gets fine color and compositions something like my color prints."[11] Although he probably retained an interest in, and an affection for, his color prints all his life, more than likely he realized that the public received them well enough, but more as an afterthought to his watercolors and oils. Furthermore, as he moved to more modernist styles, the decorative qualities of the monotypes were less appropriate to the abstract principles he now wanted to explore.

But during the approximately seven years (ca. 1895 to 1902) that Prendergast worked in the medium of monotype, he produced an astounding range of images that parallel, but do not duplicate, his oils and watercolors. A surprisingly small number of monotypes are directly related to other pieces. Some monotypes, such as *Lady in Pink Skirt* (cat. no. 119), follow drawings or sketches found in his sketchbooks (fig. 40); others are clearly related to finished oils or watercolors, as if the monotypes themselves were used as sketches. However, the vast majority of monotypes depict a corner of the world that is simpler and more intimate than that shown in the larger works.

Fig. 40. Maurice Prendergast, Page from "Boston Sketch Book," ca. 1897-98 p. 22, Watercolor and pencil on paper (7 x 7½ in.), Courtesy, Museum of Fine Arts, Boston, Gift of Mrs. Charles Prendergast in honor of Perry T. Rathbone (59.957)

The extraordinary series of shipboard scenes, of which *Woman on Ship Deck* (cat. no. 111) and *The Ocean Palace* (cat. no. 112) are two examples, is unlike any of the sea and shore views found in Prendergast's contemporary watercolors. The limited palette may indicate that these were done before Murphy's invention of "color prints," and indeed, they have some of the romanticism of Prendergast's scenes of Dieppe (cat. no. 4) from the early 1890s. The small format of the monotype also lent itself to the depiction of children (cat. nos. 113–115), particularly the individual child as in *Jumping Rope* (cat. no. 113). It also allowed Prendergast to continue his studies of individual women (cat. nos. 116-119), something he had stopped doing in watercolor following his return from Paris in 1894. These women with their muffs, boas, and flowered hats present a standard of sophistication seldom matched in any era.

The monotypes Prendergast produced of Italian scenes during and after his return from Italy in 1899 (cat. nos. 120-123) are often as compositionally complex as the Italian watercolors. Some depict familiar scenes, such as Pincian Hill or the Spanish Steps, but others take a close-up view of life in the streets and markets. *Market Scene* (cat. no. 121), *Orange Market* (cat. no. 122), and *Roma: Flower Stall* (cat. no. 123) are some of the few depictions of ordinary Italian people engaged in everyday activities to be found in his work.

An exception to Prendergast's practice of chosing the more intimate subjects for his monotypes can be found in the circus and ballet scenes that first appeared in an exhibition in March of 1901.[12] The clowns, performers in tutus, and lights are curiously subdued in color (cat. no. 124) as if to muffle the normally raucous sights and sounds. Performers of all kinds were used as artistic subjects in Paris, and the reference to the "Nouveau Cirque" (fig. 41) may indicate that the monotypes are reminiscences of a Parisian circus. The muted tones suggest a distant parallel to Picasso's later Rose Period circus scenes.

Prendergast's last monotypes were done in an energetic style of curving brushstrokes that attest to the level of virtuosity he attained in this difficult medium (cat. nos. 126-129). The one statement he made about his process was in the form of some instructions to his friend Esther Williams which she wrote down and preserved (1905):

> Paint on copper in oils, wiping parts to be white. When [the] picture suits you, place on it Japanese paper and either press in a press or rub with a spoon till it pleases you. Sometimes the second or third plate is the best.[13]

It is impossible to tell whether this reflects his process for all the monotypes or reflects his method just for the last ones he did; but it does clarify some difficult technical issues. According to these instructions, he used oil paint rather than printer's ink, which accounts for the extreme subtlety of the color, but must have necessitated using a fairly "dry" mixture of pigment and oil to avoid a "halo" of excess oil bleeding into the blank paper. As Langdale has pointed out, a thin layer of "dry" oil paint on copper would have forced the artist to paint and print quickly to avoid having the design become *too* dry to print.[14]

As for Prendergast's statement that "sometimes the second or third plate is the best," there is ample evidence of his love of tinkering with the design and stretching the limits of traditional monotype. While there are very few examples of faint second or third pulls (fig. 42), there are many more examples of pulls that stand alone as independent works of art. A comparison of *Lighthouse* (cat. no. 127) and *Beach Scene with Lighthouse* (cat. no. 128) reveals that Prendergast has treated the two pulls differently. He has substantially altered the first pull (cat. no. 127) with watercolor additions while leaving the second (cat no. 128) untouched and muted in color.

This type of multiple printing of the monotype plate is truly a contradiction of the traditional definition of the term;

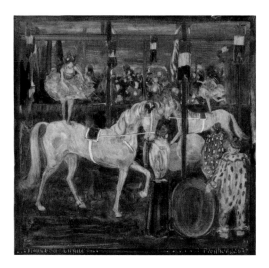

Fig. 41. Maurice Prendergast, *Nouveau Cirque (Paris)*, ca. 1895, Monotype on paper (13⅞ x 13¾ in.; image), © Daniel J. Terra Collection, Terra Museum of American Art, Chicago (29.1984)

Fig. 42. Maurice Prendergast, *Bareback Rider,* ca. 1895, Monotype on paper (7¹/₂ x 5³/₄ in.; image), Williams College Museum of Art, Gift of Mrs. Charles Prendergast (85.21.1)

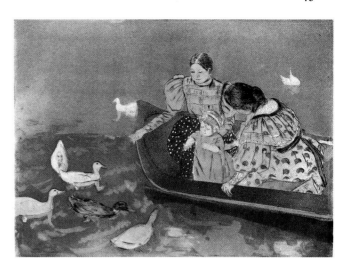

Fig. 43. Mary Cassatt, *Feeding the Ducks* (fourth state), 1895, Drypoint and aquatint (11⁵/₈ x 15¹/₂ in., platemark; 15⁵/₈ x 19³/₄ in., sheet), Private Collection

and since it theoretically allows for the printing of different colors at different times, it does make "color printing" more feasible than with the traditional single-pull monotype. This may well have been the feature that Prendergast, Murphy, and Hopkinson introduced into their prints in 1897, for which they felt the term monotype was no longer applicable.

This type of experimentation with color prints to elicit painterly effects was a hallmark of color printing in the 1890s both in Europe and America. In Boston alone, the efforts of Arthur Wesley Dow to teach traditional Japanese methods of woodblock printing to a new generation of American print-makers would have made everyone in Boston art circles aware of handcrafted prints.[15] Prendergast would also have been familiar with Whistler's prints in the 1890s and most

probably those of Mary Cassatt. Cassatt had two exhibitions in Paris while Prendergast was there (1891 and 1893) and two in New York (1895 and 1898), all of which featured her color drypoint-and-aquatints. A set of Cassatt's ten color prints from 1891 entered a Boston private collection that same year, and Prendergast's patron Sarah Sears owned at least one, *Feeding the Ducks* (fig. 43).[16]

It is significant that Prendergast, like these contemporary printmakers, was bold enough to use a progressive printmaking technique rather than to settle for mastering the conventional. In this, as in his other art, he showed signs of innate restlessness. But it is in these more intimate works that we can come closest to sharing the artist's own thrill of search and discovery.

Notes

1. For example, Montross Gallery showed "Early Works by Arthur B. Davies, William J. Glackens, Robert Henri, Maurice Prendergast" in April 1920.

2. The Ehrich Print Gallery, New York, held an "Exhibition of Unusual Monotypes by Contemporary Artists" (March 17-April 5, 1919) which included five Prendergast monotypes.

3. The Ehrich Print Gallery lent three monotypes to the "Summer Exhibition" (1919) of the Memorial Art Gallery, Rochester, New York. One of these, *The Ships* (*Catalogue Raisonné,* no. 1676), was purchased by Emily Sibley Watson and donated to the Memorial Art Gallery that same year (1919).

4. Brooks, "Anecdotes," p. 566.

5. Cecily Langdale has given a well-researched view of Prendergast's production and exhibition of the monotypes in two major catalogues: *The Monotypes of Maurice Prendergast* (New York: Davis and Long, 1979) and *Monotypes by Maurice Prendergast in the Terra Museum of American Art* (Chicago: Terra Museum of American Art, 1984).

6. The only information about this exhibition comes from reviews: "The Fine Arts: Gallery and Studio Notes," *Boston Evening Transcript,* April 24, 1897, p. 4, and "Collection of Decorative Drawings Shown at Hart & Watson's," *Boston Sunday Herald,* December 19, 1897, p. 30.

7. "The Fine Arts," *Boston Evening Transcript,* April 3, 1897, p. 16 (which indicates that the exhibition has been put off from spring to fall), and

"Coming Exhibits at Hart & Watson's," *Boston Evening Transcript,* November 16, 1897, p. 6.

8. "The Fine Arts: Gallery and Studio Notes," p. 4.

9. "Collection of Decorative Drawings Shown at Hart & Watson's," p. 30.

10. *Ibid.* "The exhibition as a whole has interested picture buyers as well as print collectors as the prints seem to fill a want in cultivated homes of modest size to which small bits of decorative color and graceful sentiment are more appropriate than large and pictorial canvases."

11. MP to Charles Prendergast, [mid-June 1907], Prendergast Archive, Williams College Museum of Art.

12. A monotype called *The Circus* is listed in the catalogue of the "Fourteenth Annual Exhibition of the Boston Water Color Club," March 1 to 16, 1901.

13. Rhys, p. 75.

14. Langdale, *Terra,* p. 21.

15. For Dow's printmaking theories and influence see Moffatt, Chapter IV, "Japanese Currents."

16. The set of ten prints bought by Sylvester Koehler for Mrs. Kingsmill Marrs is now in the Worcester Art Museum. Cassatt visited her friend Sears in Boston in early 1898. It is conceivable that Cassatt and Prendergast met at that time—just before Prendergast's trip to Italy funded by Sears. For information about Sarah Sears's collection, see Stephanie Mary Buck, "Sarah Choate Sears: Artist, Photographer, and Art Patron" (unpublished MFA thesis: Syracuse University, 1984), p. 114.

Plates

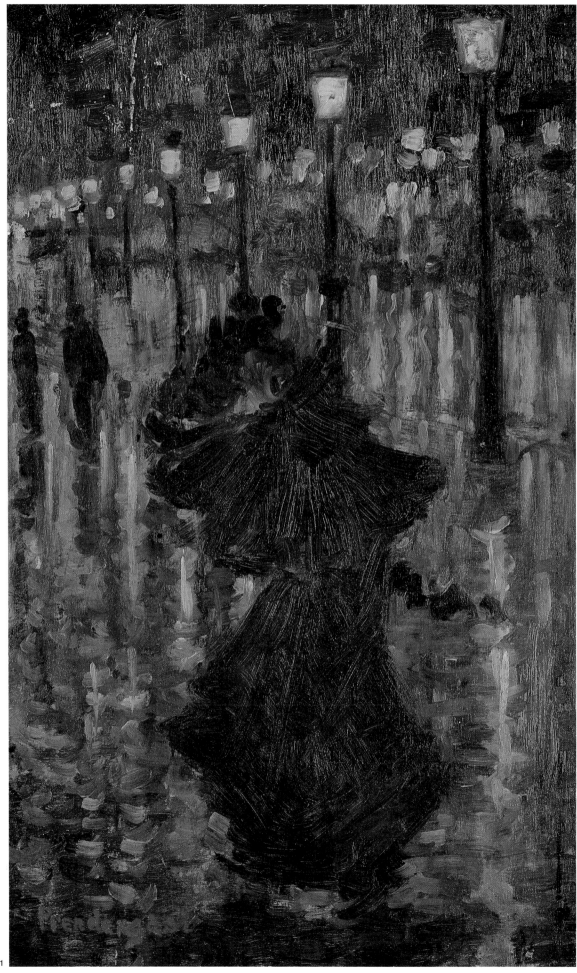

1

 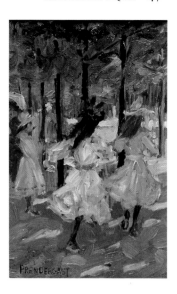

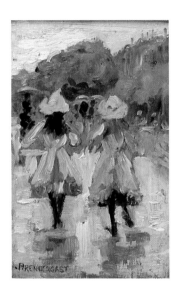 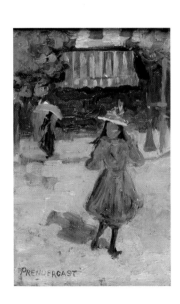 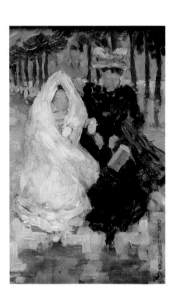

2

Sketches in Paris

ca. 1892–94

Oil on panel

(6¹/₄ x 3³/₄ in.; 17.1 x 9.5 cm; each panel)
Addison Gallery of American Art, Phillips Academy,
Andover, Massachusetts
(1939.2)

1

Evening Shower, Paris

ca. 1892–94

Oil on panel

(12¹/₂ x 8¹/₂ in.; 31.7 x 21.6 cm)
Private Collection

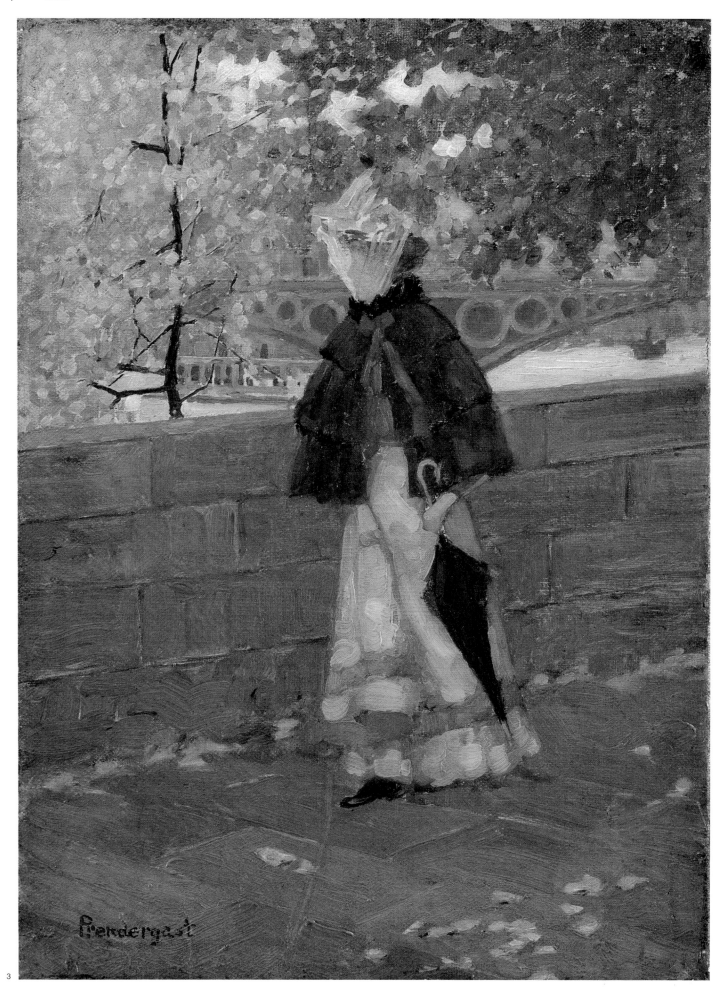

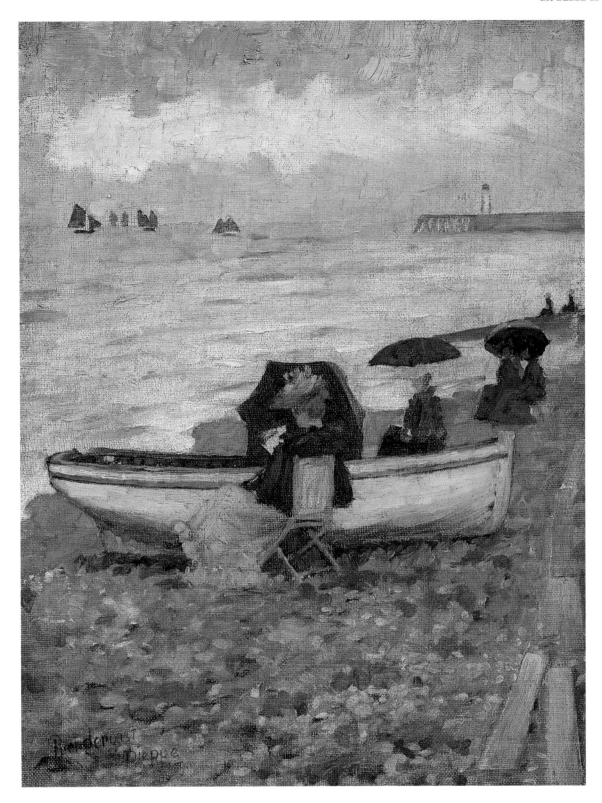

3
Along the Seine
ca. 1892–94
Oil on canvas
(13 x 9¹/₂ in.; 33.0 x 24.1 cm)
Collection of Whitney Museum of American Art. Purchase
(39.27)

4
Dieppe
ca. 1892–94
Oil on canvas
(12³/₄ x 9¹/₂ in.; 32.4 x 24.1 cm)
Collection of Whitney Museum of American Art. Gift of
Arthur G. Altschul
(75.51)

5
Paris Boulevard in Rain
1893
Watercolor and pencil on paper
(13 x 10 in.; 33.0 x 25.4 cm)
Marcia Fuller French

6
South Boston Pier
1896
Watercolor and pencil on paper
(18¼ x 14 in.; 46.4 x 35.6 cm)
Smith College Museum of Art, Northampton, Massachusetts.
Purchased, Charles B. Hoyt Fund, 1950
(1950:43)

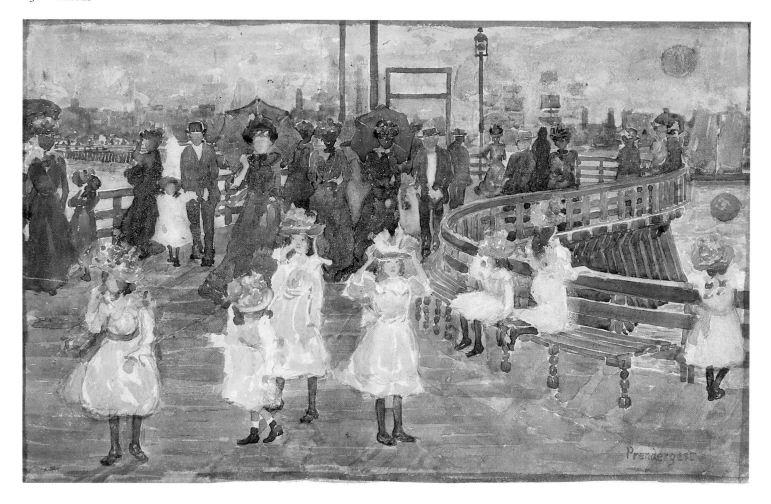

7

South Boston Pier

ca. 1895–97

Watercolor and pencil on paper

(12¼ x 19⅛ in.; 31.2 x 48.5 cm)

Gift of Annie Swan Coburn in memory of Olivia Shaler
Swan, © 1989 The Art Institute of Chicago. All rights
reserved.

(1948.208)

8

Revere Beach

1896

Watercolor and pencil on paper

(14 x 10 in.; 35.6 x 25.4 cm)

Collection of Mr. and Mrs. Raymond J. Horowitz

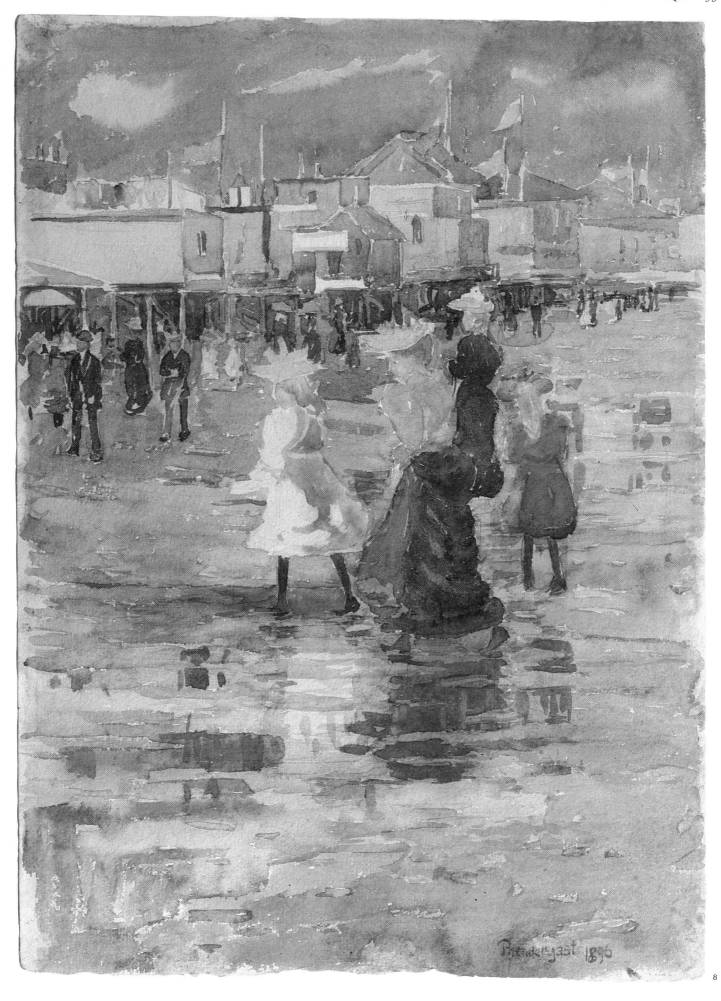

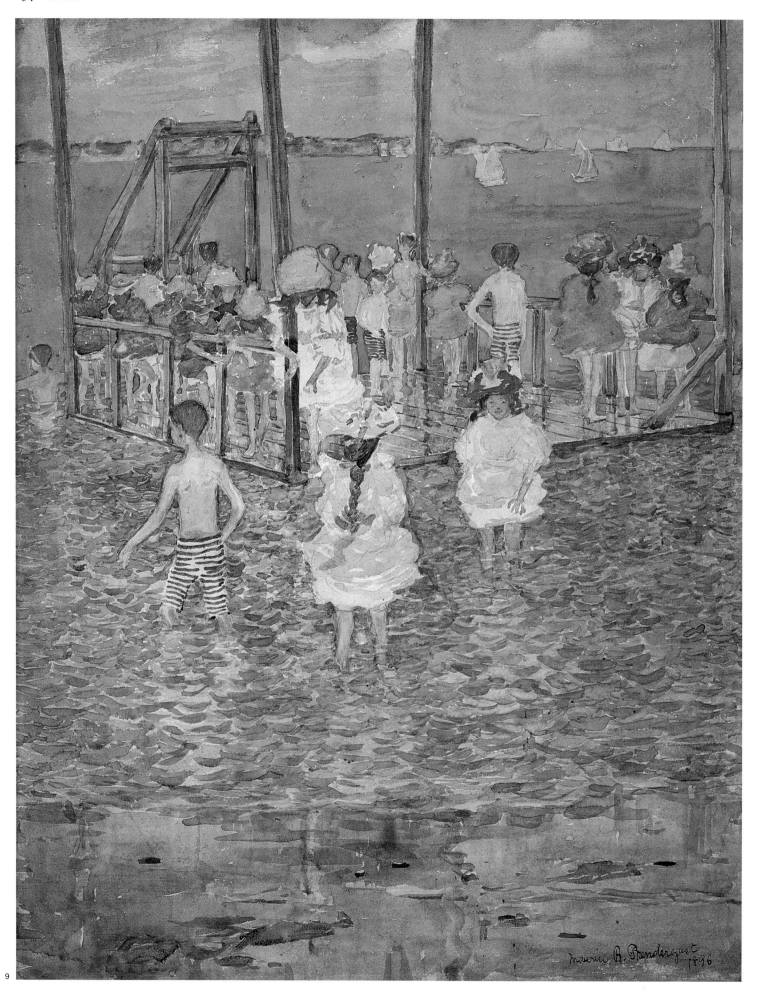

9

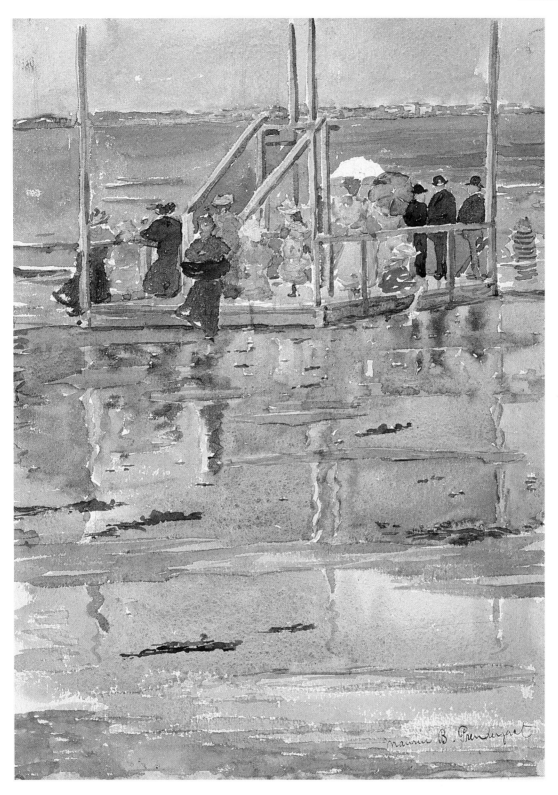

9
Children on a Raft
1896
Watercolor and pencil on paper
(17½ x 13⅜ in.; 44.5 x 34.0 cm)
Manoogian Collection

10
Float at Low Tide, Revere Beach
ca. 1896-97
Watercolor and pencil on paper
(13¼ x 9¼ in.; 33.7 x 23.5 cm; sight)
Addison Gallery of American Art, Phillips Academy,
Andover, Massachusetts, Gift of Mrs. William C. Endicott
(1942.2)

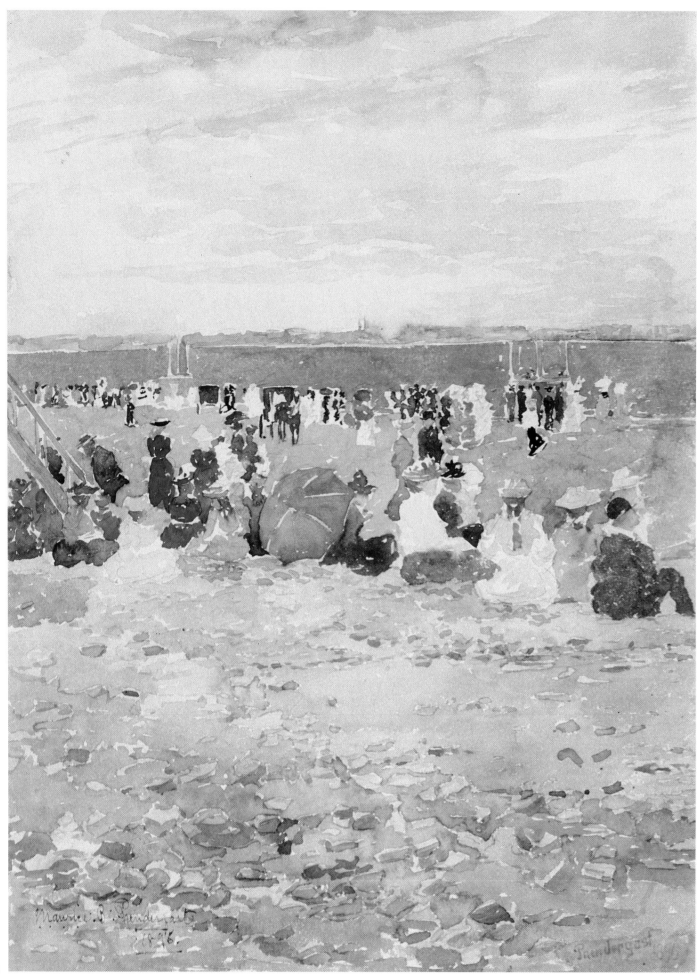

11

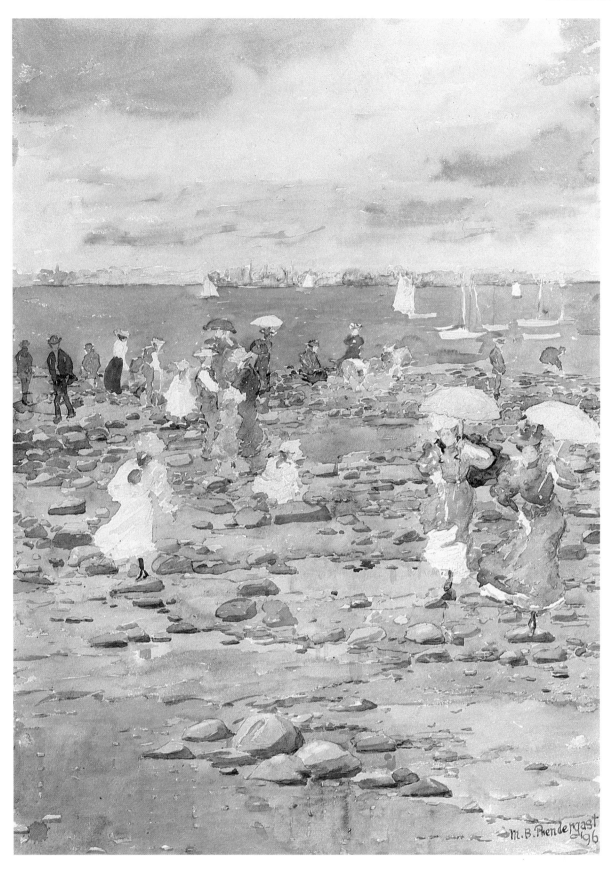

11
Revere Beach
1896
Watercolor and pencil on paper
(13⁵/₈ x 9⁷/₈ in.; 34.6 x 25.1 cm)
The Saint Louis Art Museum, Purchase
(109.1947)

12
Summer Visitors
1896
Watercolor and pencil on paper
(19 x 15 in.; 48.3 x 38.1 cm)
Private Collection, Courtesy of Marshall C. Henis,
Steppingstone Gallery, Great Neck, New York

13
Ladies with Parasols
ca. 1896-97
Watercolor and pencil on paper
(12³/₄ x 10 in.; 32.4 x 25.4 cm)
Collection of Robert and Kathryn Steinberg

14
Low Tide, Nantasket
ca. 1896-97
Watercolor and pencil on paper
(20¹/₈ x 14 in.; 51.1 x 35.6 cm)
Williams College Museum of Art, Gift of Mrs. Charles
Prendergast
(86.18.2)

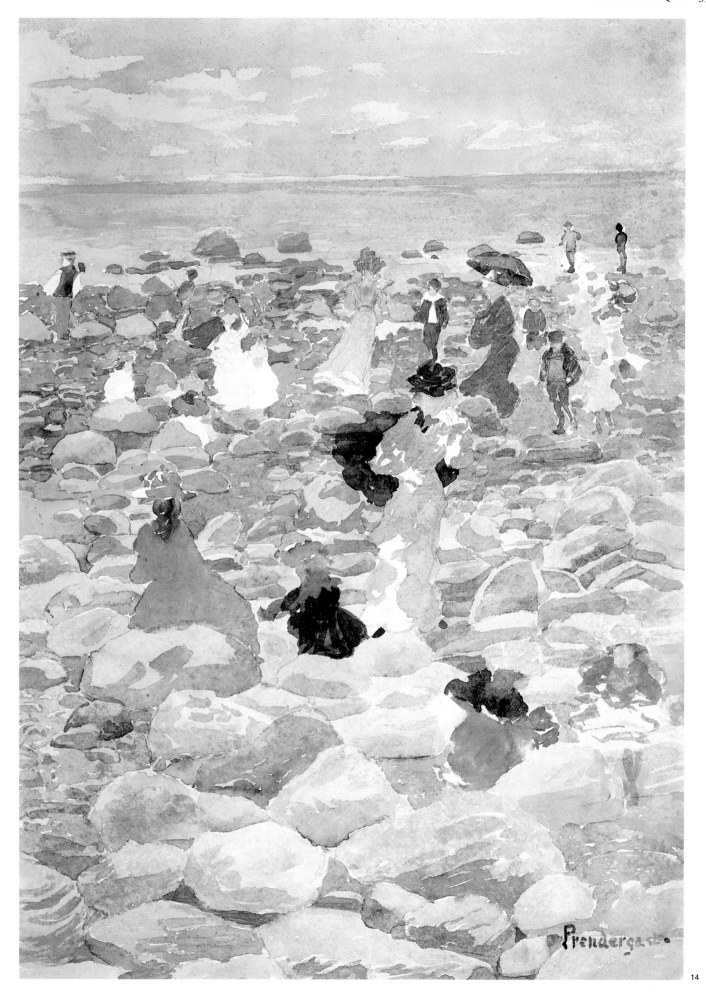

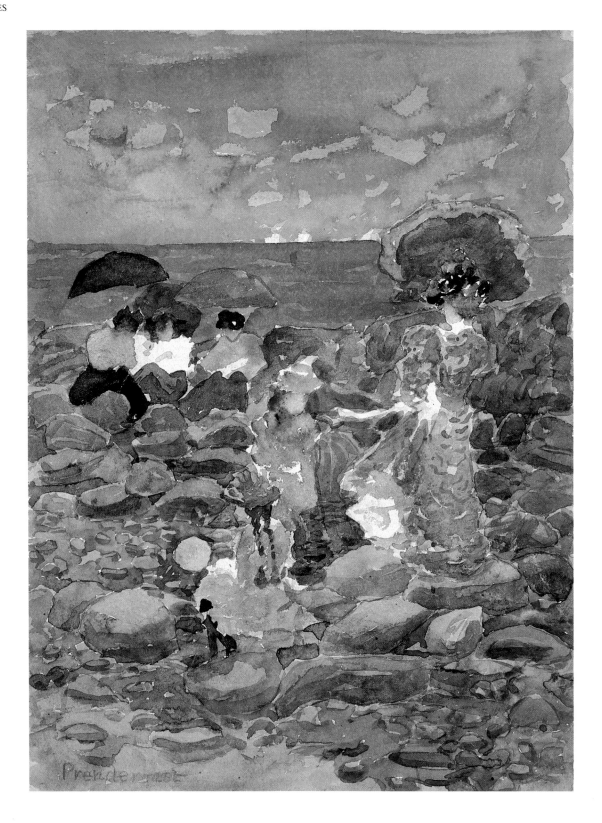

15

Low Tide

ca. 1896–97

Watercolor and pencil on paper

(14 x 10 in.; 35.6 x 25.4 cm)

Williams College Museum of Art, Gift of Mrs. Charles
Prendergast

(86.18.55)

16

Rocky Shore, Nantasket

ca. 1896–97

Watercolor, pencil and ink on paper

(17 x 12¹/₂ in.; 43.2 x 31.7 cm)

Mr. and Mrs. Granville M. Brumbaugh

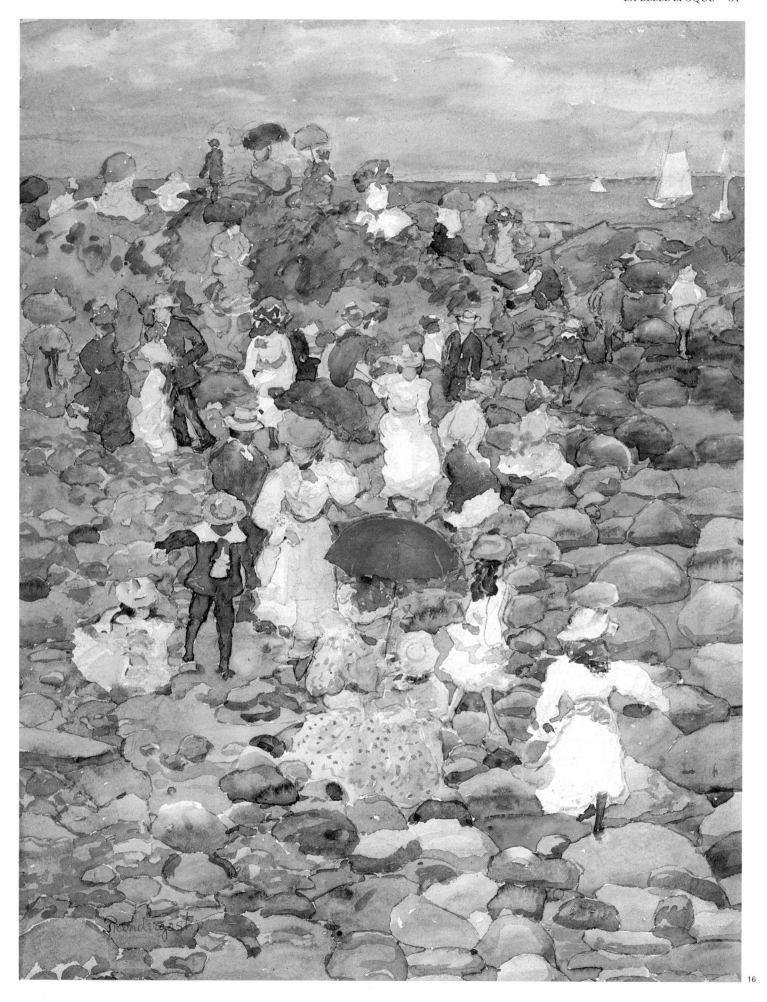

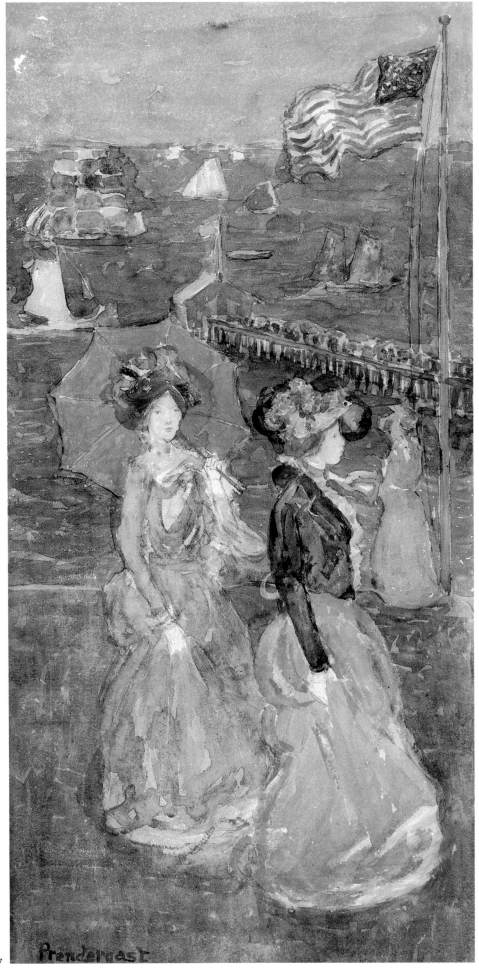

17

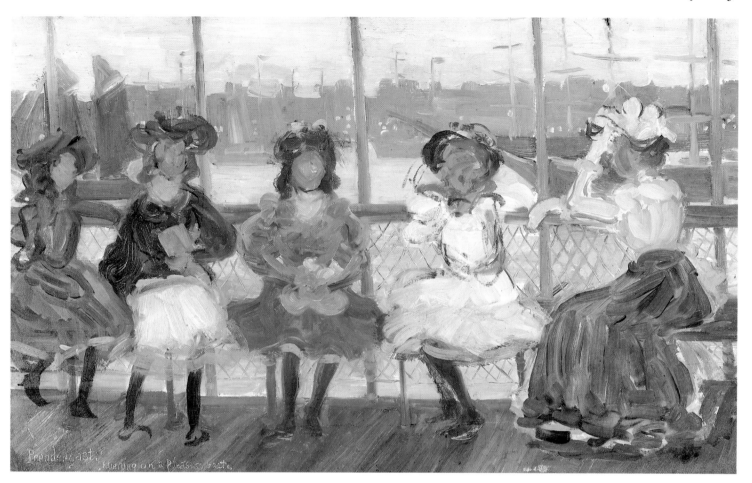

18

Evening on a Pleasure Boat

ca. 1895-97

Oil on canvas

(14 x 22 in.; 35.6 x 55.9 cm)

© Daniel J. Terra Collection, Terra Museum of American Art,
Chicago

(28.1980)

17

Figures under the Flag

ca. 1900-05

Watercolor and pencil on paper

(20¹/₂ x 10¹/₄ in.; 52.1 x 26.0 cm)

Williams College Museum of Art, Gift of Mrs. Charles
Prendergast

(86.18.70)

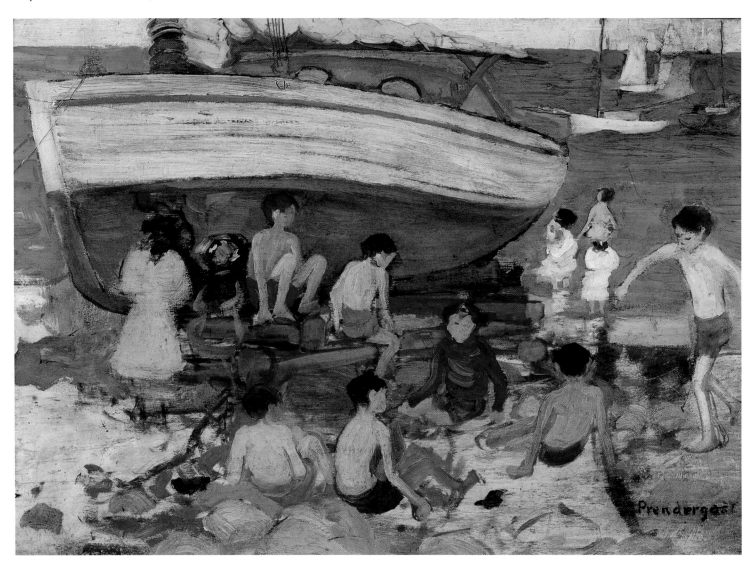

19
Low Tide
ca. 1895–97
Oil on panel
(13¹/₂ x 18 in.; 34.3 x 45.7 cm)
Williams College Museum of Art, Gift of Mrs. Charles
Prendergast
(86.18.40)

20
Splash of Sunshine and Rain
1899
Watercolor and pencil on paper
(19³/₈ x 14¹/₄ in.; 49.2 x 36.2 cm)
The collection of Alice M. Kaplan

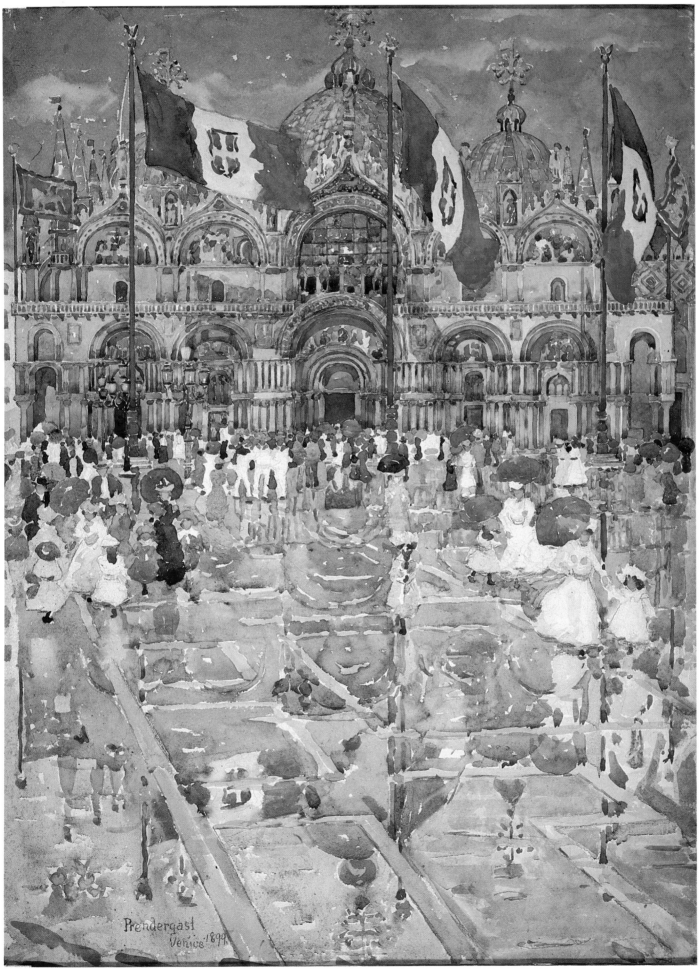

21
St. Mark's, Venice
1898
Watercolor and pencil on paper
(14¹/₈ x 19¹/₂ in.; 35.9 x 49.5 cm)
National Gallery of Art, Washington, D.C.; Gift of Eugénie
Prendergast
(1984.63.1)

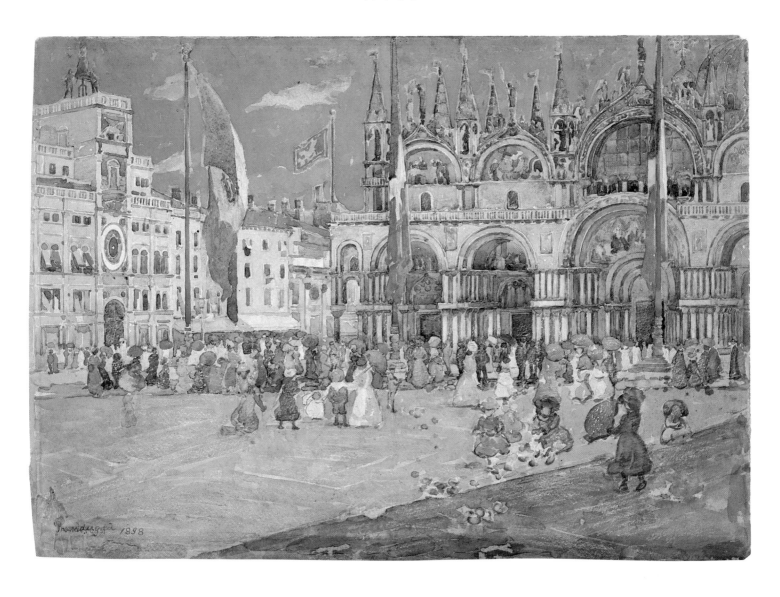

22

Venice

ca. 1898–99

Watercolor and pencil on paper

($14^1/_8$ x $20^3/_4$ in.; 35.9 x 52.7 cm)

Williams College Museum of Art, Gift of Mrs. Charles

Prendergast

(86.18.61)

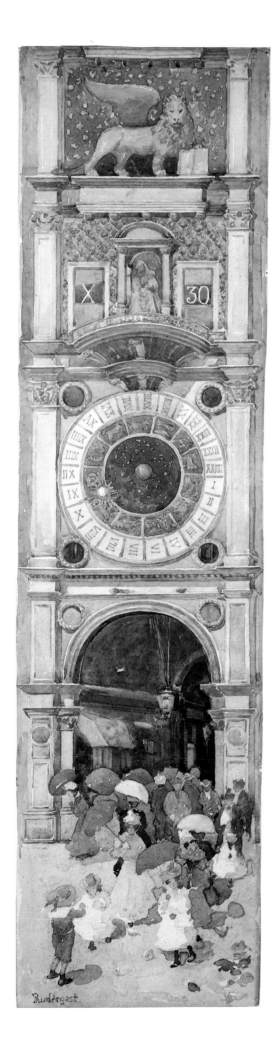

23
St. Mark's Square, Venice (The Clock Tower)
ca. 1898–99
Watercolor and pencil on paper
(26 x 6 in.; 66.0 x 15.2 cm)
Collection of the William A. Farnsworth Library
and Art Museum
(44.316)

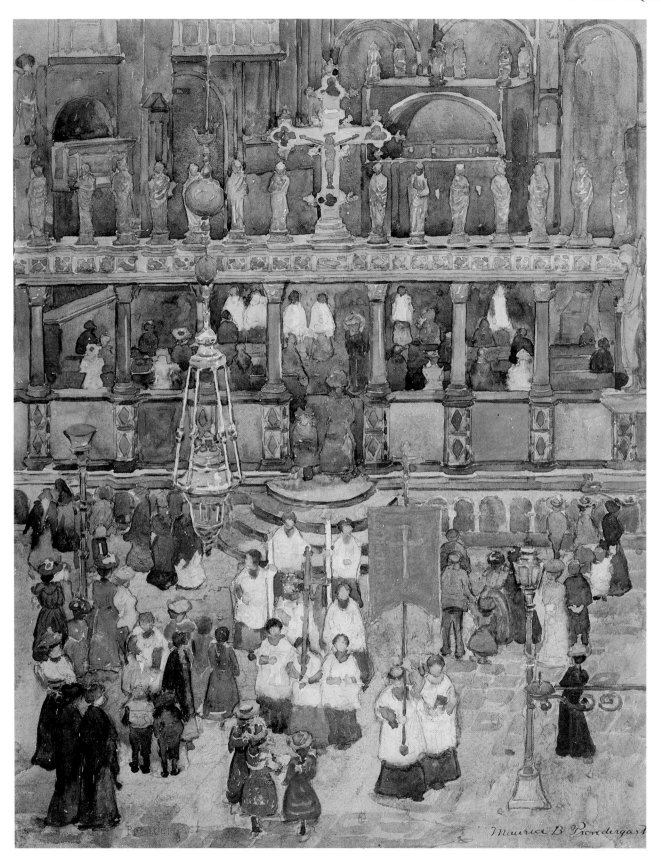

24

Easter Procession, St. Mark's

ca. 1898–99

Watercolor and pencil on paper

(18 x 14 in.; 45.7 x 35.6 cm; sight)

Collection of Erving and Joyce Wolf

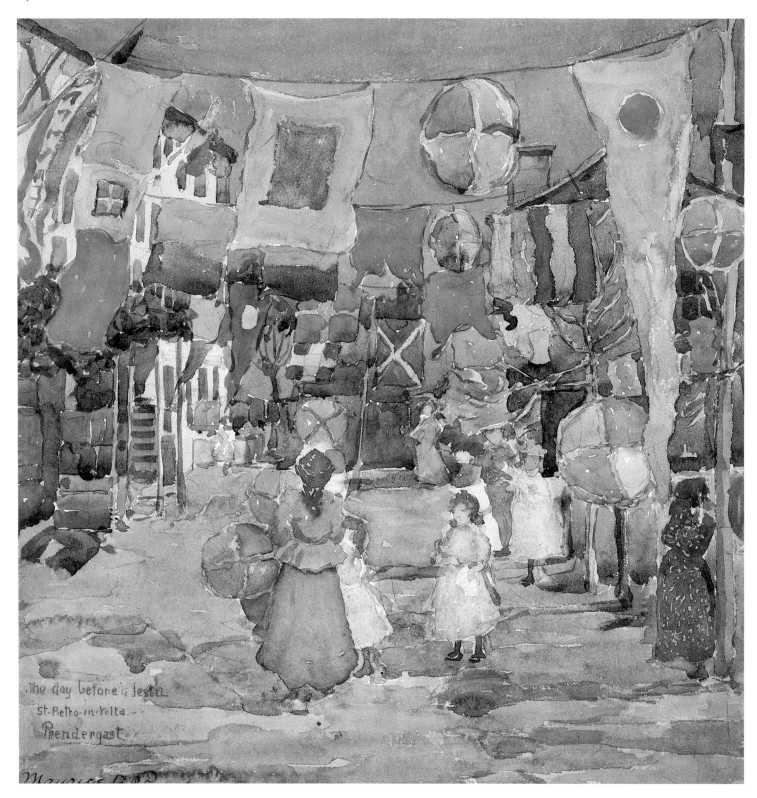

The day before a festa.
St. Pietro in Volta
Prendergast
Maurice D P

25
Fiesta–Venice–S. Pietro in Volta
ca. 1898–99
Watercolor and pencil on paper
(13³/₈ x 12¹/₂ in.; 34.0 x 31.7 cm)
Williams College Museum of Art,
Gift of Mrs. Charles Prendergast
(86.18.76)

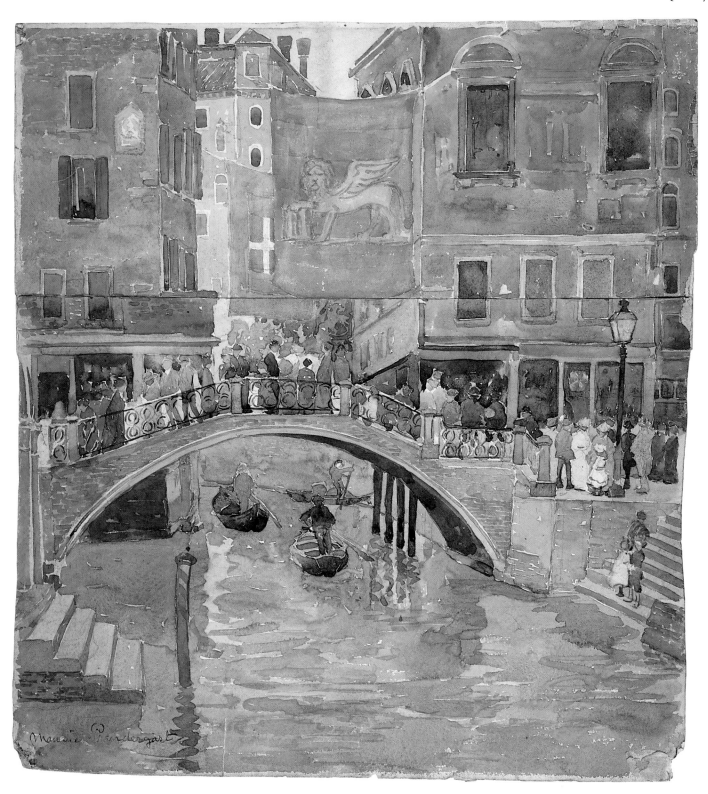

26
Venice
ca. 1898–99
Watercolor and pencil on paper
(17¼ x 15½ in.; 43.8 x 39.4 cm)
Addison Gallery of American Art, Phillips Academy,
Andover, Massachusetts, Bequest of Miss L. P. Bliss
(1931.96)

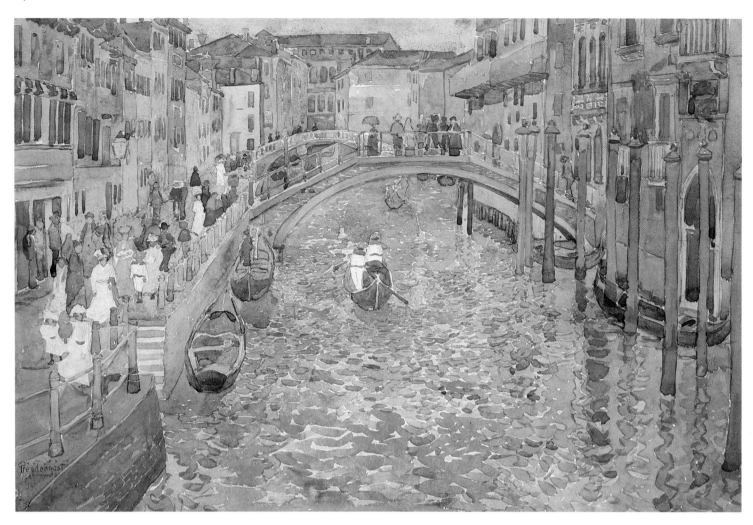

27
Venetian Canal Scene
ca. 1898–99
Watercolor and pencil on paper
(13⁷/₈ x 20³/₈ in.; 35.2 x 51.8 cm)
Private Collection

28
Grand Canal, Venice
ca. 1898–99
Watercolor and pencil on paper
(9³/₄ x 13⁵/₈ in.; 24.8 x 34.6 cm; sight)
Collection of Mrs. Charles Prendergast

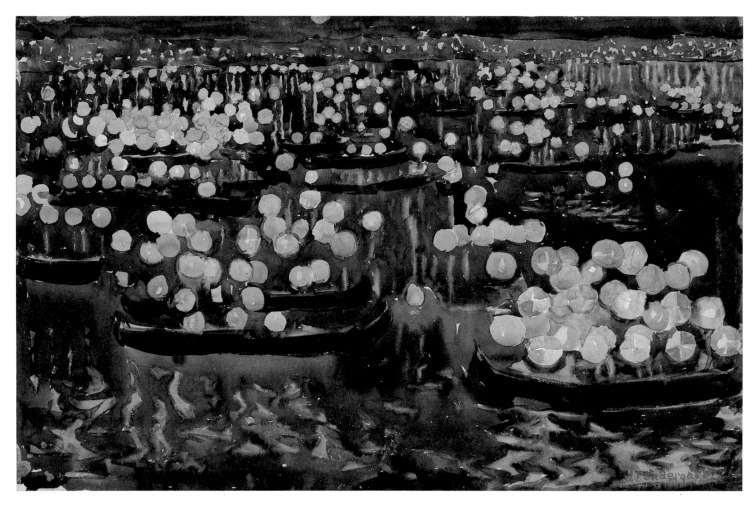

29
Festa del Redentore
ca. 1899
Watercolor and pencil on paper
(11 x 17 in.; 27.9 x 43.2 cm)
Collection of Mrs. Charles Prendergast

30
Assisi
ca. 1898-99
Watercolor and pencil on paper
(15³/₈ x 11 in.; 39.1 x 28 cm)
Williams College Museum of Art, Gift of Mrs. Charles
Prendergast
(86.18.59)

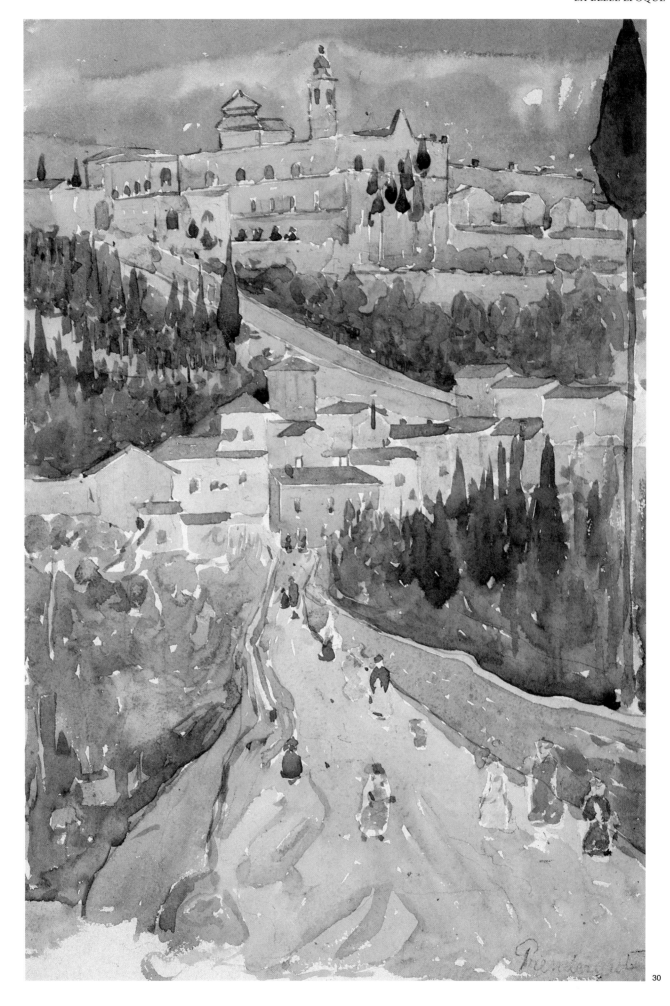

30

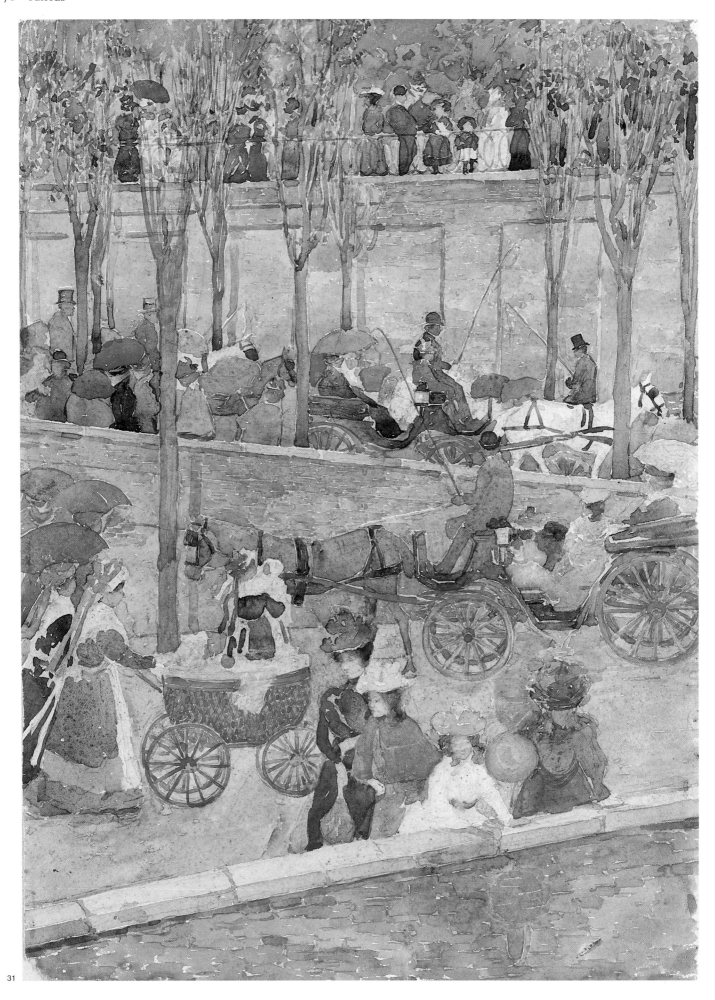

31

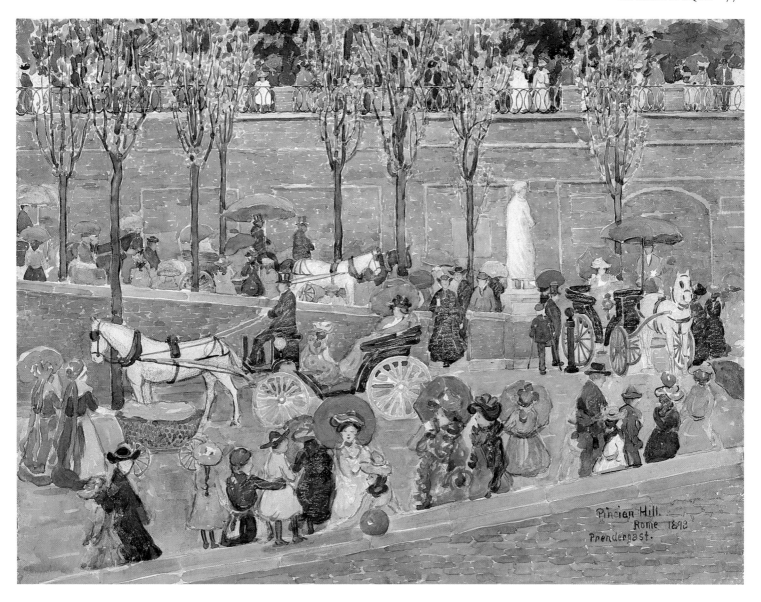

32
Pincian Hill, Rome
1898
Watercolor and pencil on paper
($20^{3}/_{4}$ x $26^{7}/_{8}$ in.; 52.7 x 68.2 cm; sight)
The Phillips Collection, Washington, D. C.
(1609)

31
Afternoon, Pincian Hill
ca. 1898-99
Watercolor and pencil on paper
($15^{1}/_{8}$ x $10^{5}/_{8}$ in.; 38.4 x 26.4 cm)
Honolulu Academy of Arts, Gift of Mrs. Philip E. Spalding,
1940
(11,653)

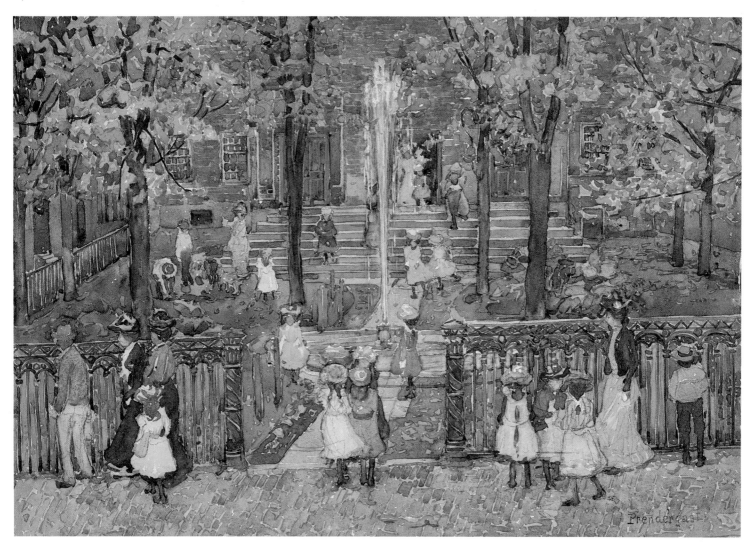

33
West Church, Boston
ca. 1900-01
Watercolor, pencil, and opaque white on paper
(10⁷/₈ x 15³/₈ in.; 27.6 x 39.0 cm)
Museum of Fine Arts, Boston, Charles Henry Hayden Fund
(58.1199)

34
Madison Square
1901
Watercolor and pencil on paper
(15 x 16¹/₂ in.; 38.1 x 41.9 cm)
Collection of Whitney Museum of American Art. Joan
Whitney Payson Bequest
(76.14)

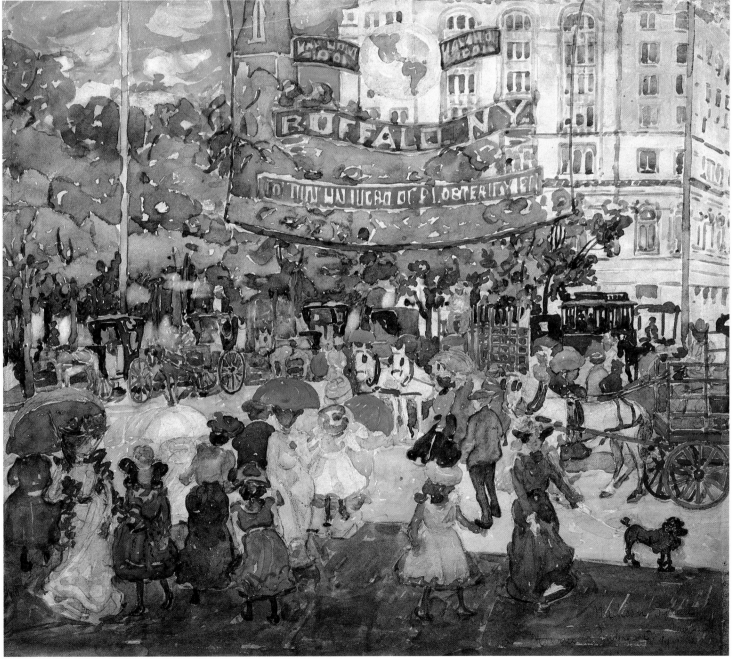

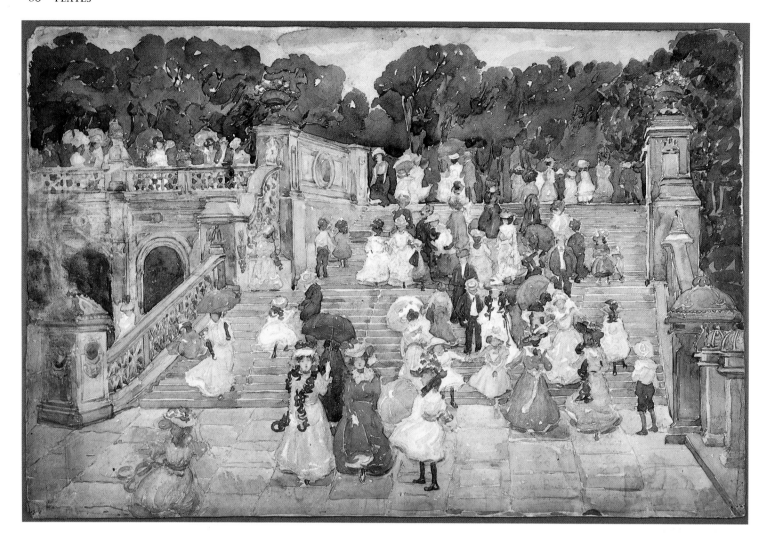

35
The Mall, Central Park

1901

Watercolor and pencil on paper

(15¼ x 22½ in.; 38.7 x 56.9 cm)

(1939.431)

36
Central Park
1900
Watercolor, pastel, charcoal and pencil on paper
(14³/₈ x 21¹/₂ in.; 36.5 x 54.6 cm)
Collection of Whitney Museum of American Art. Purchase
(32.41)

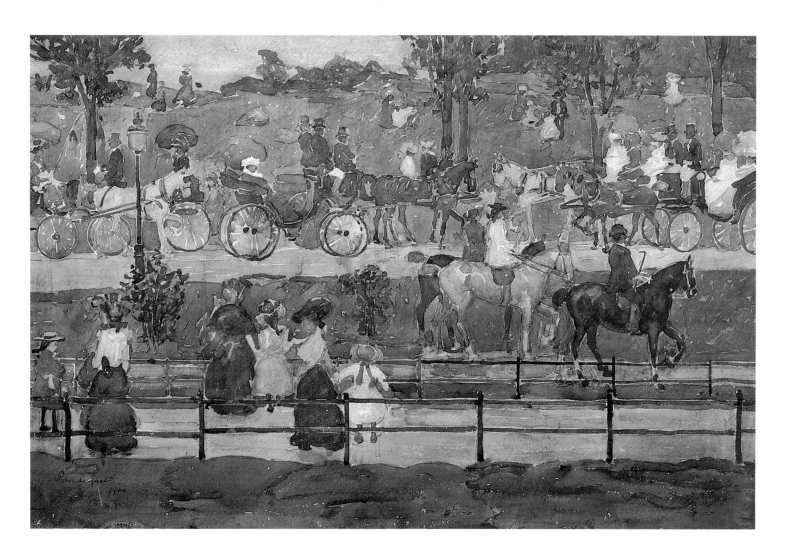

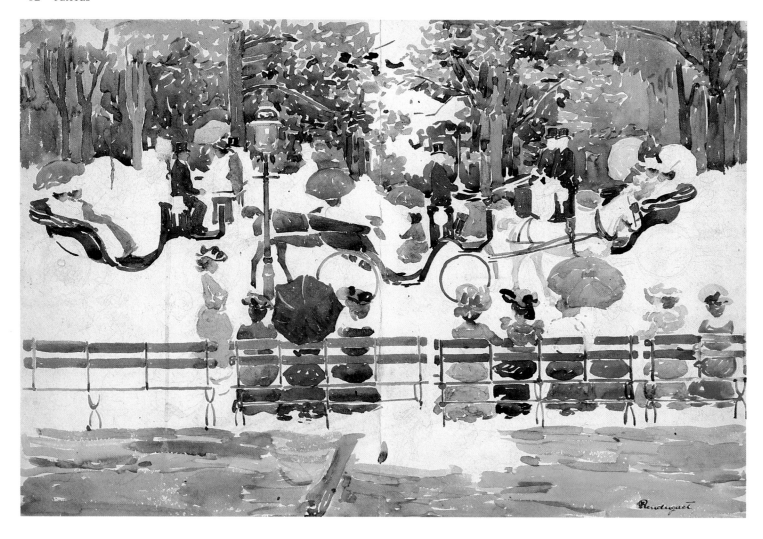

37
Central Park
ca. 1901
Watercolor and pencil on paper
(15¹/₄ x 22 in.; 38.7 x 55.9 cm)
Williams College Museum of Art,
Gift of Mrs. Charles Prendergast
(67.13)

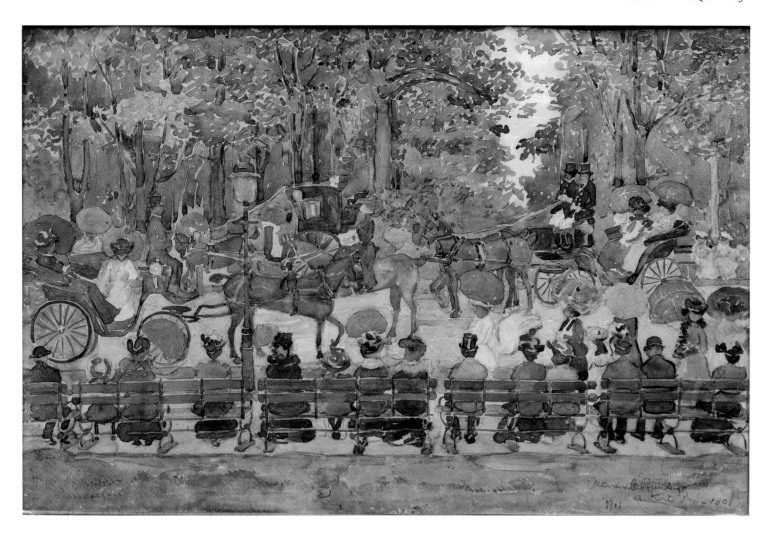

38

Central Park

1901

Watercolor, pencil, ink and pastel on paper

(14$^{3}/_{8}$ x 21$^{1}/_{2}$ in.; 36.5 x 54.9 cm; sight)

Collection of Whitney Museum of American Art. Purchase

(32.42)

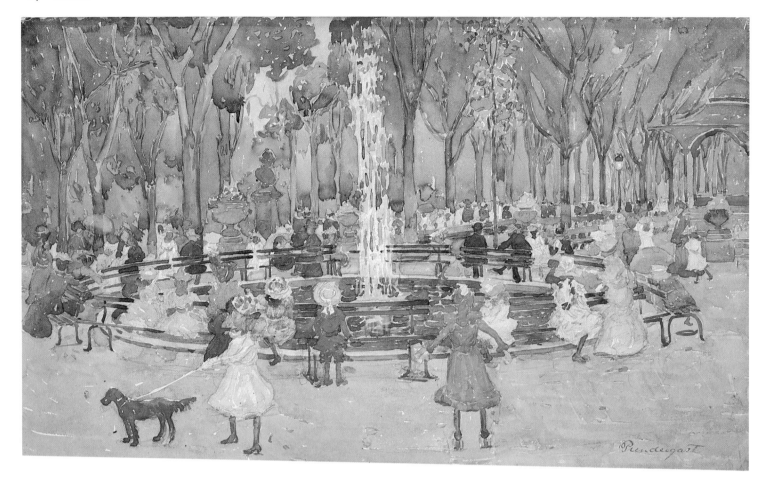

39

In Central Park, New York

ca. 1900–03

Watercolor and pencil on paper

(12¹/₄ x 20 in.; 31.3 x 50.8 cm)

Addison Gallery of American Art, Phillips Academy,

Andover, Massachusetts, Gift of Anonymous Donor

(1928.48)

40
Merry-Go-Round, Nahant
ca. 1900-01
Watercolor and pencil on paper
(13¹/₄ x 19 in.; 33.7 x 48.3 cm; sight)
Museum of Fine Arts, Springfield, Massachusetts
(49.D02)

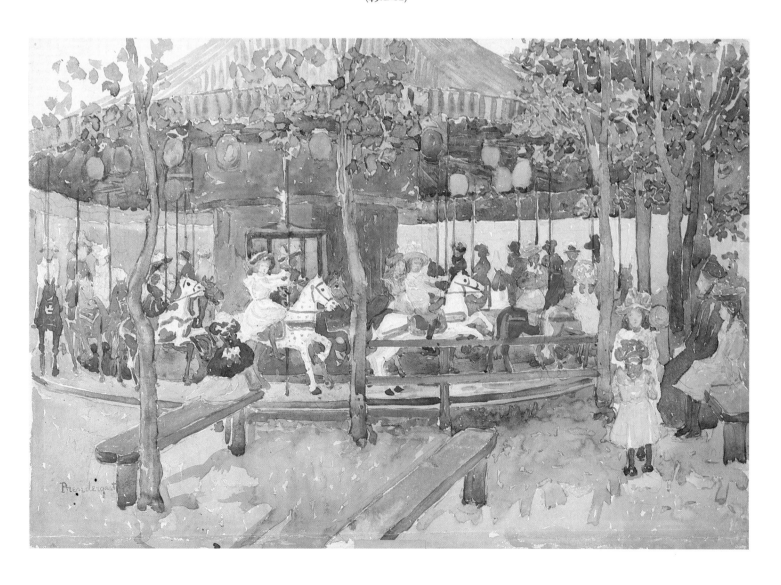

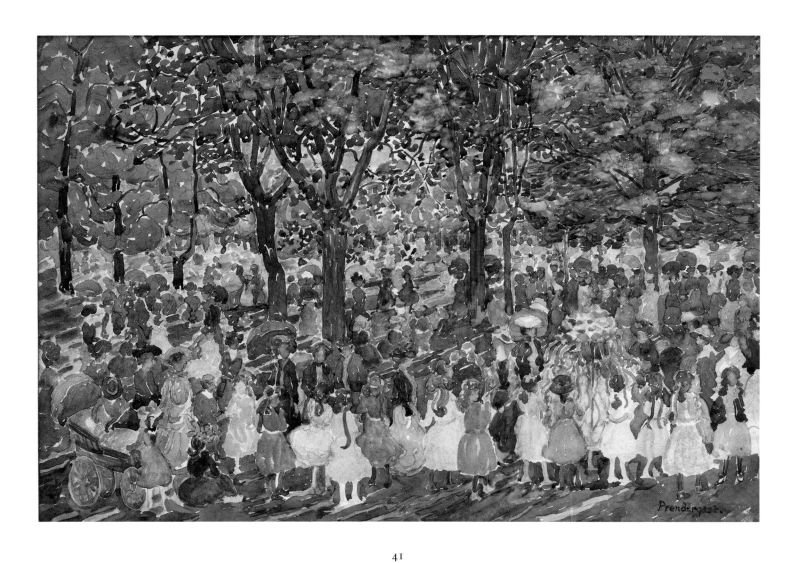

41
May Day, Central Park
ca. 1900–03
Watercolor and pencil on paper
(14¹/₂ x 21⁵/₈ in.; 36.8 x 54.9 cm)
Collection of Whitney Museum of American Art. Exchange
(48.19)

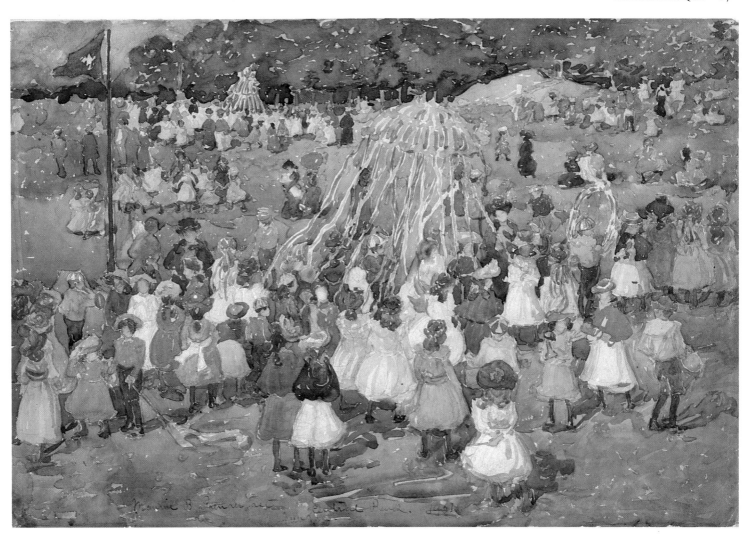

42
May Day, Central Park
1901
Watercolor and pencil on paper
(13⅞ x 19⅞ in.; 35.4 x 50.6 cm)
The Cleveland Museum of Art, Gift from J. H. Wade
(26.17)

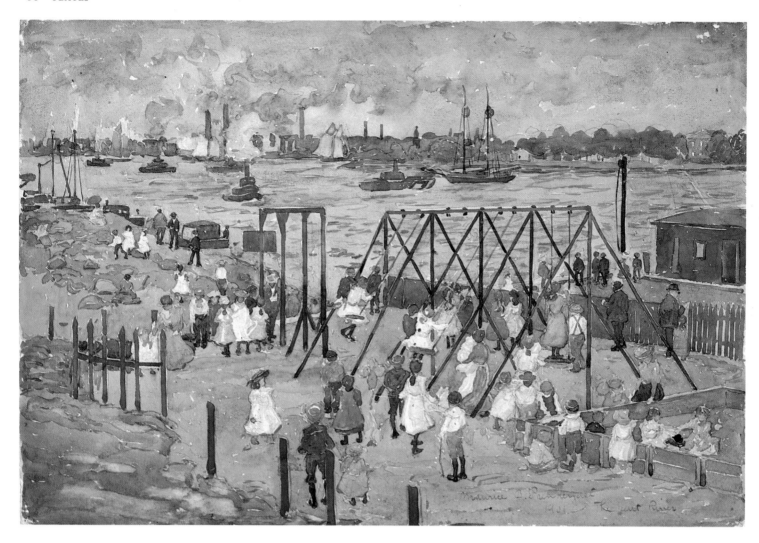

43
The East River

1901

Watercolor and pencil on paper

(13⁷/₈ x 20 in.; 35.2 x 50.8 cm)
Collection, The Museum of Modern Art, New York. Gift of
Abby Aldrich Rockefeller
(132.35)

44
Surf, Cohasset
ca. 1900–05
Watercolor and pencil on paper
($10^5/8$ x $14^7/8$ in.; 27.9 x 38.7 cm)
Collection of Mrs. Charles Prendergast

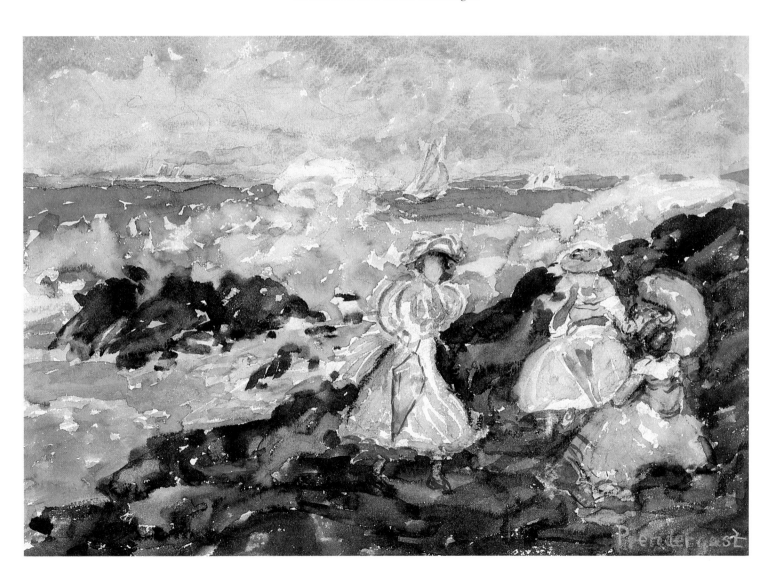

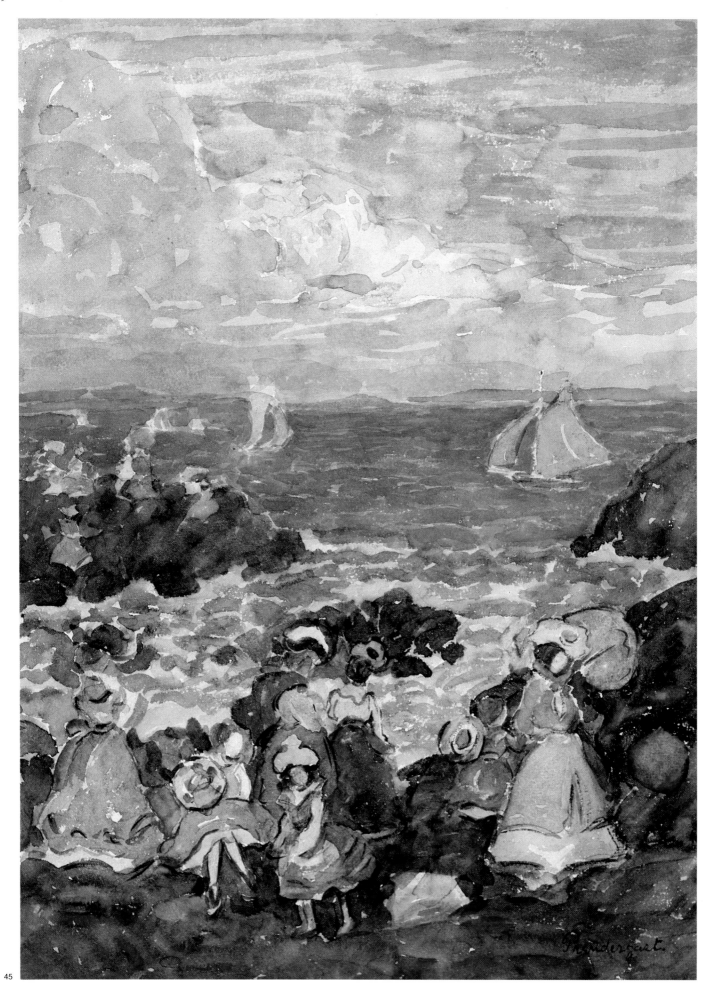

45

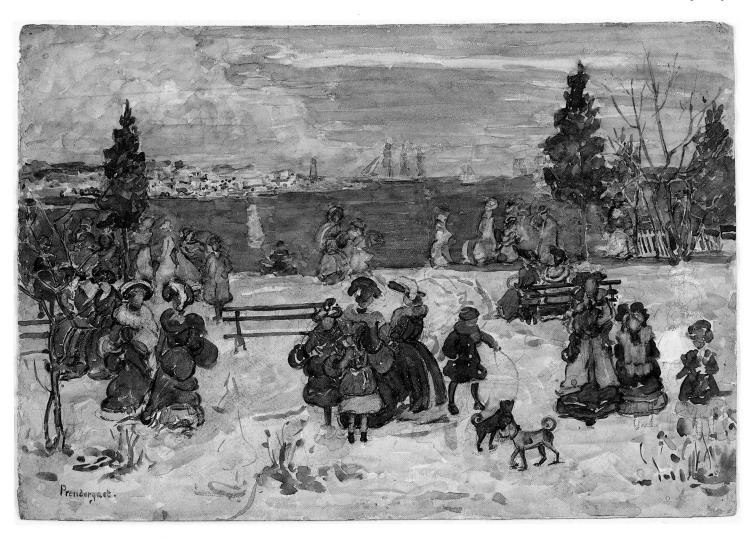

46
April Snow, Salem
ca. 1905-07
Watercolor, pencil and colored pencil on paper
(15¼ x 22⅛ in.; 38.7 x 56.2 cm)
Collection, The Museum of Modern Art, New York. Gift of
Abby Aldrich Rockefeller
(129.35)

45
Surf, Nantasket
ca. 1900-05
Watercolor and pencil on paper
(15⅜ x 11⅛ in.; 39.1 x 28.3 cm)
Williams College Museum of Art, Gift of Mrs. Charles
Prendergast
(86.18.60)

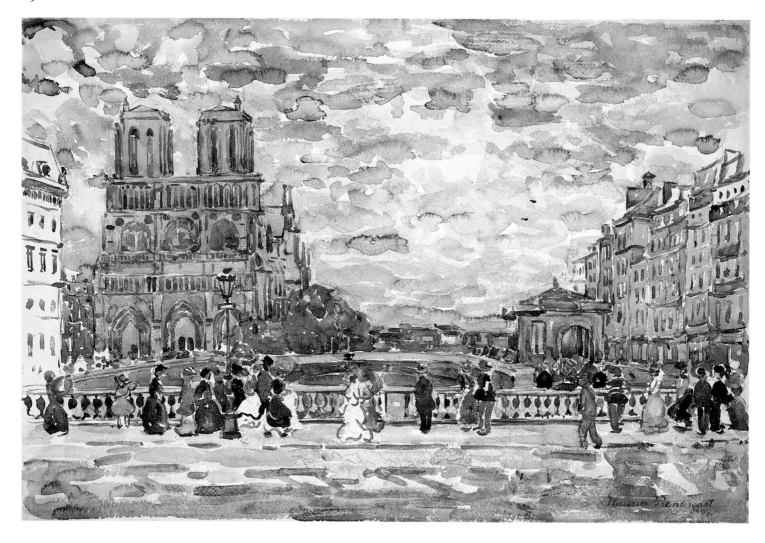

47
Notre Dame, Paris

ca. 1907
Watercolor and pencil on paper
(13⁷/₈ x 20 in.; 35.2 x 50.8 cm)
Worcester Art Museum, Worcester, MA
(1941.36)

48
Paris

ca. 1907
Watercolor and gouache on blue paper
(12¹/₄ x 9³/₄ in.; 31.1 x 24.8 cm; sight)
Collection of Mrs. Charles Prendergast

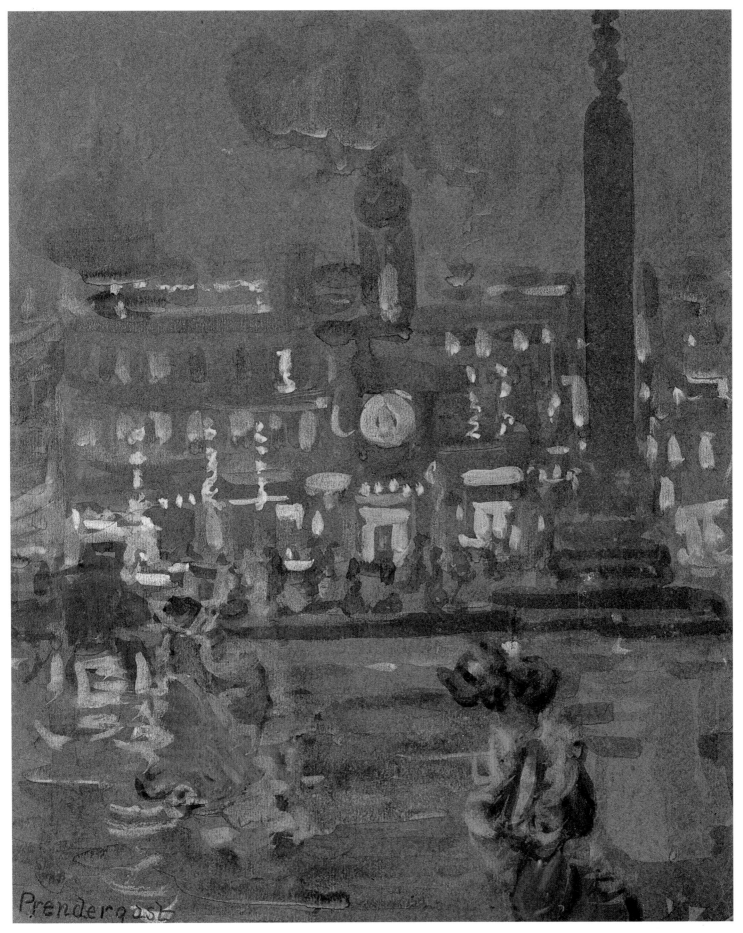

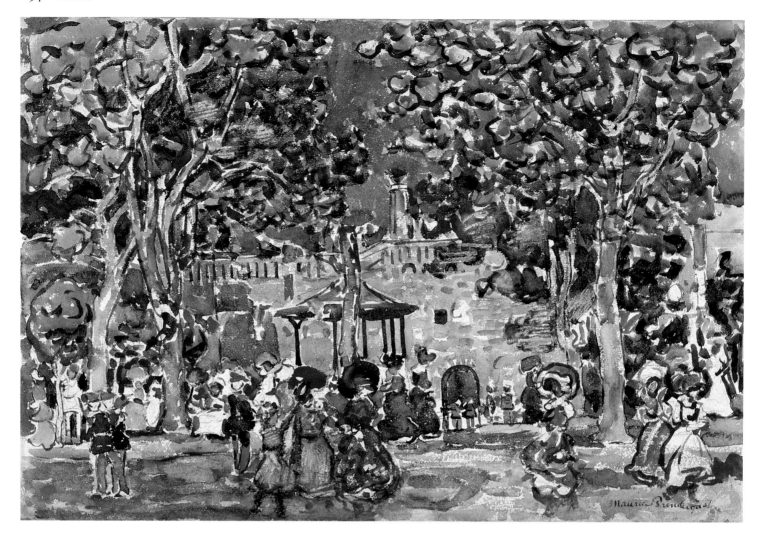

49
Band Concert
ca. 1907
Watercolor and pencil on paper
(13⅞ x 19¼ in.; 35.2 x 49.0 cm)
Mead Art Museum, Amherst College, Museum Purchase
(1951.336)

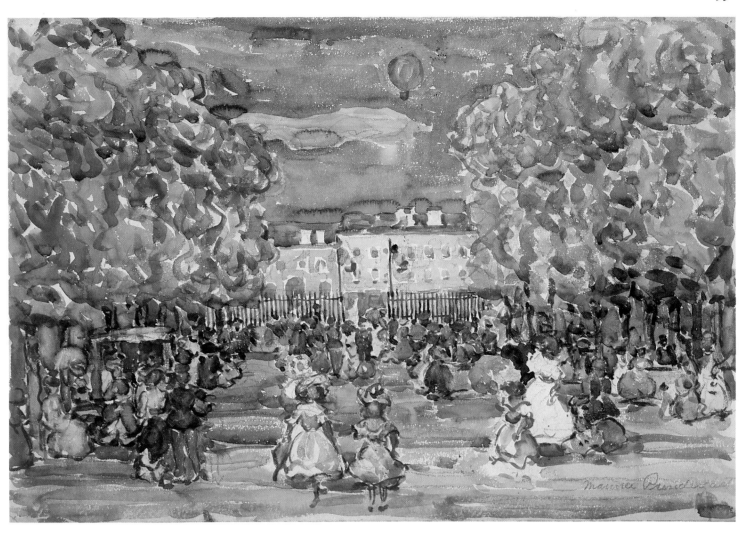

50

The Balloon

ca. 1907

Watercolor and pencil on paper

(13⅞ x 20 in.; 35.2 x 50.8 cm)

Addison Gallery of American Art, Phillips Academy,

Andover, Massachusetts, Gift of Anonymous Donor

(1928.50)

51
Paris Omnibus
ca. 1907
Oil on panel
(10¹/₄ x 13⁵/₈ in.; 26.0 x 34.6 cm)
Bucknell University
(1960.1.2)

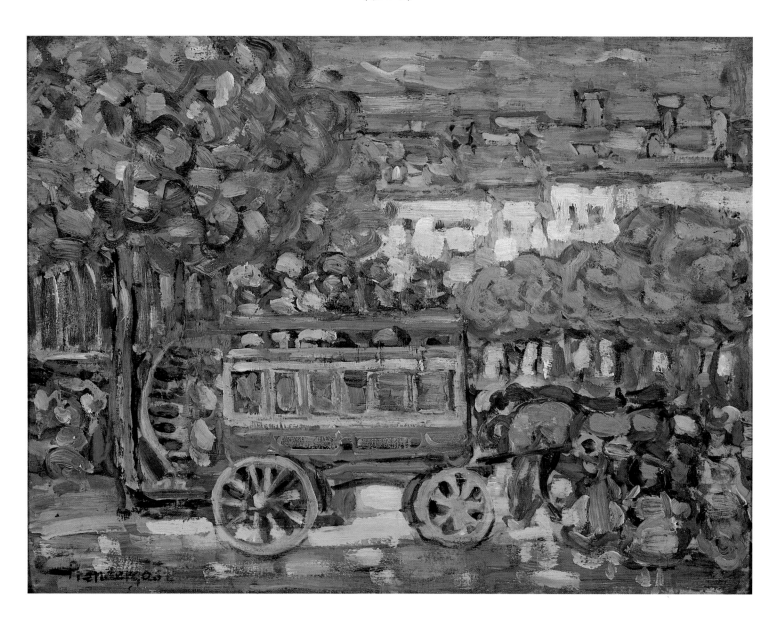

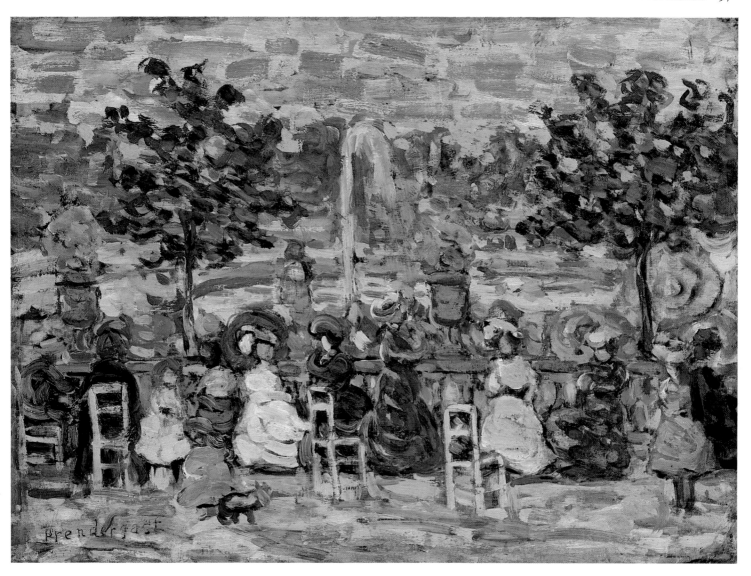

52
In Luxembourg Gardens
ca. 1907
Oil on panel
(10¹/₄ x 13³/₄ in.; 26.0 x 34.9 cm)
The Phillips Collection, Washington, D. C.
(1605)

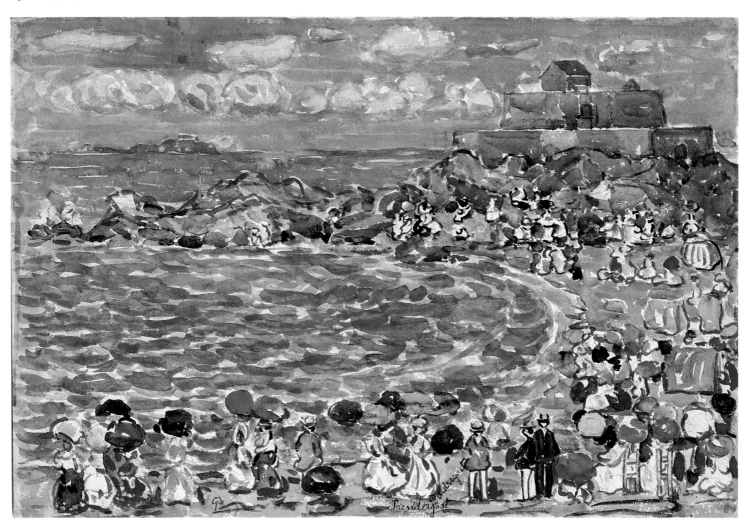

53
Beach, St. Malo
ca. 1907
Watercolor and charcoal on paper
(13³/₄ x 19⁷/₈ in.; 34.9 x 50.5 cm)
The Cleveland Museum of Art, Gift of William Mathewson
Milliken in memory of H. Oothout Milliken
(49.543)

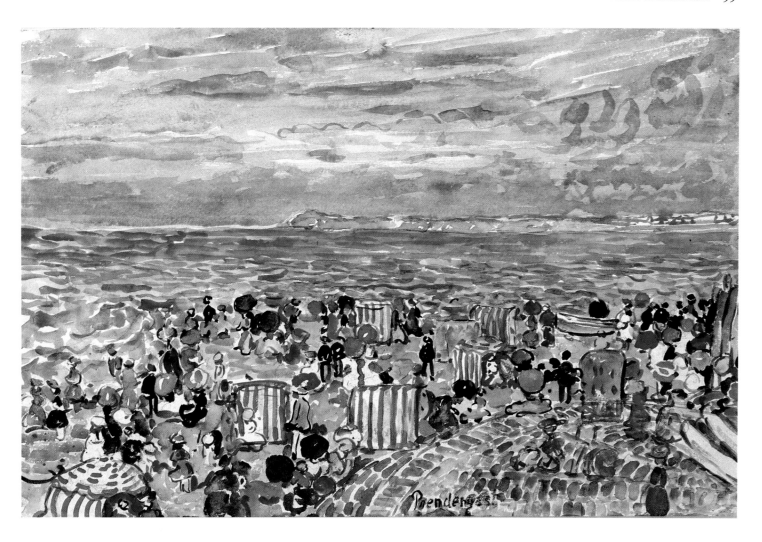

54
St. Malo No. 2
ca. 1907
Watercolor and crayon on paper
(12³/₄ x 19¹/₄ in.; 32.4 x 48.9 cm)
Columbus Museum of Art,
Ohio: Gift of Ferdinand Howald, 1931
(31.247)

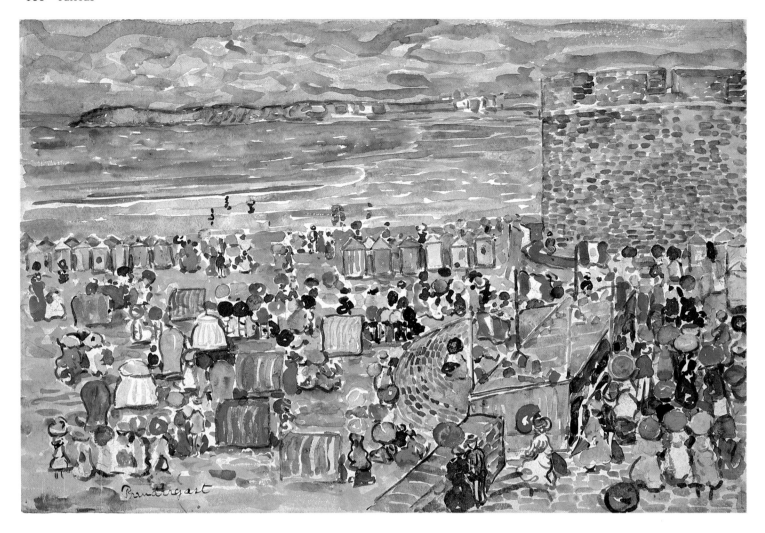

55
On the Beach, St. Malo

ca. 1907

Watercolor and pencil on paper

(13$^1/_2$ x 19$^7/_8$ in.; 34.3 x 50.5 cm)
Addison Gallery of American Art, Phillips Academy,
Andover, Massachusetts, Bequest of Miss L. P. Bliss
(1931.94)

56
Rising Tide, St. Malo

ca. 1907

Watercolor and pencil on paper

(18$^5/_8$ x 13$^1/_2$ in.; 47.3 x 34.3 cm)
Yale University Art Gallery, Gift of George Hopper Fitch,
B. A., 1932
(1978.125.1)

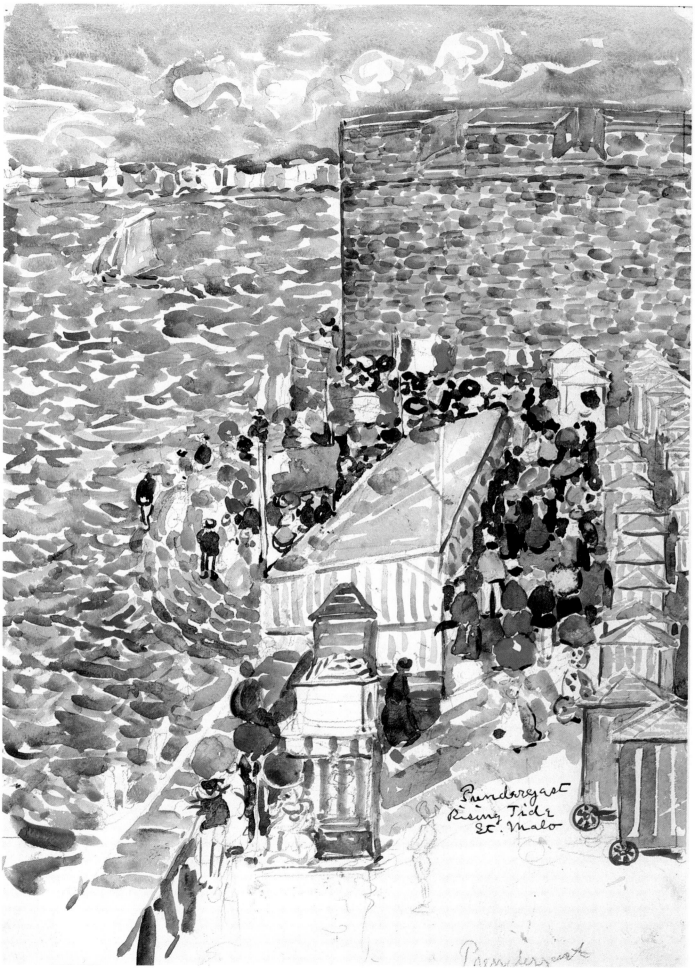

Prendergast
Rising Tide
St. Malo

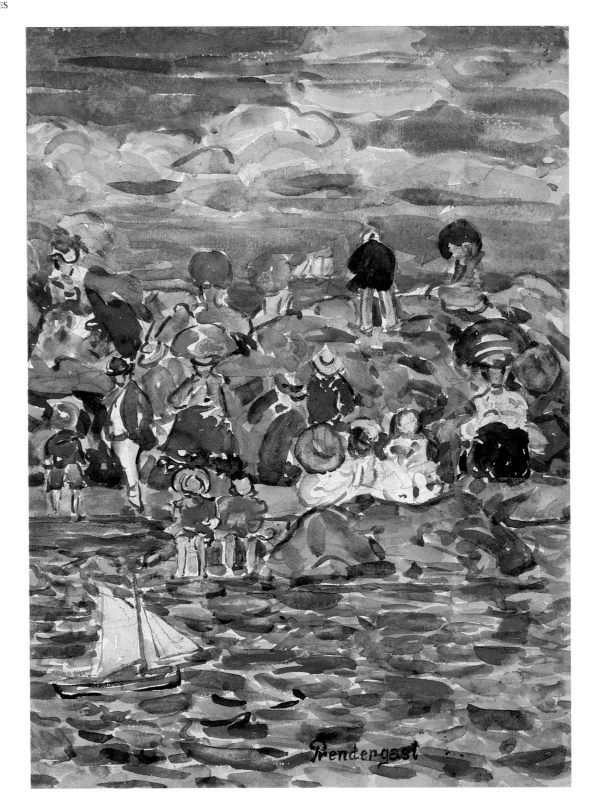

57
Beach, St. Malo
ca. 1907
Watercolor and pencil on paper
(15 x 10³/₄ in.; 38.1 x 27.3 cm)
Private Collection

58
St. Malo
ca. 1907
Watercolor, pencil and gouache on paper
(15¹/₄ x 11 in.; 38.7 x 27.9 cm)
Williams College Museum of Art,
Gift of Mrs. Charles Prendergast
(86.18.74)

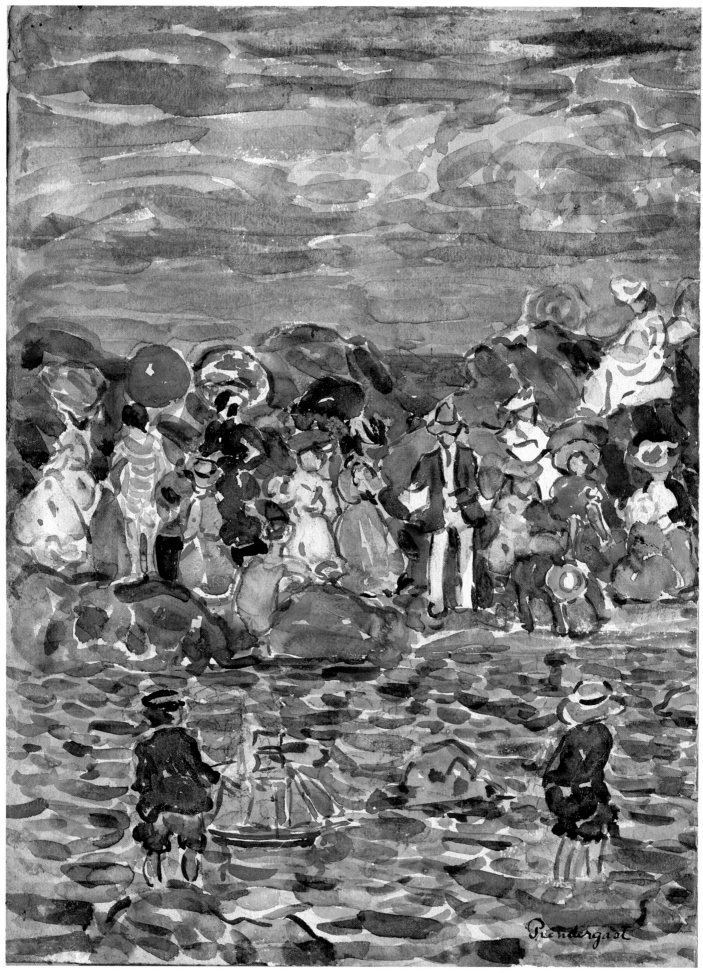

58

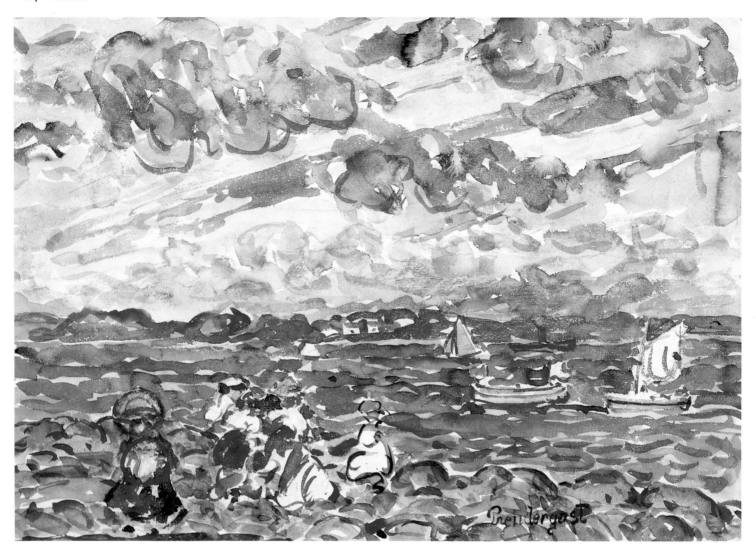

59
St. Malo
ca. 1907
Watercolor and pencil on paper
(11¼ x 15¼ in.; 28.6 x 38.7 cm)
Williams College Museum of Art,
Gift of Mrs. Charles Prendergast
(86.18.75)

60
Lighthouse at St. Malo
ca. 1907
Oil on canvas
(20¹/₈ x 24⁵/₈ in.; 51.1 x 62.6 cm)
The William Benton Museum of Art, The University of
Connecticut. Gift of Mrs. Eugénie Prendergast
(72.31)

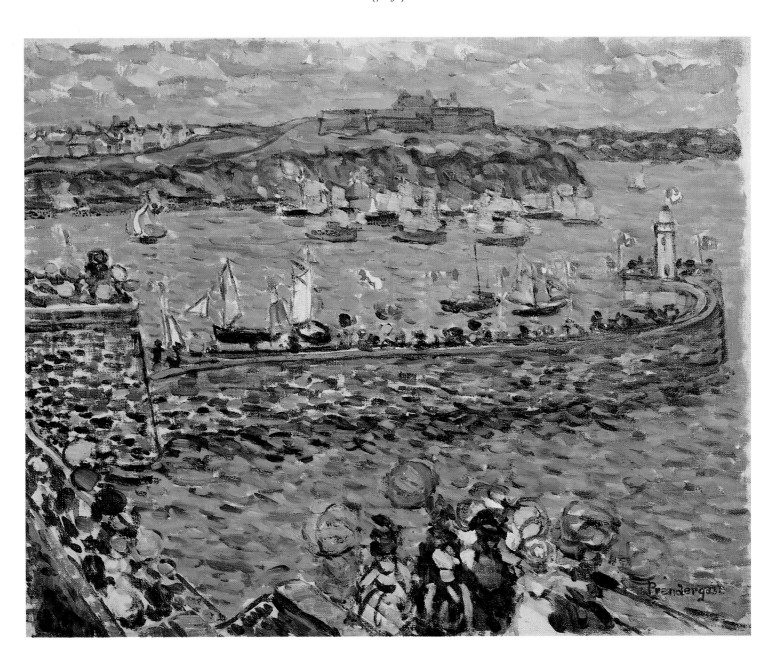

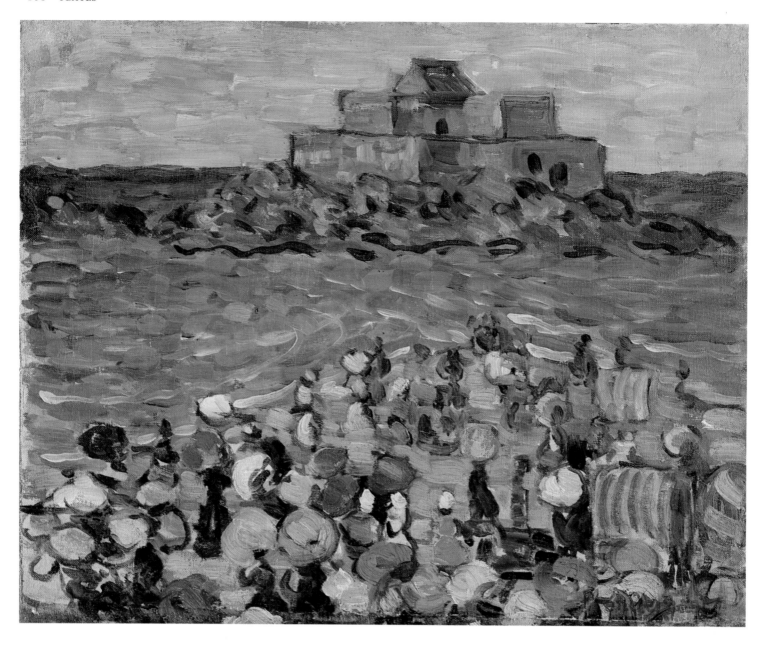

61
Chateaubriand's Tomb, St. Malo

ca. 1907

Oil on canvas

(11½ x 14½ in.; 29.2 x 36.8 cm)
Mr. and Mrs. Bob London

62

St. Malo

ca. 1903–06

Oil on panel

(10¹/₂ x 13³/₄ in.; 26.7 x 34.9 cm)

The Cleveland Museum of Art, Mr. and Mrs. Charles
G. Prasse Collection
(82.162)

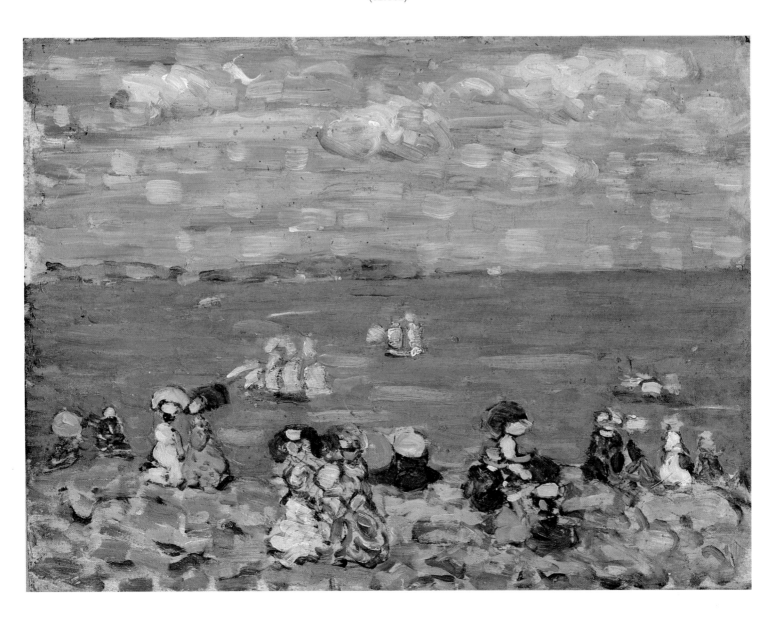

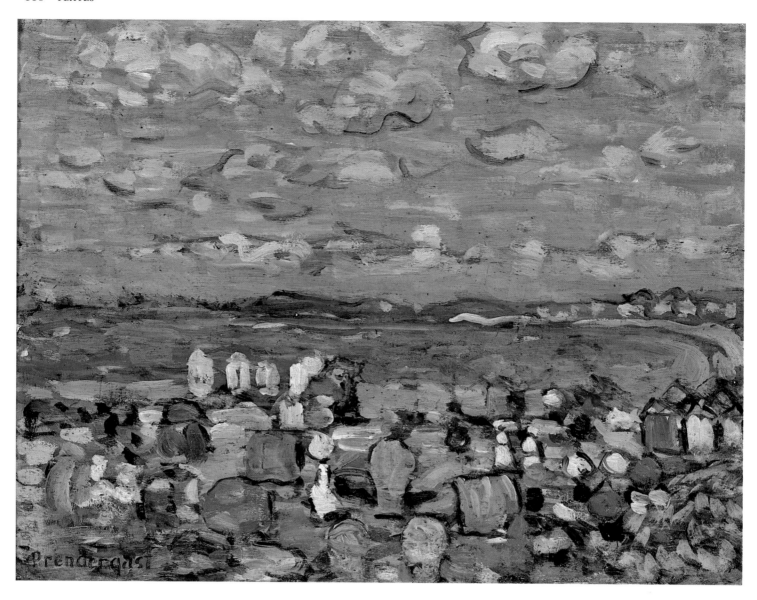

63
Crescent Beach
ca. 1907
Oil on panel
(10¼ x 13½ in.; 26 x 34.1 cm)
Bucknell University
(1960.1.3)

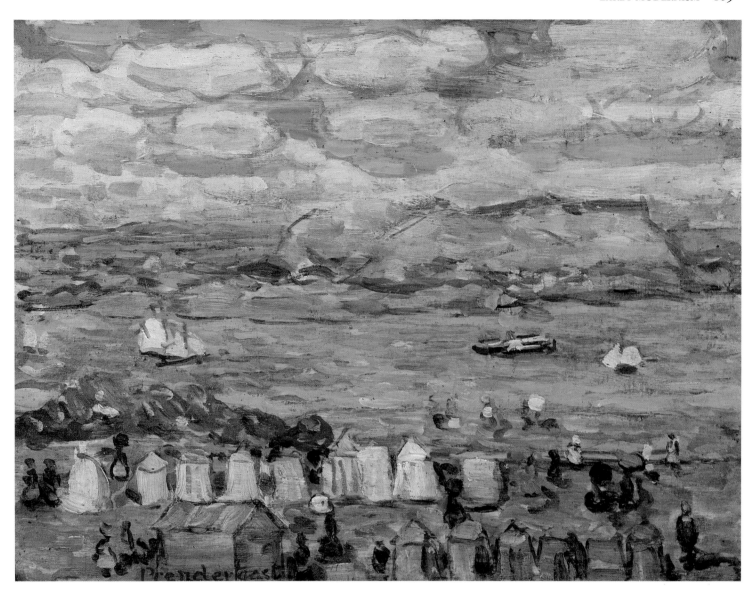

64
Study St. Malo No. 11
ca. 1907
Oil on panel
(10¹/₂ x 13³/₄ in.; 26.7 x 34.9 cm)
Private Collection

65
Study St. Malo, No. 12
ca. 1907
Oil on panel
(10¹/₂ x 13³/₄ in.; 26.7 x 34.9 cm)
Collection of Mrs. Charles Prendergast

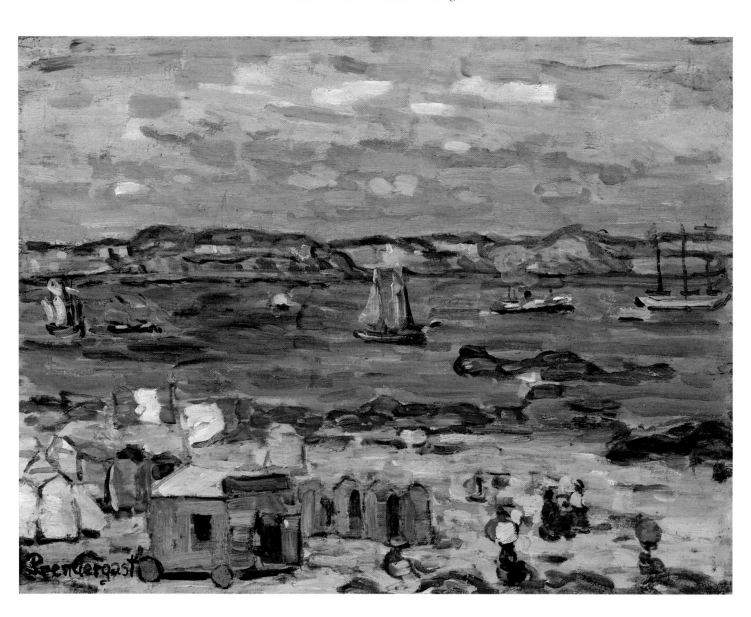

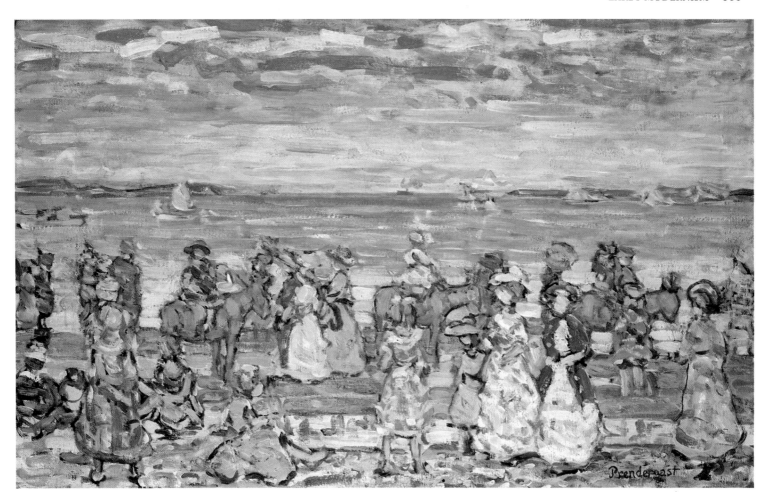

66

Opal Sea

ca. 1907–10

Oil on canvas

(22 x 34 in.; 55.9 x 86.4 cm)
© Daniel J. Terra Collection,
Terra Museum of American Art, Chicago
(30.1980)

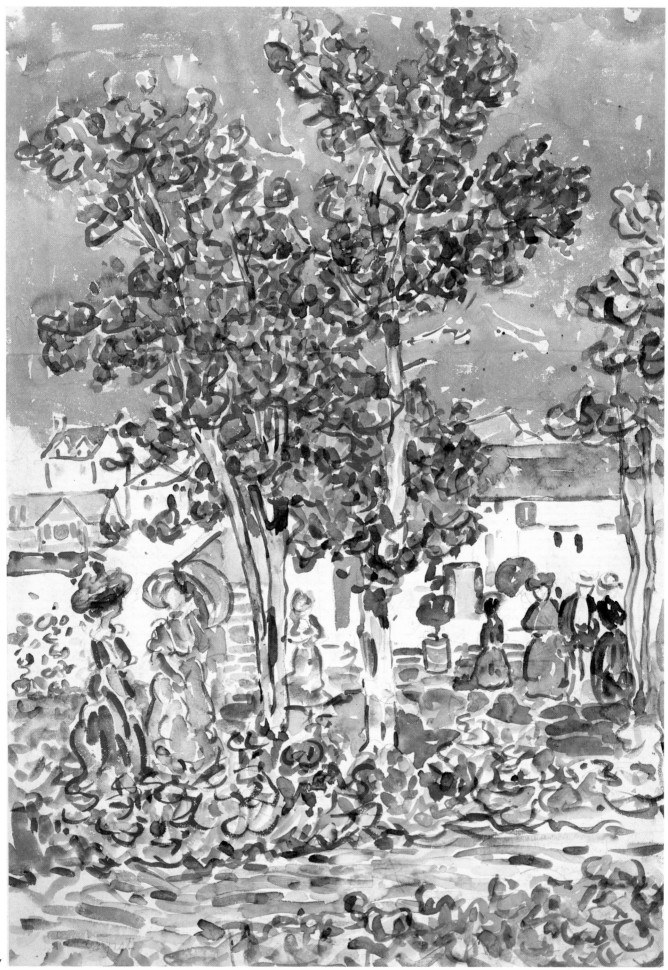

67

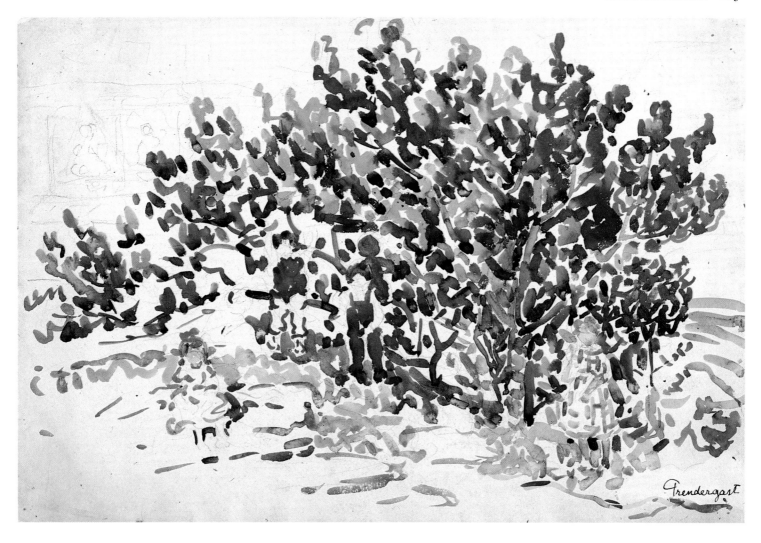

68
Children in the Tree
ca. 1910-11
Watercolor and pencil on paper
(15¹/₈ x 22¹/₄ in.; 38.4 x 56.5 cm)
Collection of Mrs. Charles Prendergast

67
Spring Promenade
ca. 1910-11
Watercolor and pencil on paper
(21⁵/₈ x 14⁷/₈ in.; 54.9 x 37.8 cm; sight)
Williams College Museum of Art,
Gift of Mrs. Charles Prendergast
(86.18.6)

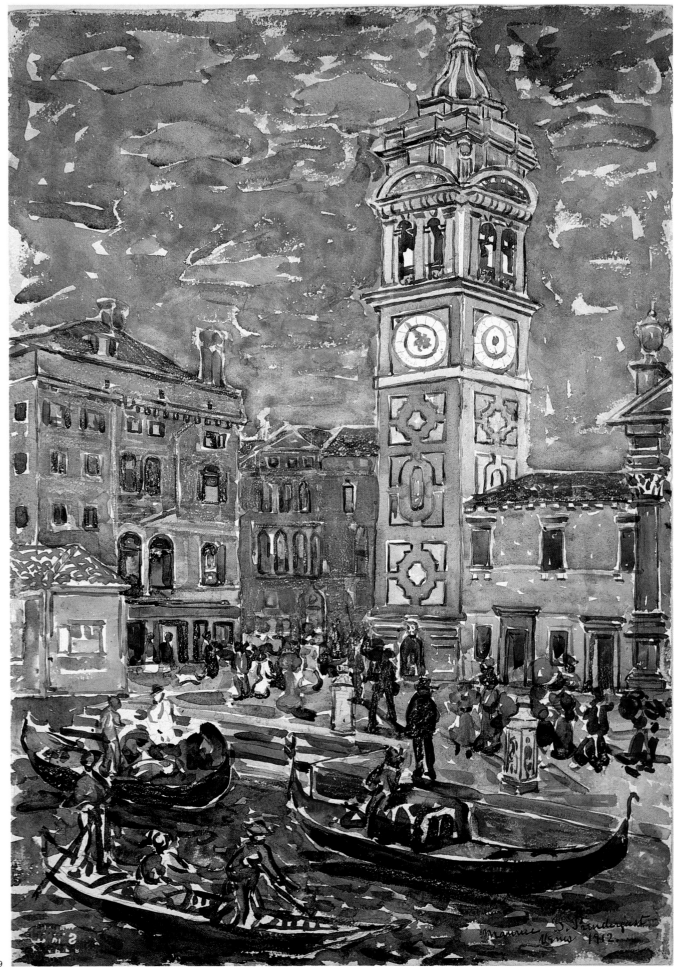

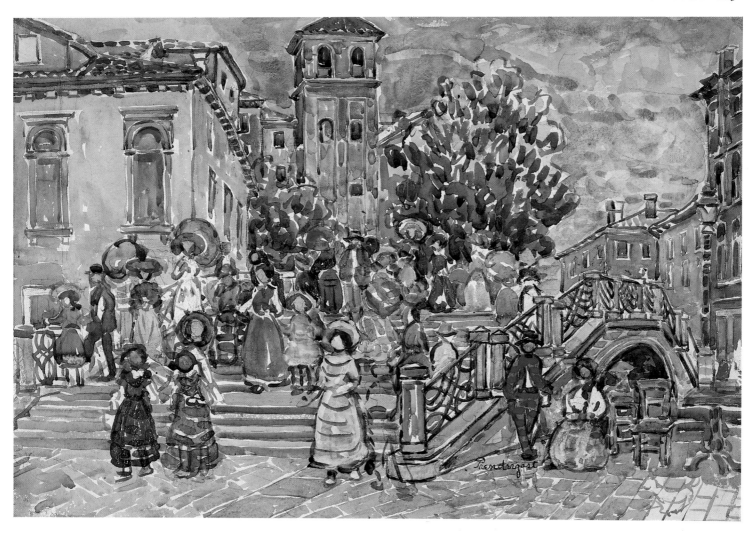

70

Venice

ca. 1911–12

Watercolor and pencil on paper

(14⁵/₈ x 21¹/₄ in.; 37.5 x 34.5 cm)
Columbus Museum of Art,
Ohio: Gift of Ferdinand Howald, 1931
(31.251)

69

Santa Maria Formosa, Venice

ca. 1911–12

Watercolor and pencil on paper

(22 x 15¹/₄ in.; 55.8 x 38.9 cm)
Museum of Fine Arts, Boston, Charles Henry Hayden Fund
(59.58)

71
Canal
ca. 1911-12
Watercolor and pencil on paper
(15³/₈ x 22 in.; 39.1 x 55.9 cm)
Munson-Williams-Proctor Institute Museum of Art, Utica,
New York, Edward W. Root Bequest
(57.213)

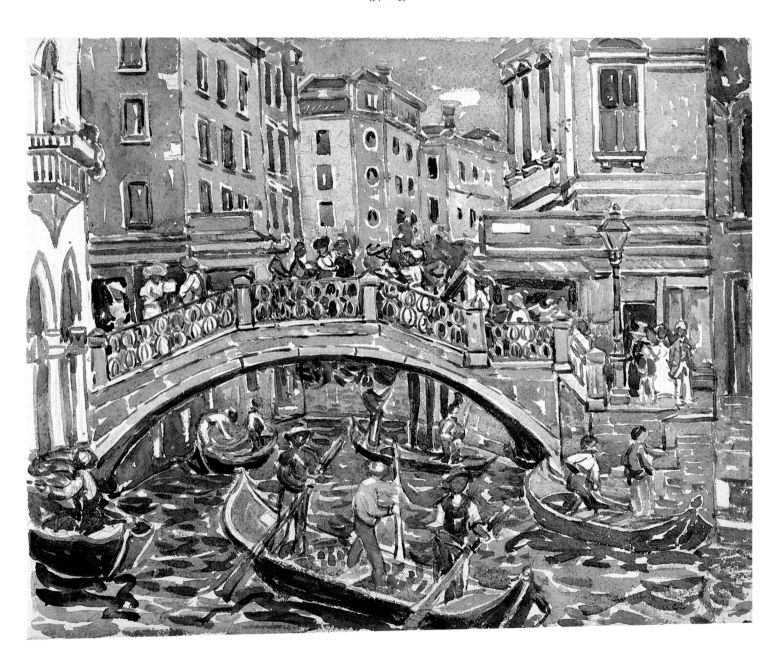

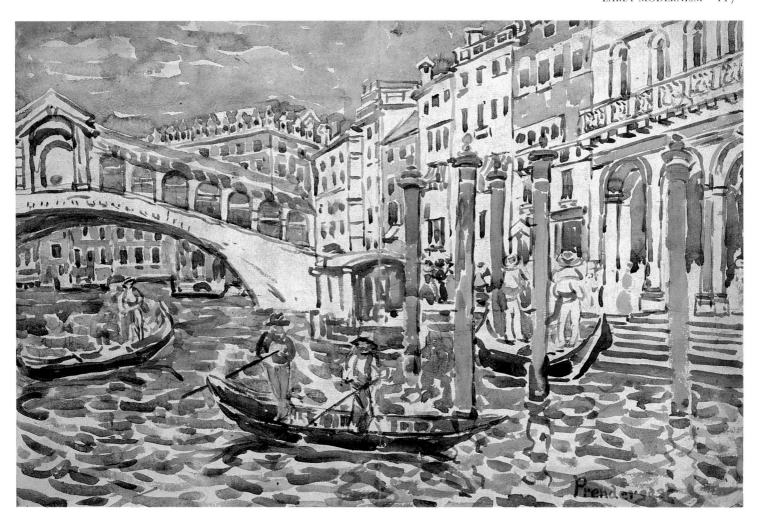

72

Rialto, Venice

ca. 1911–12

Watercolor and pencil on paper

(14⁷/₈ x 21⁵/₈ in.; 38.1 x 55.9 cm)

Williams College Museum of Art,

Gift of Mrs. Charles Prendergast

(86.18.79)

73
Still Life: Fruit and Flowers

ca. 1910-13

Oil on canvas

(18^1/$_2$ x 21^1/$_2$ in.; 47.0 x 54.6 cm)
Collection of The Montclair Art Museum, Museum Purchase,
Florence O. R. Lang Fund.

(54.20)

74
Still Life

ca. 1910–13

Oil on canvas

(16 x 20¹/₄ in.; 40.6 x 51.4 cm)
Collection of Mrs. John W. Griffith

75
La Rouge: Portrait of Miss Edith King
ca. 1910–13
Oil on canvas
(28¹/₂ x 31¹/₂ in.; 72.4 x 80.0 cm)
Lehigh University Art Galleries – Museum Operation,
Bethlehem, Pennsylvania.
The Anna E. Wilson Memorial Collection
(LUP56.1007)

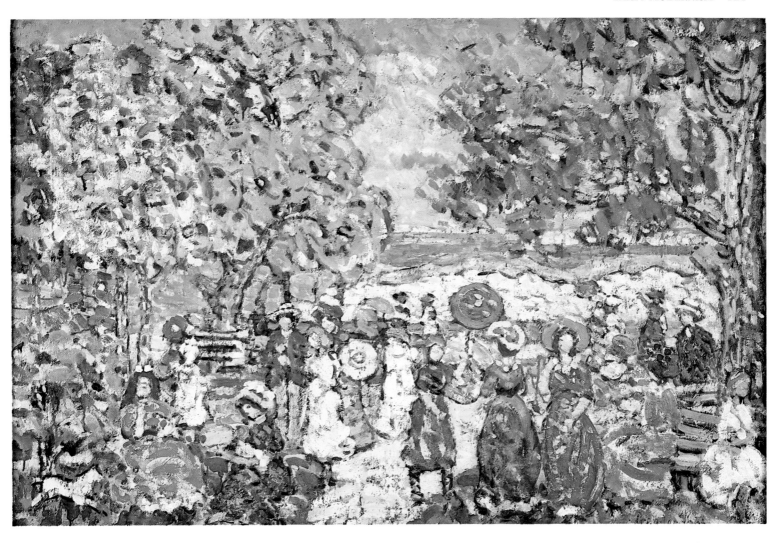

76
Landscape with Figures
ca. 1910–13
Oil on canvas
(29⅝ x 42⅞ in.; 75.2 x 108.9 cm)
Munson–Williams–Proctor Institute Museum of Art, Utica,
New York, Edward W. Root Bequest
(57.212)

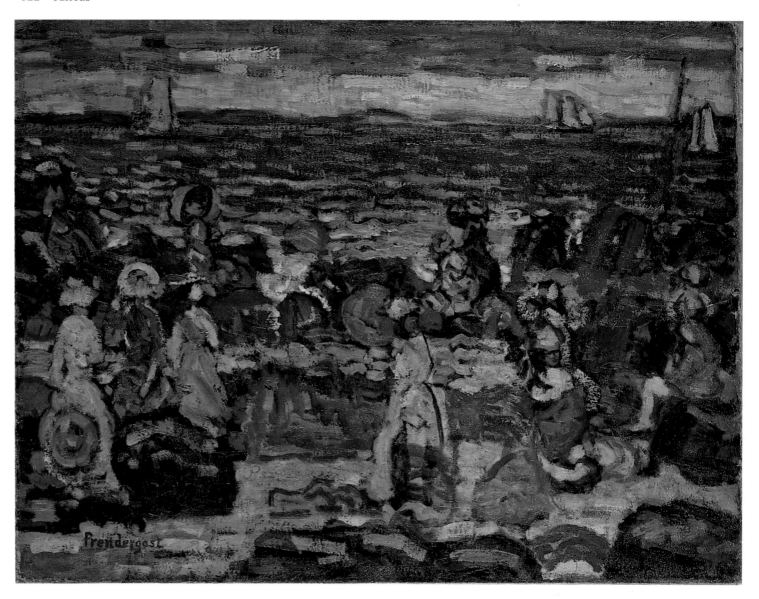

77

A Dark Day

ca. 1910–13

Oil on canvas

(21¹/₄ x 27³/₈ in.; 53.3 x 68.6 cm)
Hirshhorn Museum and Sculpture Garden, Smithsonian
Institution. Gift of the Joseph H. Hirshhorn Foundation, 1966
(66.4129)

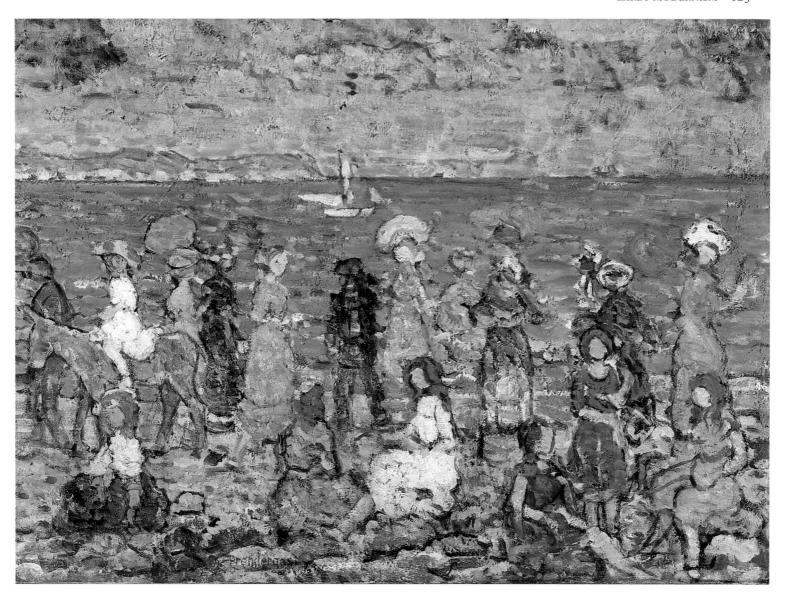

78

Seashore

ca. 1913

Oil on canvas

(24 x 32 in.; 61.0 x 81.3 cm)

The Saint Louis Art Museum, Purchase: Eliza McMillan Fund

(33.1948)

79
Boat Landing, Dinard
ca. 1914
Watercolor, gouache and charcoal on paper
(15¹/₄ x 22¹/₄ in.; 38.7 x 57.1 cm)
Williams College Museum of Art,
Gift of Mrs. Charles Prendergast
(86.18.71)

80
Marblehead
ca. 1914–15
Watercolor, pencil, charcoal and pastel on paper
(11 1/2 x 18 in.; 29.2 x 45.7 cm)
Williams College Museum of Art,
Gift of Mrs. Charles Prendergast
(86.18.5)

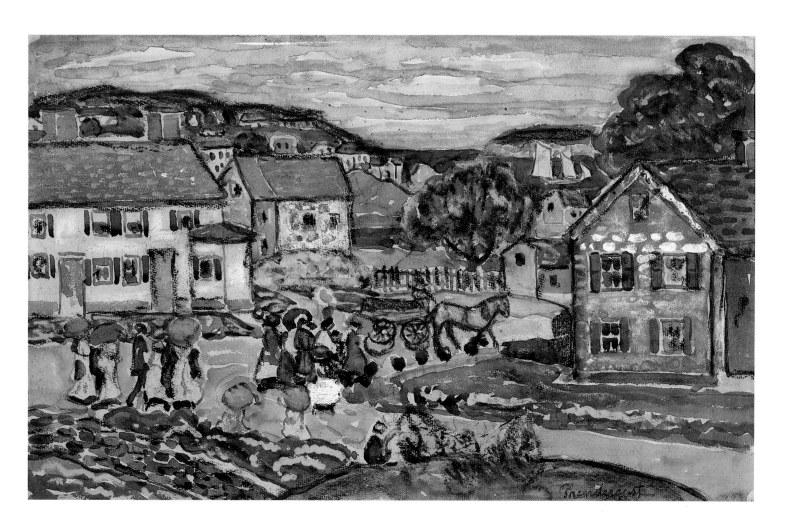

81
New England Harbor
ca. 1919–23
Oil on canvas
(24 x 28 in.; 61.0 x 71.1 cm)
Cincinnati Art Museum;
the Edwin and Virginia Irwin Memorial
(1959.51)

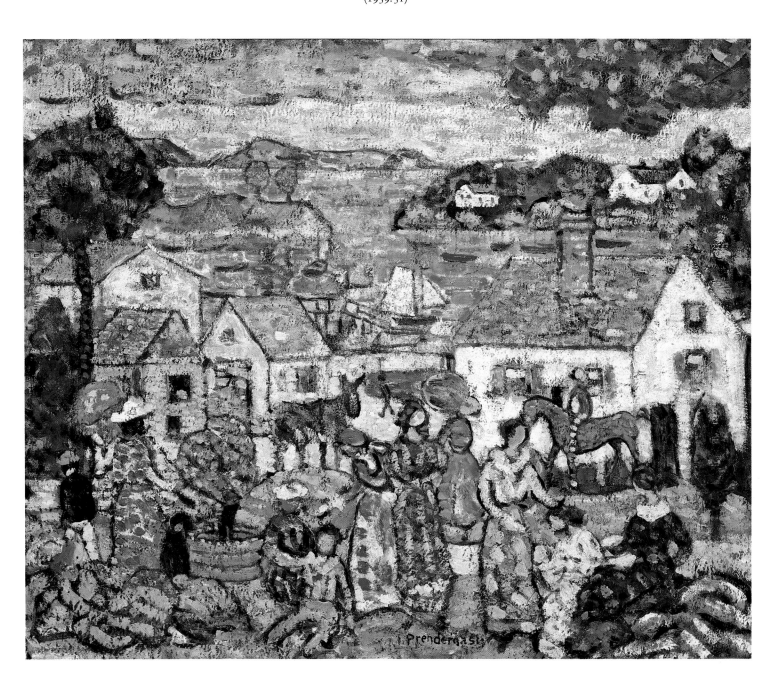

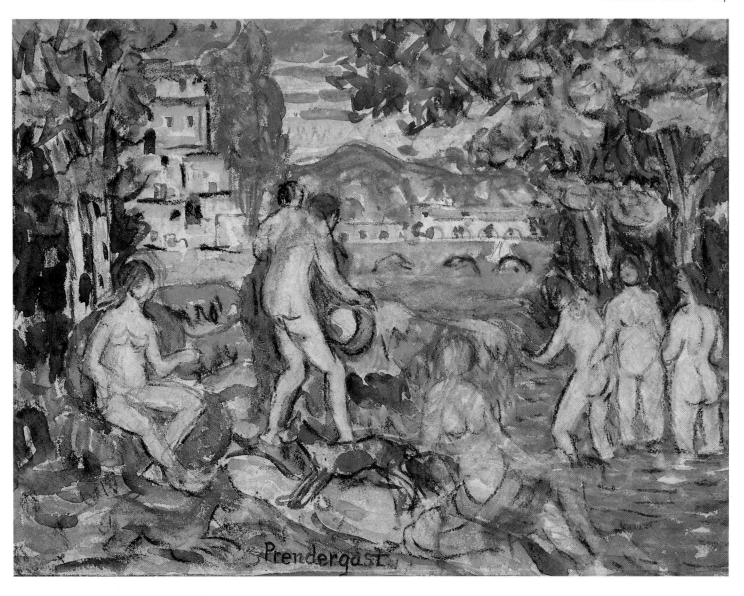

82
Bathers
ca. 1912–15
Watercolor and pastel on paper
(14¹/₂ x 18¹/₂ in.; 36.8 x 47.0 cm)
Williams College Museum of Art,
Gift of Mrs. Charles Prendergast
(86.18.9)

83
The Promenade
ca. 1913
Oil on canvas
(30 x 34 in.; 76.2 x 86.4 cm)
Collection of Whitney Museum of American Art. Alexander
M. Bing Bequest
(60.10)

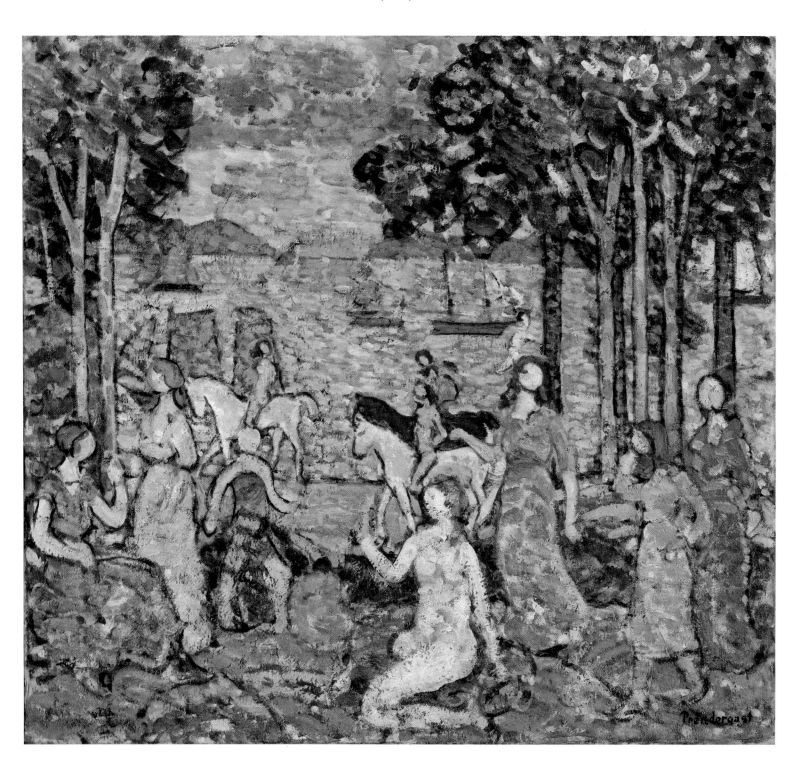

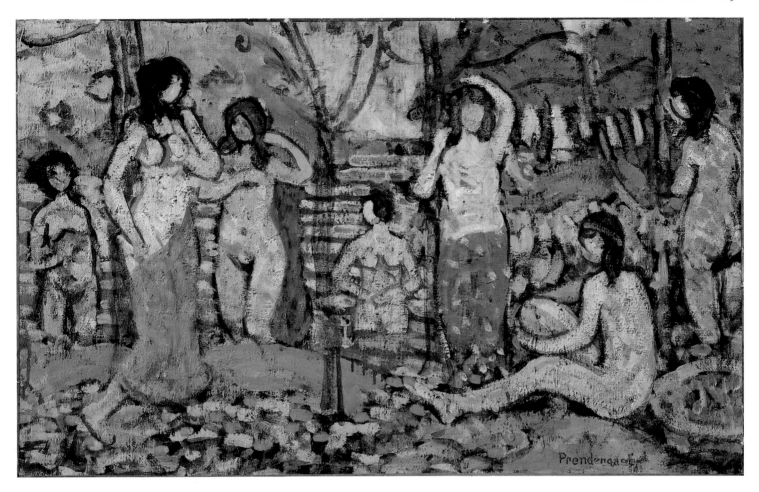

84
Beach No. 3

ca. 1913

Oil on canvas

(18⁷/₈ x 29⁷/₈ in.; 47.9 x 75.9 cm)
The Metropolitan Museum of Art, Bequest of Miss Adelaide
Milton de Groot, 1967.
(67.187.135)

85
Figures in Landscape
1912–15
Watercolor, charcoal, pastel and pencil on paper
(13$\frac{1}{2}$ x 19$\frac{1}{2}$ in.; 34.3 x 49.5 cm; sight)
Collection of Mrs. Charles Prendergast

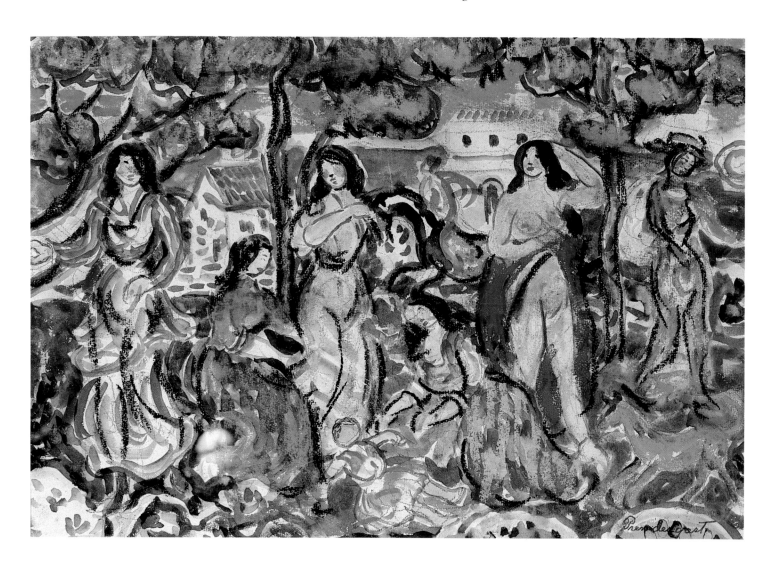

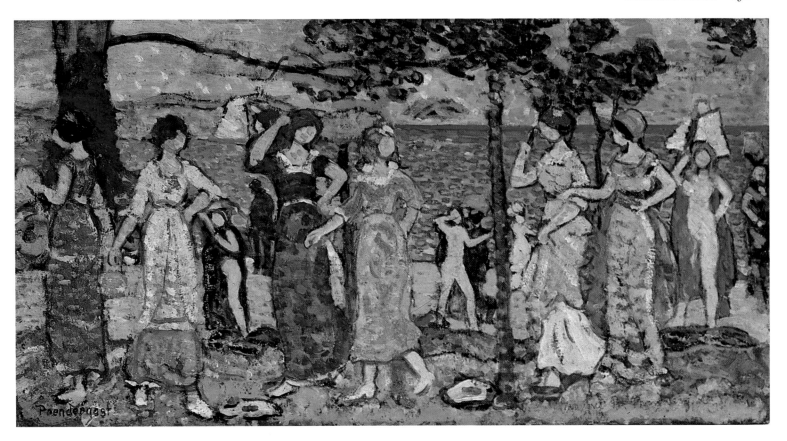

86
Women at Seashore
ca. 1914–15
Oil on panel
(17 x 32 in.; 43.2 x 81.3 cm)
The Carnegie Museum of Art, Pittsburgh; Bequest of Edward
Duff Balken, 1960
(60.42)

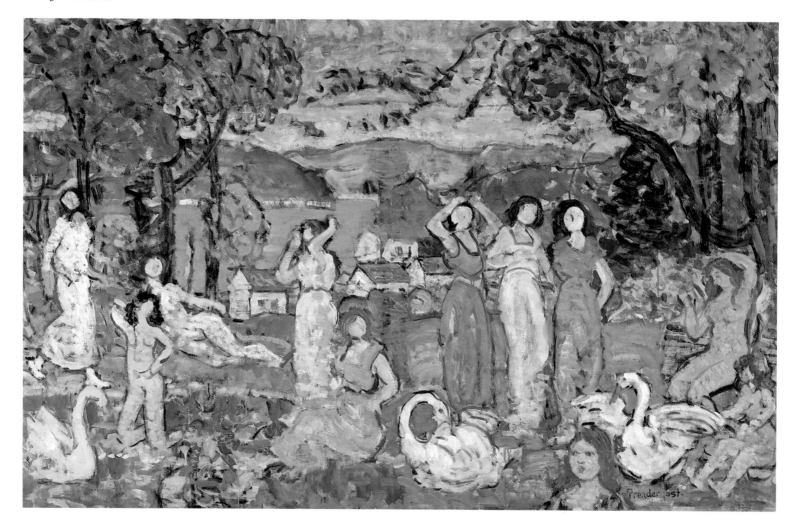

87

The Picnic

ca. 1914–15

Oil on canvas

(37 x 57 in.; 94.0 x 144.8 cm)
National Gallery of Canada, Ottawa
(4528)

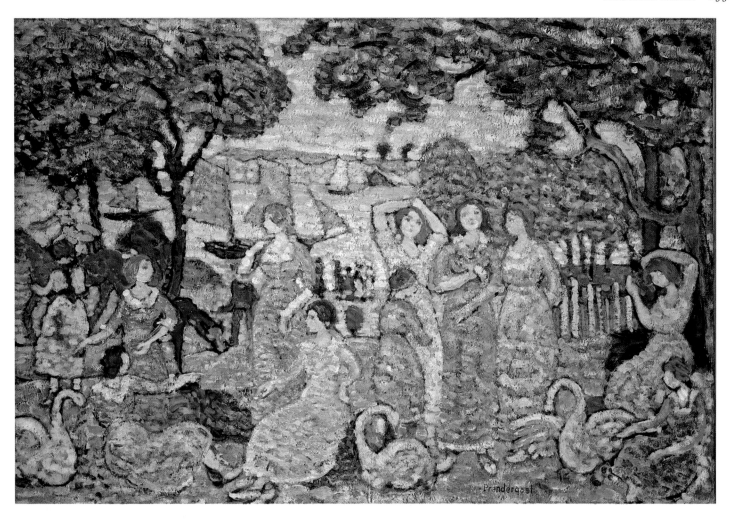

88

The Swans

ca. 1914-15

Oil on canvas

(30¹/₄ x 43¹/₈ in.; 76.8 x 189.5 cm; sight)
Addison Gallery of American Art, Phillips Academy,
Andover, Massachusetts, Bequest of Miss L. P. Bliss
(1931.95)

89
Sea Maidens
ca. 1910–13
Watercolor, pencil and pastel on paper
(13⁷/₈ x 19⁷/₈ in.; 35.2 x 50.5 cm)
Private Collection

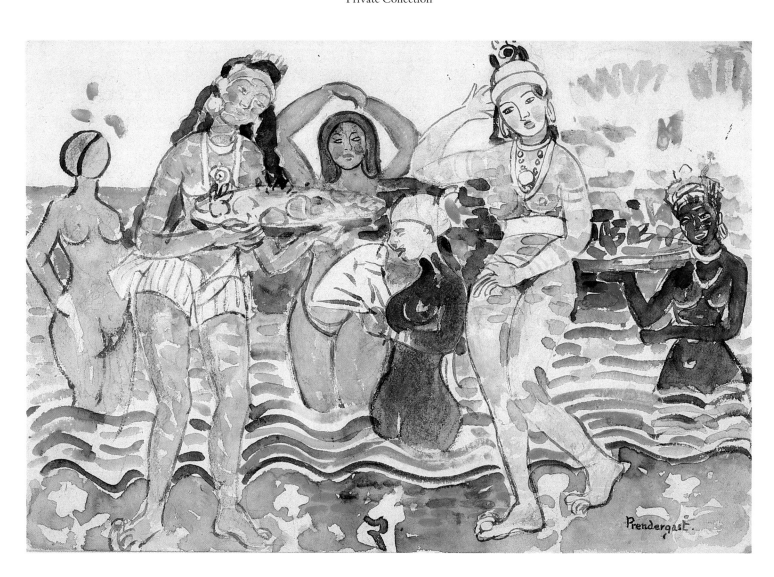

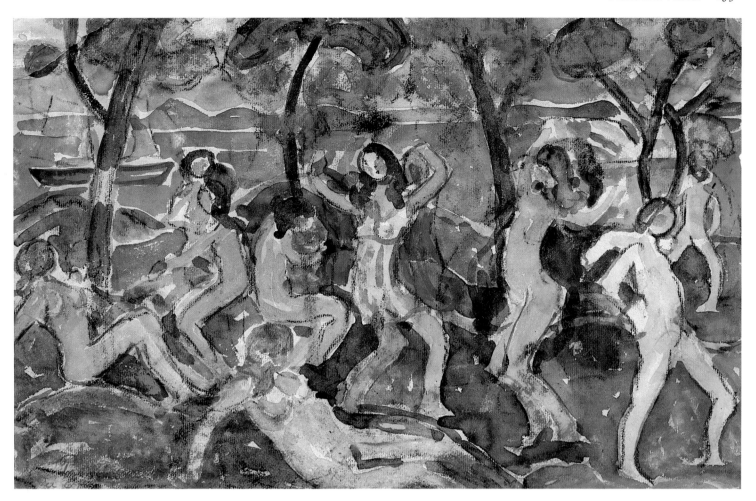

90
Bathers
ca. 1912–15
Watercolor and pencil on paper
(11³/₈ x 17¹/₂ in.; 28.9 x 44.5 cm)
The William Benton Museum of Art, The University of
Connecticut. Gift of the Eugénie Prendergast Foundation
(74.8.2)

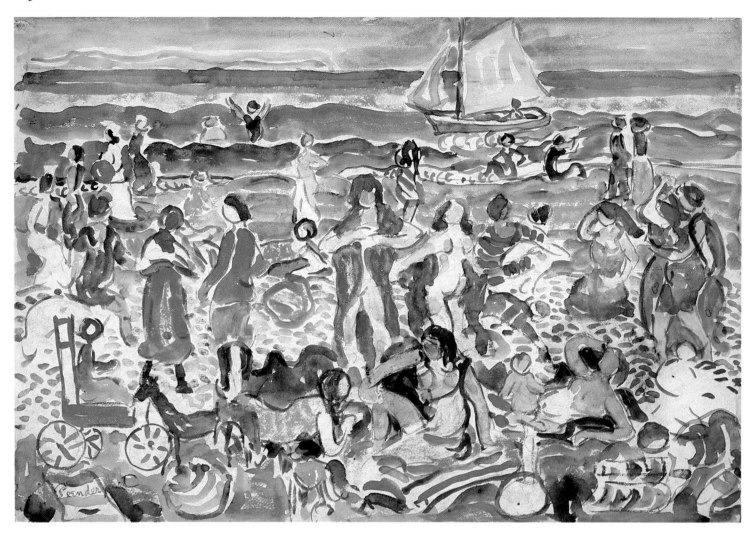

91
Bathers
ca. 1916-19
Watercolor, pencil, pastel and black chalk on paper
(13⁷/₈ x 19⁷/₈ in.; 35.2 x 50.3 cm)
The Saint Louis Art Museum, Gift of Mr. and Mrs.
G. Gordon Hertslet
(55.1967)

92
Fantasy
ca. 1914–15
Oil on panel
(22 x 26 in.; 55.8 x 66.0 cm)
Williams College Museum of Art,
Gift of Mrs. Charles Prendergast
(85.45)

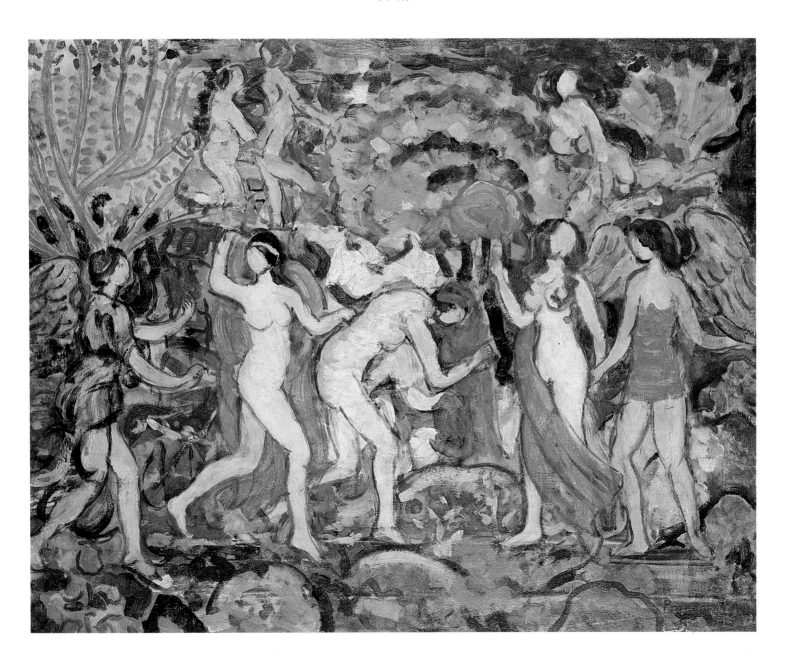

93
Blue Mountains
ca. 1914-15
Oil on canvas
(16¹/₄ x 25⁵/₈ in.; 41.3 x 65.1 cm)
Collection of Mrs. Charles Prendergast

94
Rider Against Blue Hills
ca. 1914–15
Oil on canvas
(20 x 30¹/₄ in.; 50.8 x 76.8 cm)
Williams College Museum of Art,
Gift of Mrs. Charles Prendergast
(86.18.10)

95
Sunset

ca. 1915–18

Oil on canvas

(21 x 32 in.; 53.3 x 81.3 cm; sight)
Museum of Fine Arts, Boston. Purchased by Exchange
(1989.228)

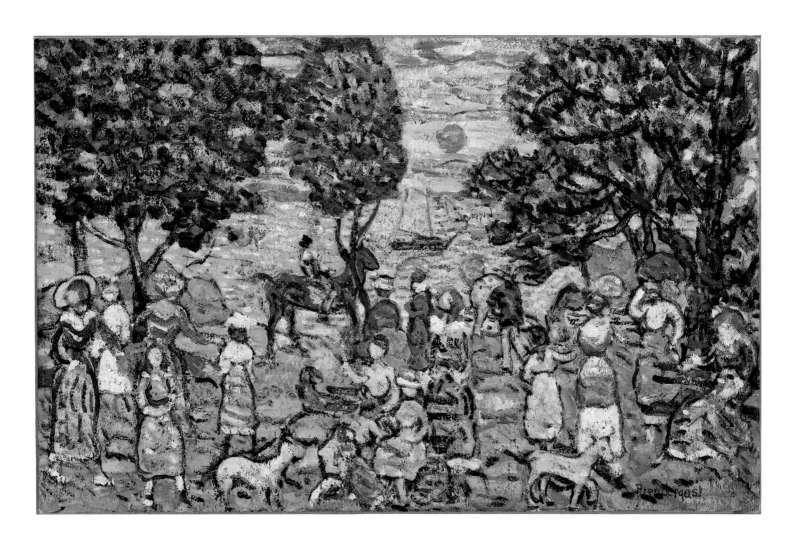

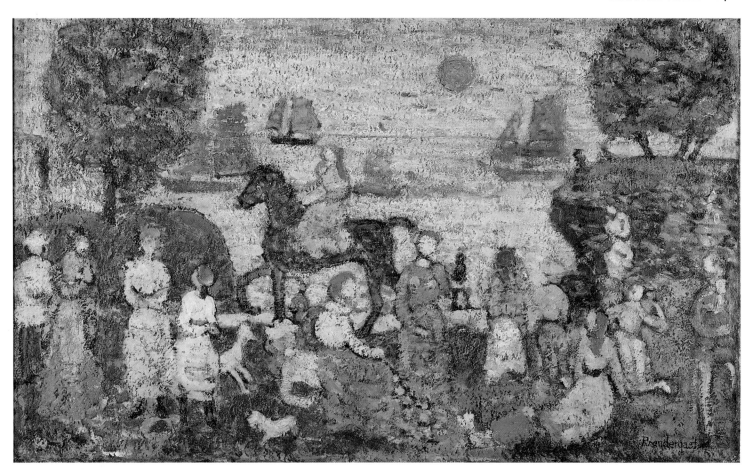

96
Sunset and Sea Fog
ca. 1918–23
Oil on canvas
(18 x 29 in.; 45.7 x 73.7 cm)
The Butler Institute of American Art, Youngstown, Ohio
(955-O-128)

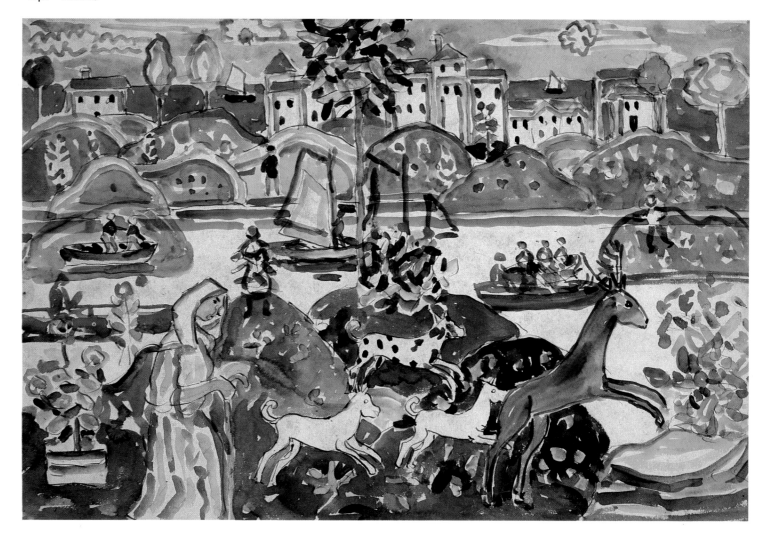

97
Fantasy
ca. 1912–15
Watercolor, pencil and ink on paper
(13³/₄ x 19¹/₂ in.; 34.9 x 50.8 cm)
Williams College Museum of Art,
Gift of Mrs. Charles Prendergast
(83.20.2)

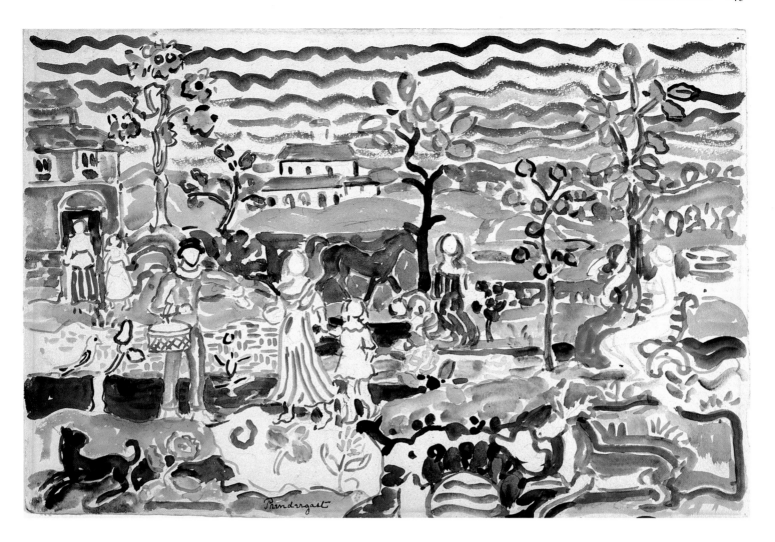

98
Decorative Composition
ca. 1913–15
Watercolor and pencil on paper
(13¹/₂ x 20 in.; 34.3 x 50.8 cm)
Los Angeles County Museum of Art, Mr. and Mrs. William
Preston Harrison Collection
(31.12.1)

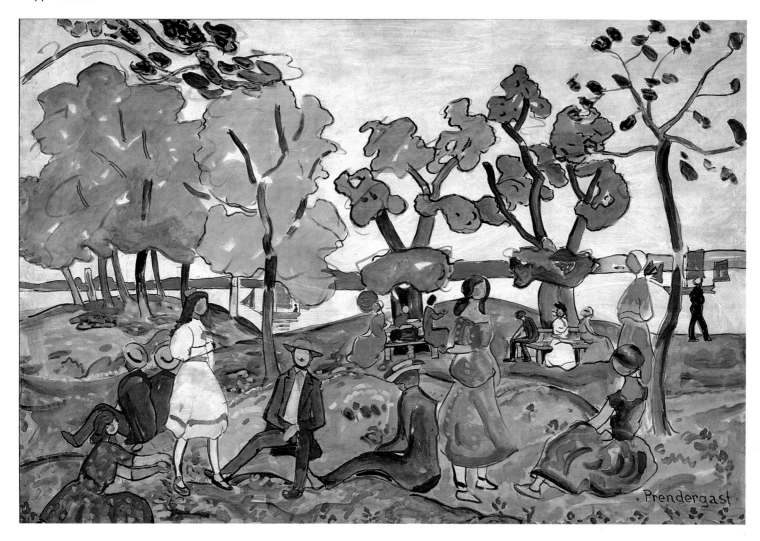

99
Picnic

ca. 1914–15

Oil on canvas

(77 x 106½ in.; 195.6 x 270.6 cm)
The Carnegie Museum of Art, Pittsburgh; Gift of the people
of Pittsburgh through the efforts of the Women's Committee,
in honor of the Sarah M. Scaife Gallery, 1972
(1972.51)

100
Promenade
ca. 1914–15
Oil on canvas
(83³/₄ x 134 in.; 212.7 x 340.4 cm)
© The Detroit Insitute of Arts, City of Detroit Purchase
(27.159)

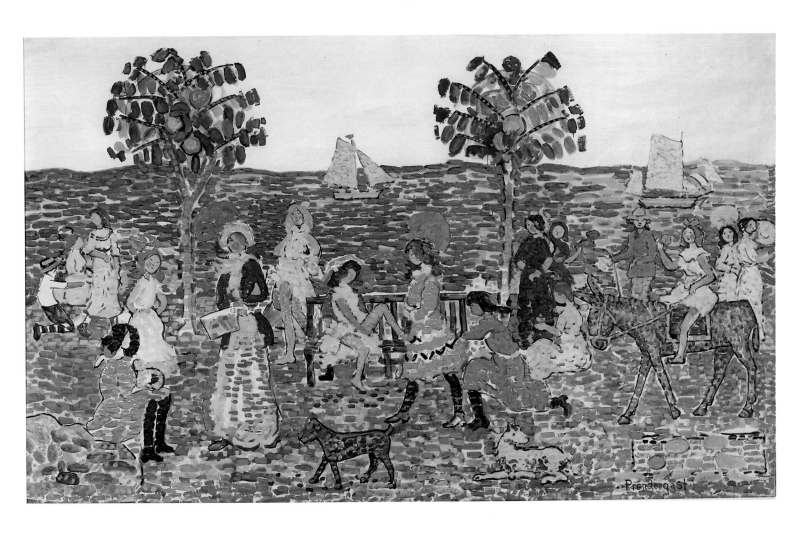

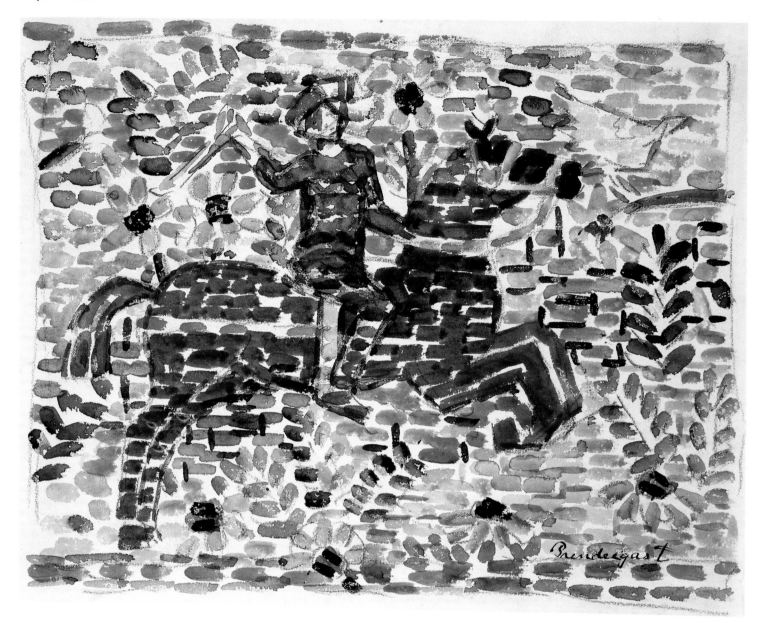

101

The Rider

ca. 1912–15

Watercolor and pencil on paper

(11¹⁄₂ x 16³⁄₈ in.; 29.3 x 41.6 cm)

Museum of Fine Arts, Boston, Anonymous Gift in memory

of John G. Pierce, Sr.

(64.1604)

102
Elephant
ca. 1912–15
Watercolor and pencil on paper
($10^{3}/_{8}$ x $11^{1}/_{2}$ in.; 26.4 x 29.2 cm)
Collection of Mrs. Charles Prendergast

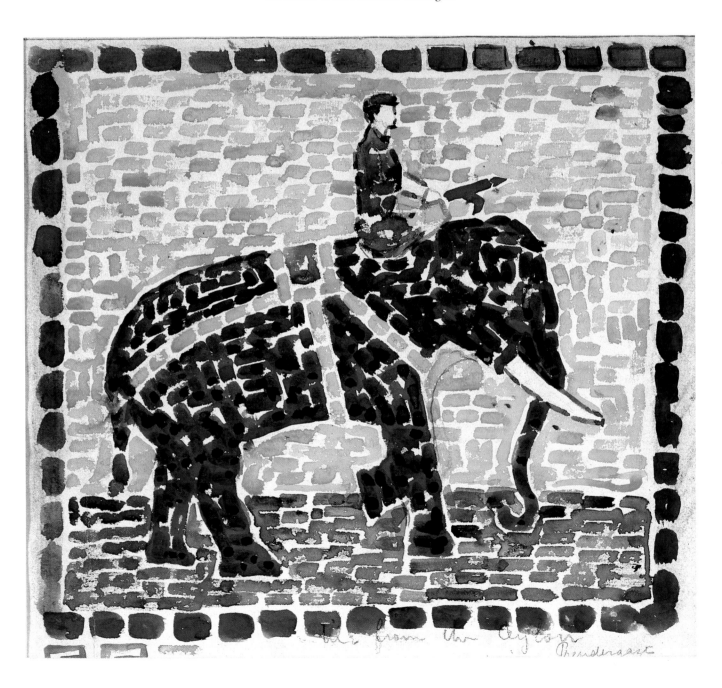

103
A Day in the Country
ca. 1914-15
Oil on canvas
(18¹/₄ x 27 in.; 46.4 x 68.6 cm)
Collection of Mrs. Charles Prendergast

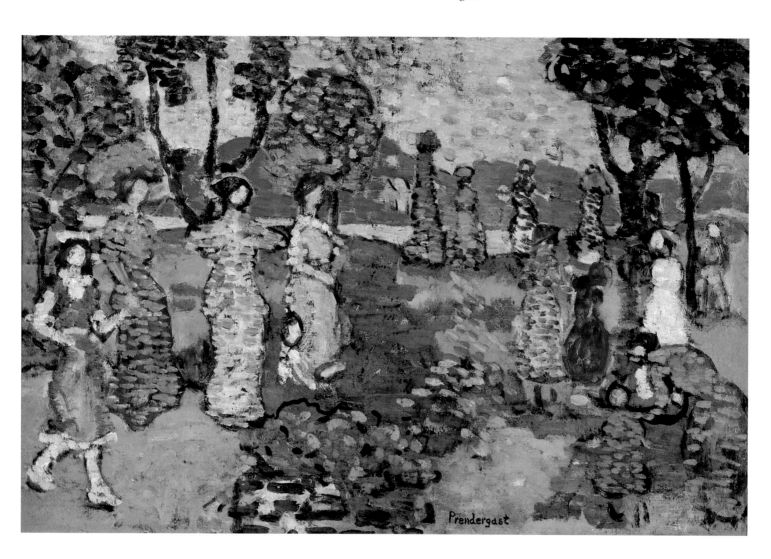

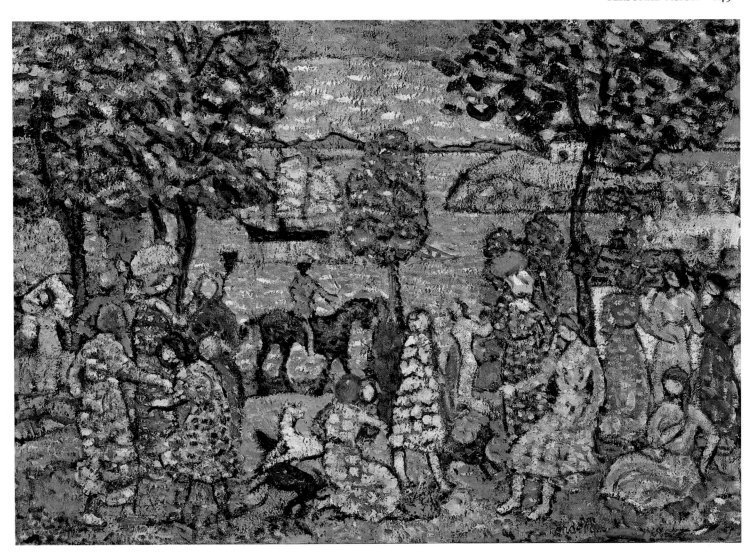

104

Fantasy

ca. 1914-15

Oil on canvas

(22⅝ x 31⅝ in.; 57.4 x 80.3 cm)
The Phillips Collection, Washington, D. C.
(1604)

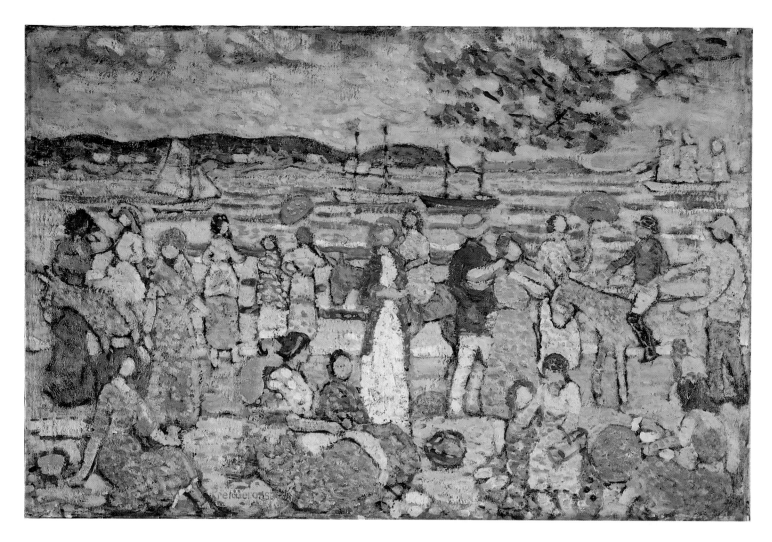

105

Along the Shore

ca. 1914–15

Oil on canvas

($23^1/_4$ x 34 in.; 59.1 x 86.4 cm)
Columbus Museum of Art,
Ohio: Gift of Ferdinand Howald, 1931
(31.252)

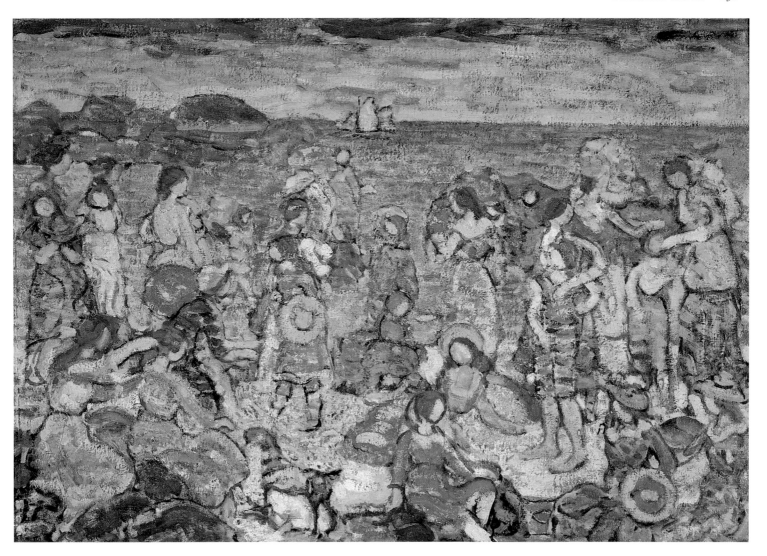

106

The Cove

ca. 1918–23

Oil on canvas

(28 x 39³/₄ in.; 71.1 x 101.0 cm)
Collection of Whitney Museum of American Art. Gift of
Gertrude Vanderbilt Whitney
(31.322)

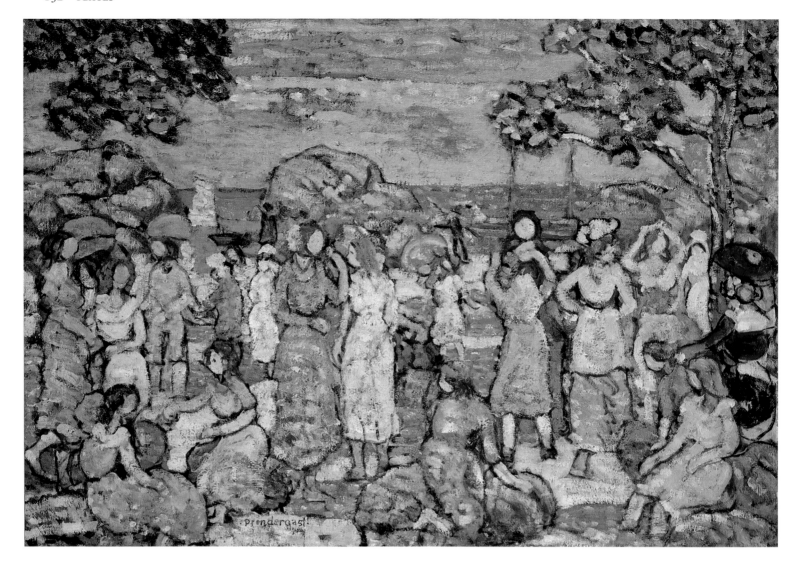

107

Beach at Gloucester

ca. 1918–21

Oil on canvas

(30⅝ x 43 in.; 77.8 x 109.2 cm)
Hirshhorn Museum and Sculpture Garden, Smithsonian
Institution. Gift of the Joseph H. Hirshhorn Foundation, 1966
(66.4130)

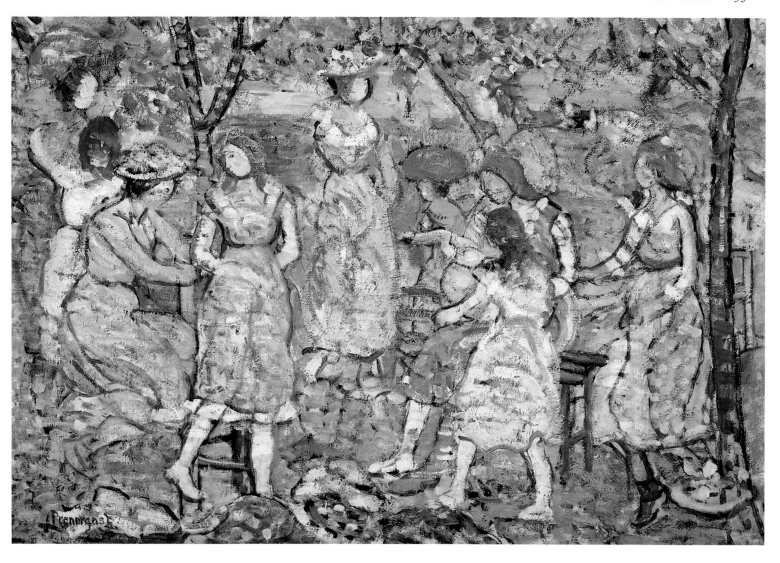

108
Girls in the Park
ca. 1914-15
Oil on canvas
(28¹/₄ x 39³/₄ in.; 71.8 x 101.0 cm)
Williams College Museum of Art,
Gift of Mrs. Charles Prendergast
(86.18.7)

109
Acadia
ca. 1918–23
Oil on canvas
(31³/₄ x 37¹/₂ in.; 80.6 x 95.2 cm)
Collection, The Museum of Modern Art, New York. Abby
Aldrich Rockefeller Fund, 1945
(167.45)

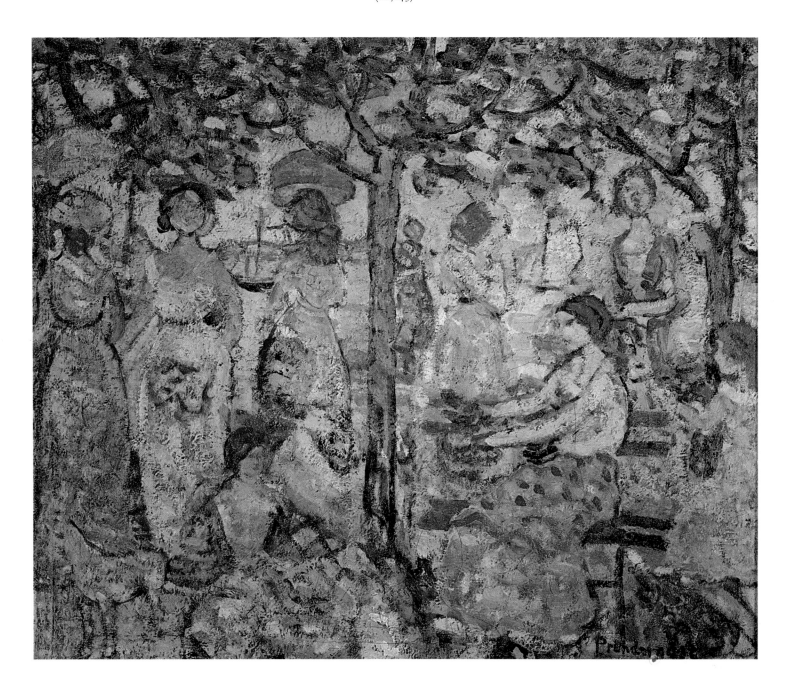

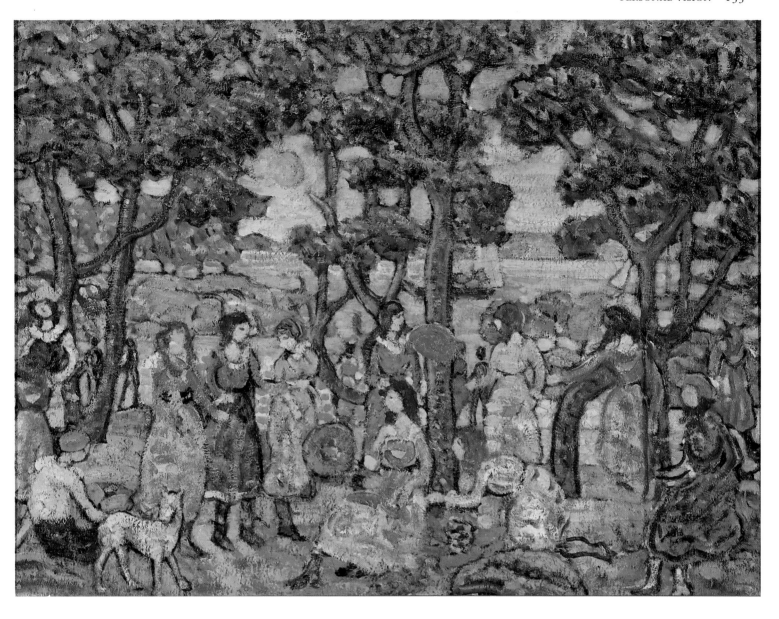

110

Landscape with Figures

1921

Oil on canvas

(32⅝ x 42⅝ in.; 82.9 x 108.3 cm)
In the Collection of The Corcoran Gallery of Art, Museum
Purchase, William A. Clark Fund
(23.17)

III

Woman on Ship Deck, Looking out to Sea

ca. 1895

Monotype on paper

(6¹/₄ x 4¹/₈ in.; 15.9 x 10.5 cm; image)
© Daniel J. Terra Collection,
Terra Museum of American Art, Chicago
(20.1986)

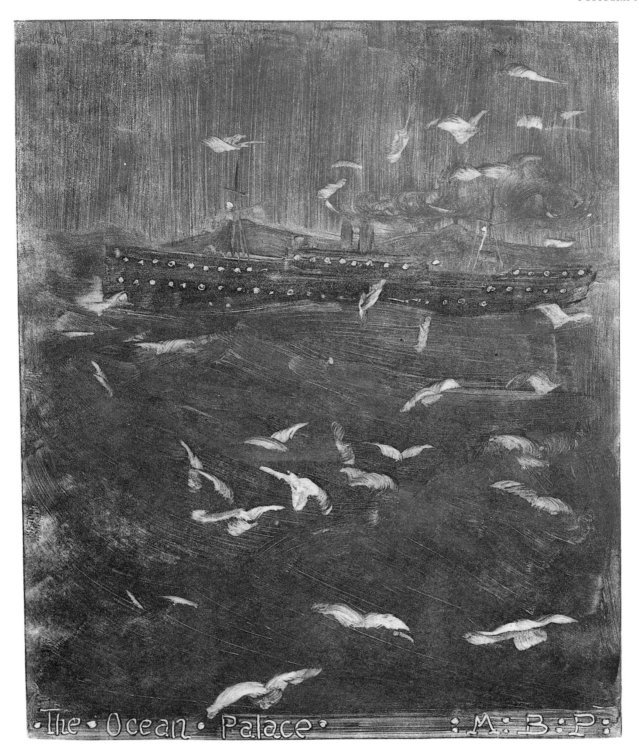

112

The Ocean Palace

ca. 1895

Monotype on paper

($7^1/_2$ x $6^1/_4$ in.; 19.1 x 16.5 cm; image)

The University of Iowa Museum of Art,

Gift of Robert E. Brady

(1969.410)

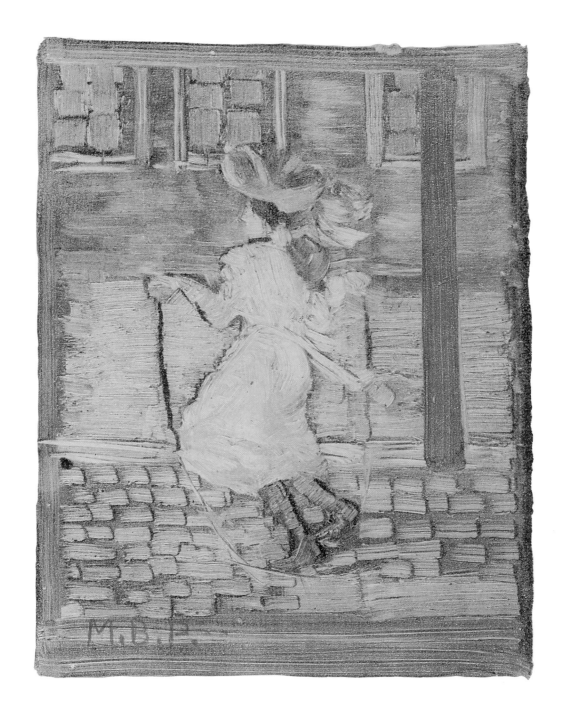

113
Jumping Rope
ca. 1895–97
Monotype on paper
(6⁹/₁₆ x 5³/₁₆ in.; 16.7 x 13.2 cm; image)
© Daniel J. Terra Collection,
Terra Museum of American Art, Chicago
(35.1982)

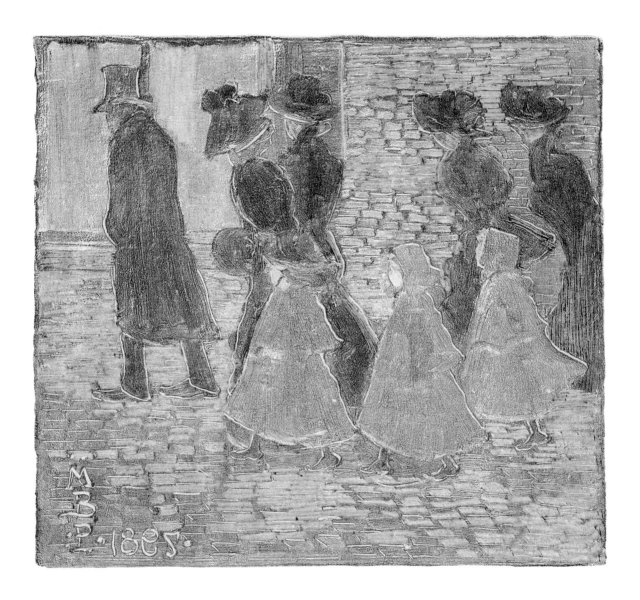

114

The Three Little Girls in Red

1895

Monotype on paper

(5⅝ x 6 in.; 14.3 x 15.2 cm; image)

Museum of Fine Arts, Boston, George P. Gardner Fund

(55.228)

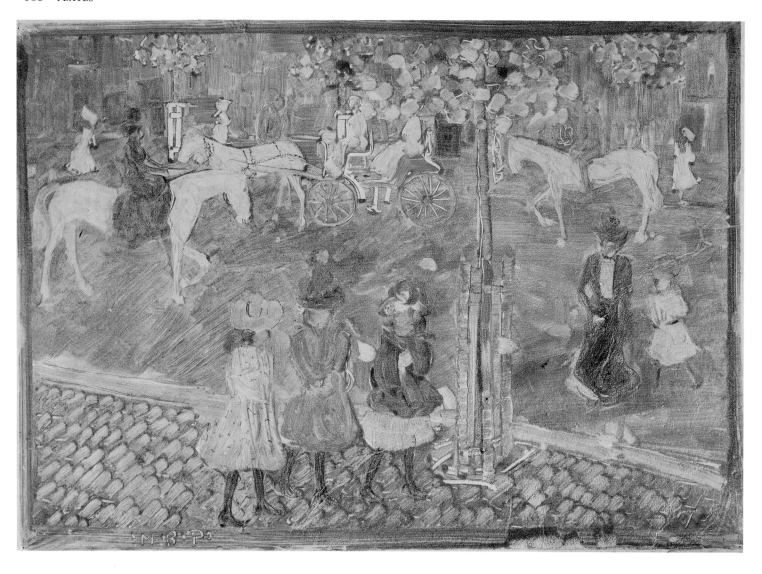

115

Horseback Riders

ca. 1895-1900

Monotype on paper with pencil additions

(9¹/₈ x 12¹/₄ in.; 23.2 x 31.1 cm; image)
Ball State University Art Gallery, Muncie, Indiana,
Permanent loan from the Elisabeth Ball Collection, George
and Frances Ball Foundation
(L83.026.25)

116

Lady with Red Cape and Muff

ca. 1900-02

Monotype on paper

(9⁵/₁₆ x 4⁷/₈ in.; 25.3 x 12.4 cm; image)
Williams College Museum of Art,
Gift of Mrs. Charles Prendergast
(85.21.2)

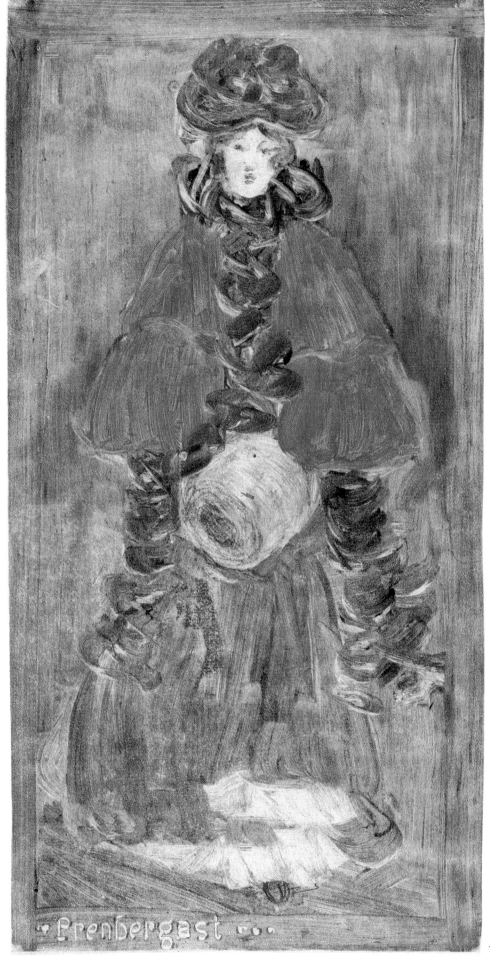

116

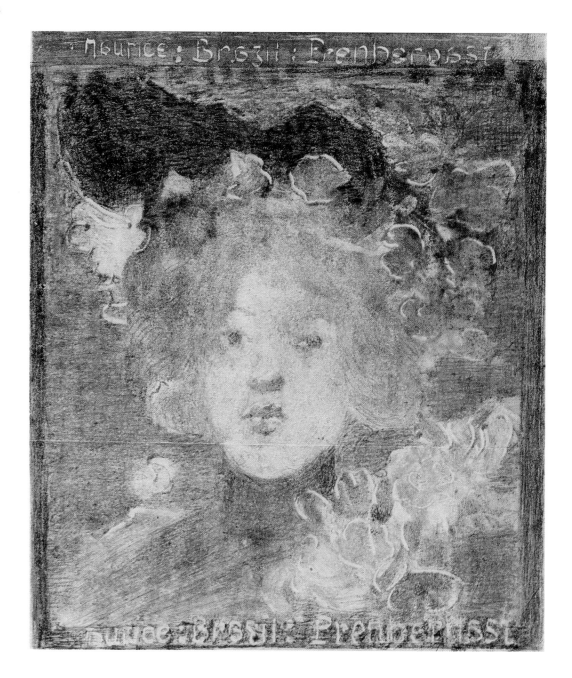

117

Head of a Girl (with roses)

ca. 1898–99

Monotype on paper

(6¹/₄ x 5³/₈ in.; 15.9 x 13.7 cm; sight)
Collection of Mrs. Suzanne Marache Geyer

118

Seated Woman in Blue

ca. 1900–02

Monotype on paper with pencil additions

(9⁹/₁₆ x 7¹/₁₆ in.; 24.3 x 18.0 cm; image)
Museum of Fine Arts, Boston, Lee M. Friedman Fund
(68.564)

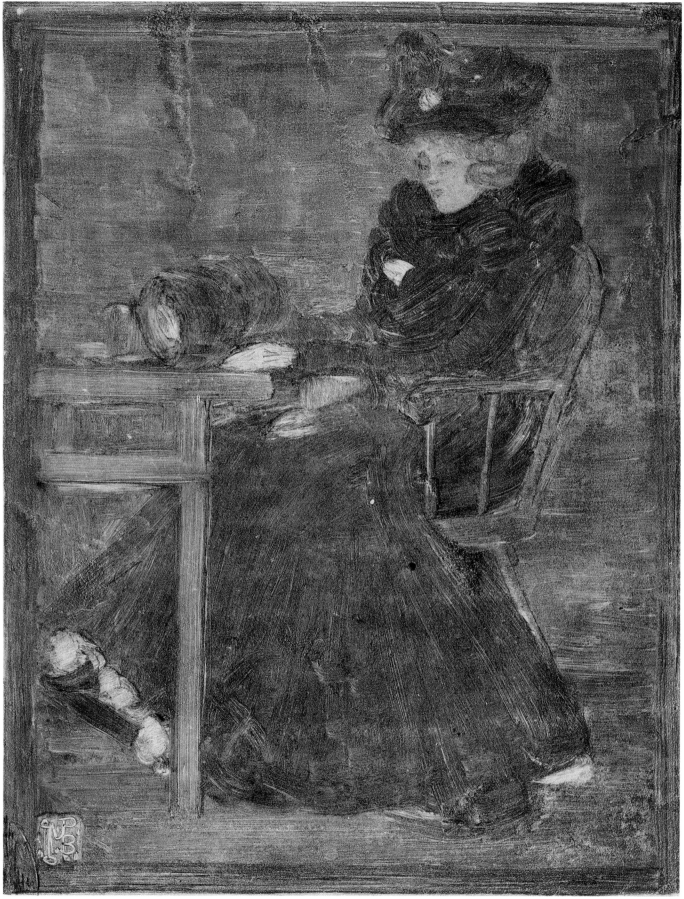

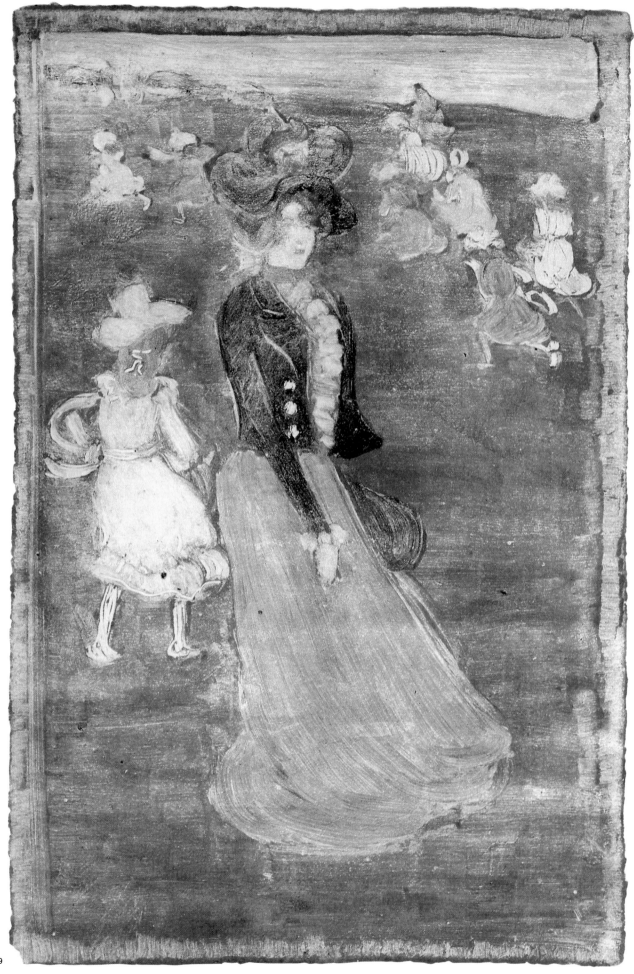

119

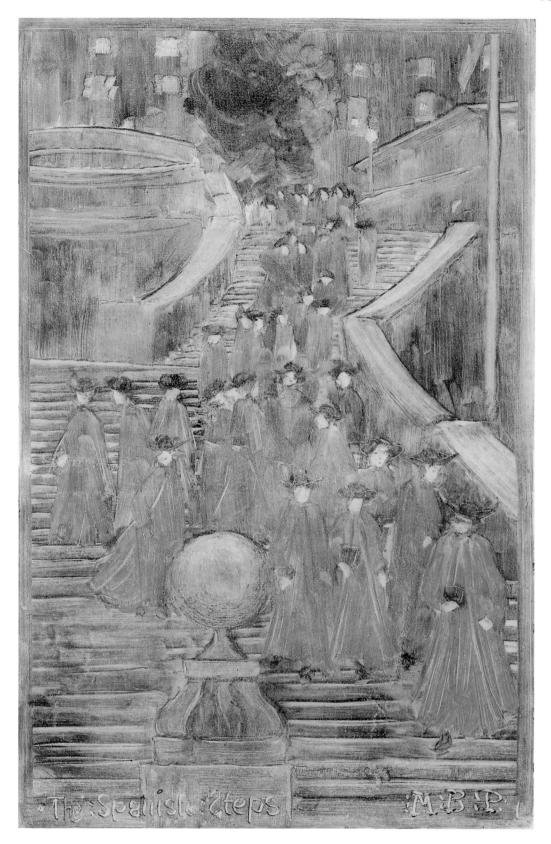

119
Lady in Pink Skirt
ca. 1895–97
Monotype on paper
(15½ x 11 in.; 39.4 x 27.9 cm; sheet)
Williams College Museum of Art,
Gift of Mrs. Charles Prendergast
(86.18.78)

120
The Spanish Steps
ca. 1898–99
Monotype on paper
(11¹¹⁄₁₆ x 7½ in.; 29.7 x 19.1 cm; image)
The Cleveland Museum of Art, Mr. and Mrs. Charles
G. Prasse Collection
(82.167)

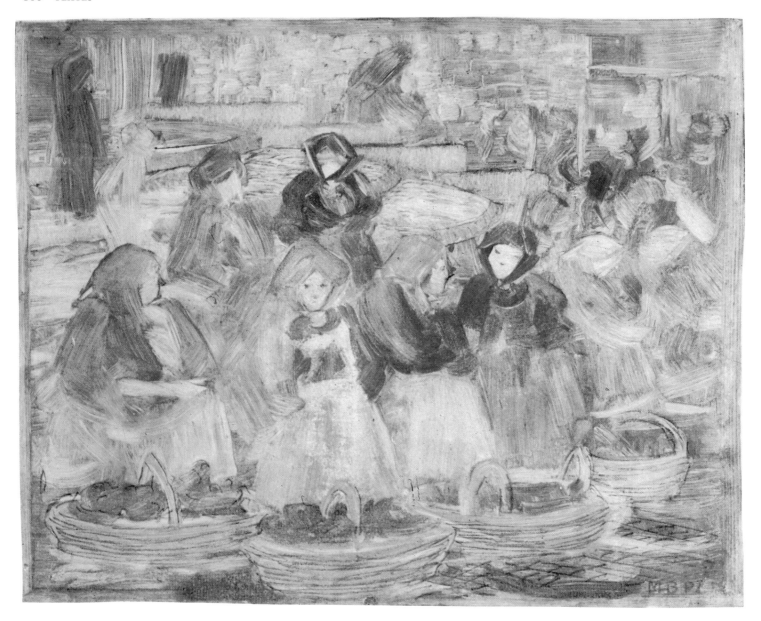

121

Market Scene

ca. 1898–99

Monotype on paper with pencil additions

(7⁵/₈ x 9³/₈ in.; 19.4 x 23.6 cm; image)
The Prints and Photographs Division, Library of Congress,
Washington, D.C.
(540031)

122

Orange Market

ca. 1898–99

Monotype on paper with pencil additions

(12⁷/₁₆ x 9¹/₈ in.; 31.6 x 23.2 cm; image)
Collection, The Museum of Modern Art, New York. Gift of
Abby Aldrich Rockefeller
(169.45)

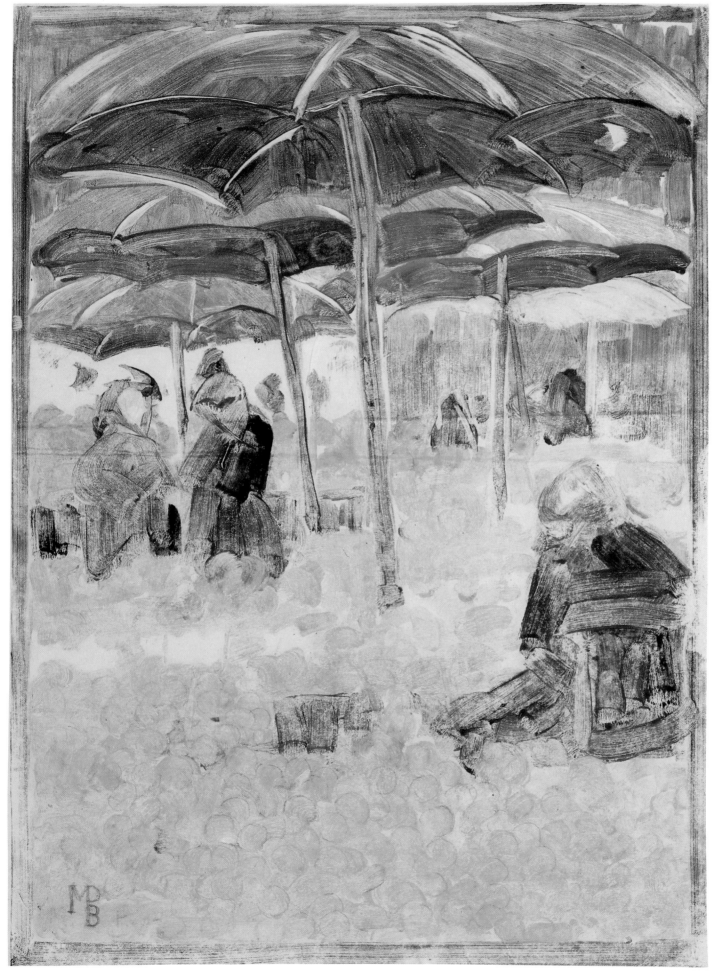

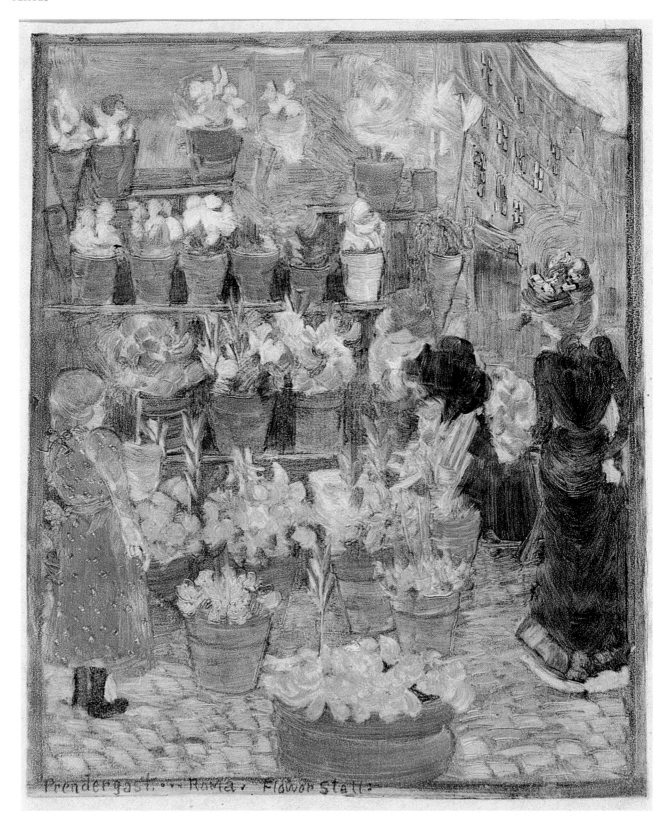

123
Roma: Flower Stall
ca. 1898–99
Monotype on paper with pencil additions
(9³⁄₈ x 7¹⁄₂ in.; 23.8 x 19.0 cm; image)
Gift of the Friends of the McNay, Marion Koogler McNay
Art Museum, San Antonio, Texas
(1976.5)

124
Circus Band
ca. 1895
Monotype on paper with pencil additions
(12³⁄₈ x 9³⁄₈ in.; 31.4 x 23.6 cm; sight)
Collection of Rita and Daniel Fraad

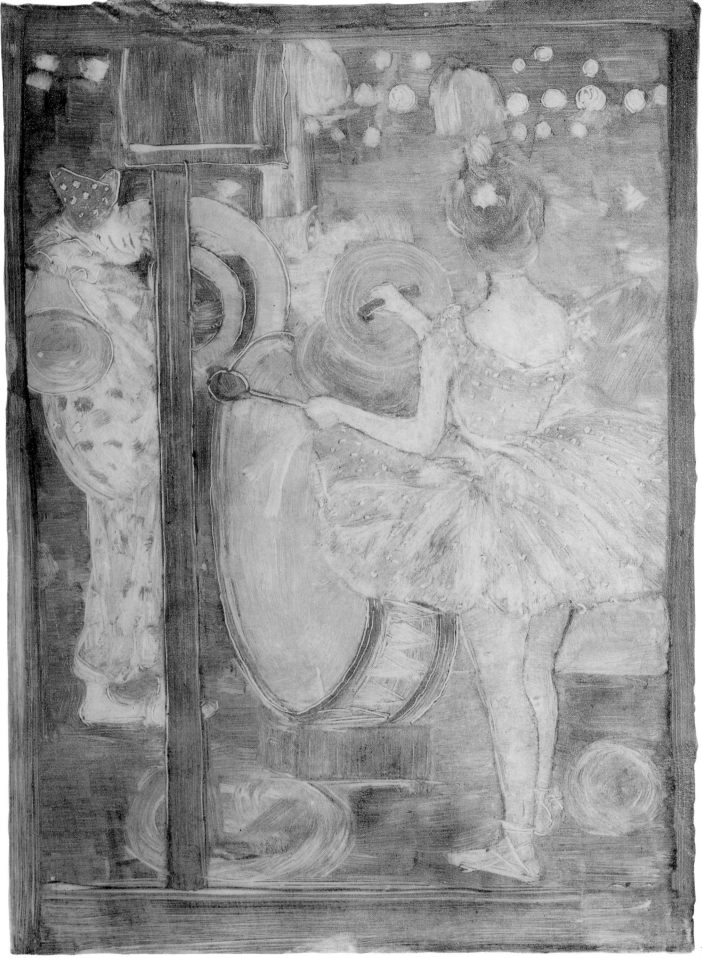

125

126

Shipyard: Children Playing

ca. 1900–02

Monotype on paper

(7⁷/₈ x 10 in.; 20.0 x 25.3 cm; image)
The Cleveland Museum of Art, Mr. and Mrs. Charles
G. Prasse Collection
(82.166)

125

Picnic with Red Umbrella

ca. 1898–99

Monotype on paper with pencil additions

(9¹/₄ x 7¹/₂ in.; 23.5 x 19.0 cm; sheet)
Horatio Colony Museum

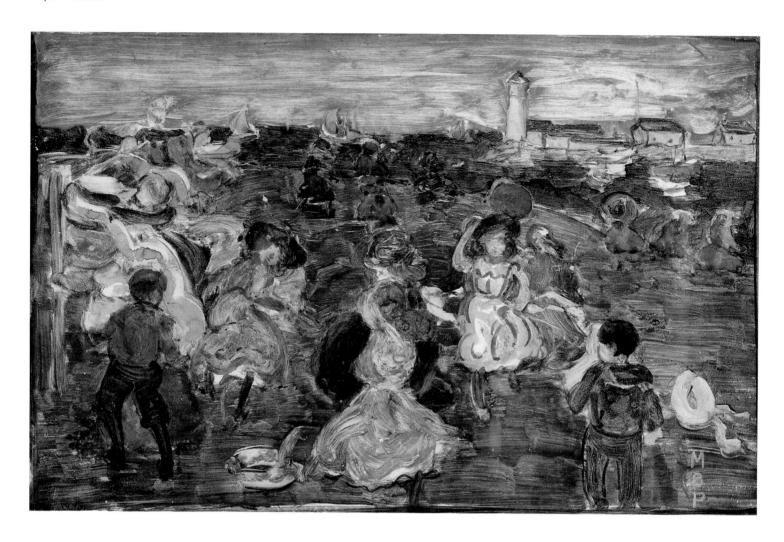

127

Lighthouse

ca. 1900–02

Monotype on paper with watercolor and pencil additions

(9¼ x 15 in.; 23.5 x 35.6 cm; image)

© Daniel J. Terra Collection,

Terra Museum of American Art, Chicago

(31.1980)

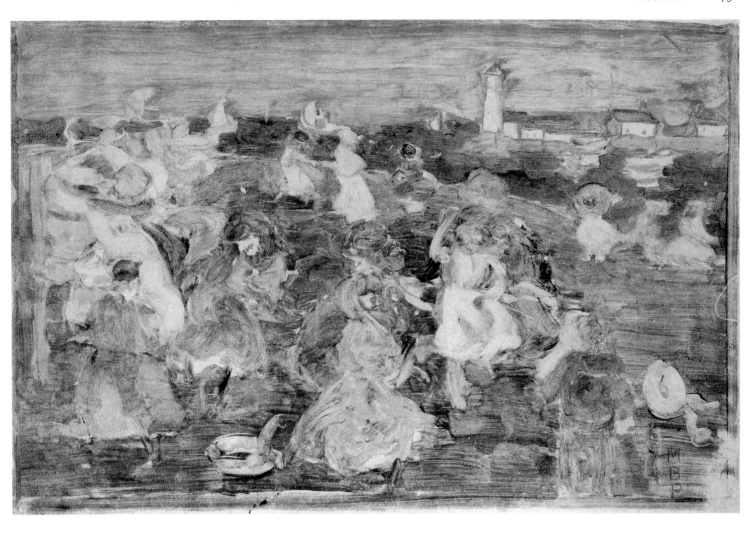

128
Beach Scene with Lighthouse

ca. 1900–02

Monotype on paper

($9^7/_{16}$ x $13^7/_8$ in.; 24.0 x 35.2 cm; image)
The Metropolitan Museum of Art, Gift of Mr. and Mrs.
Daniel H. Silberberg, 1964.
(64.123.2)

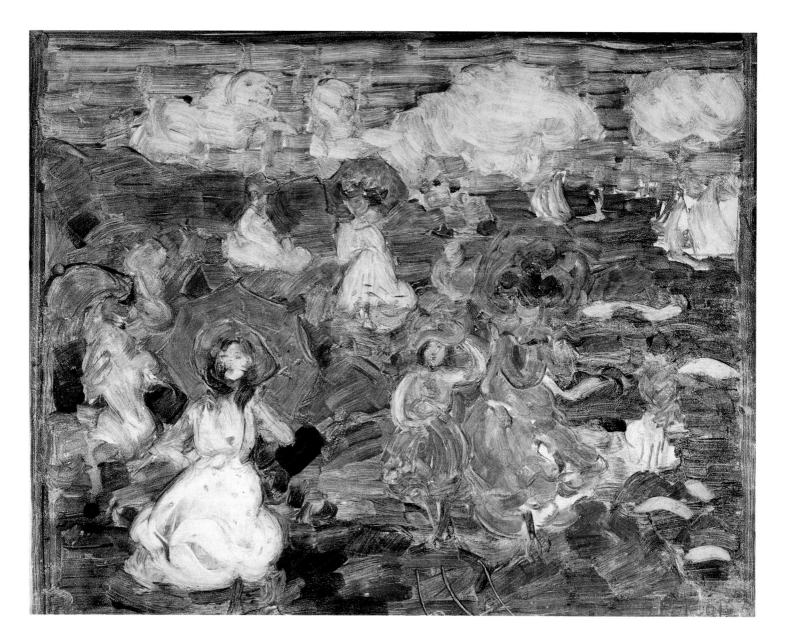

129
Summer Day
ca. 1900–02

Monotype on paper with pencil additions

(11¹/₄ x 13³/₄ in.; 28.5 x 35.0 cm; image)
© Daniel J. Terra Collection,
Terra Museum of American Art, Chicago
(10.1983)

Appendix

Chronology

Maurice Brazil Prendergast

1857 On February 23 in St. John's, Newfoundland, Mary Malvina Germaine, the fourth daughter of H. M. Germaine, M. D. of Boston, marries Maurice Prendergast [Sr.] (Family Bible, Prendergast Archive, Williams College Museum of Art).

1858 Maurice Brazil Prendergast and his twin sister, Lucy Catharine, are born and baptized on October 10 in St. John's, Newfoundland (Family Bible; St. John's Basilica Baptism Records). Lucy Catharine dies "at the age of 18 or 20" (draft of a letter from Eugénie Prendergast to Peter Wick, July 8, 1960, Prendergast Archive, Williams College Museum of Art).

1860 A brother, Richard Thomas Prendergast (with a still-born twin sister), is born on November 19, but dies in 1864 (Family Bible).

1863 Charles James Prendergast is born on May 27 and baptized on June 24 in St. John's, Newfoundland (Family Bible; St. John's Basilica Baptism Records).

1864-1865 Maurice Prendergast [Sr.] is listed as a grocer at 138 Water Street, St. John's, in the *Newfoundland Directory*.

1868 In November the Prendergast family moves to Boston (U.S. naturalization papers of Maurice Prendergast [Sr.], 1881).

1868-1872 Maurice and Charles attend Rice Grammar School for boys on Dartmouth Street in Boston. Maurice finishes eight years of schooling (ca. 1872) and goes to work wrapping packages at the drygoods store of Loring and Waterhouse (Brooks 1938; Basso 1946b).

1872-1877 Maurice Prendergast [Sr.?] is listed as "laborer" in the 1872, 1873, and 1874 *Boston City Directory* and as "confectioner" in 1875, 1876, and 1877 with a home address at 86 West Dedham Street, Boston.

1878 Maurice Brazil Prendergast is listed for the first time in the *Boston City Directory* (as "clerk") with a home address at 86 West Dedham Street.

1879 Maurice's home address remains the same, but he is listed in the *Boston City Directory* as "designer" with a business address at 266 Washington Street, Boston.

1881 Maurice Prendergast [Sr.] is naturalized as a U.S. citizen on June 24 (U.S. naturalization papers).

1882-1893 During these years the *Boston City Directory* lists the family as living at 119 Centre Street, Roxbury. No occupation is

noted for the father. From 1886 until 1890 Maurice registers his business address at 1 Province Street in downtown Boston, which would place him at the firm of Peter Gill, designer of show cards (Glavin 1982).

1883 Maurice's mother, Mary Malvina Germaine Prendergast, dies on November 27 (Family Bible).

1884 Maurice shows his work to a Mrs. Waterbury, who suggests that he study abroad (Milliken 1926).

1886-1887 Charles travels twice to England on a cattle boat, the second time with Maurice (Basso 1946b).
Two watercolors by Maurice which depict scenes in Wales are dated 1886 (*Catalogue Raisonné*, nos. 509 and 510), and a sketchbook (*Catalogue Raisonné*, no. 1475) which contains addresses in North Wales also has a sketch inscribed "May 1, 87, Everett [MA]." After their return Maurice continues to letter show cards and Charles becomes a traveling salesman for a fine arts shop (Basso 1946b).

1889 During the summer Maurice paints in Westport, Maine (Rhys 1960).

1891-1894 Maurice and Charles arrive in Paris by January 1891 (*Catalogue Raisonné*, no. 517). Maurice studies at the Académie Julian (bill for classes, Prendergast Archive, Williams College Museum of Art) and also at Colarossi's studio, as does Charles (Charles's biographical data form for associate membership, National Academy of Design, ca. 1939). The brothers meet James W. Morrice (letter from Maurice to Charles, ca. June 13, 1907, Prendergast Archive, Williams College Museum of Art), with whom Maurice spends the summers painting at Tréport, Dieppe, and Dinard. Charles returns to Boston by 1892.

1891-1892 Although living in Paris, Maurice is listed as "decorator" in the *Boston City Directory*.

1893 Still abroad, Maurice is listed as "artist" for the first time in the *Boston City Directory*.
Maurice's sketches are stolen by Michael Dignam and then published under Dignam's name in London by *The Studio* (Brooks 1938).

1894 Maurice returns to Boston on September 1 on the S. S. Cephalonia from Liverpool (passenger arrival list).
Maurice and Charles board at the Brookline Avenue corner of Francis Street, Boston (*Boston City Directory*).

1895 First known inclusion of works by Maurice in an exhibition (Boston Art Club).

1895-1896 Maurice, Charles, and their father move to 83 Hillside Avenue, Roxbury, where they continue to reside until 1896 (*Boston City Directory*).

1896 Maurice lists his address in a late 1896 exhibition at the Pennsylvania Academy of the Fine Arts as Trinity Court, Boston, a residence of apartments and studios (Hitchings 1989).

1897 Maurice begins to exhibit in New York at the Water Color Club.
Charles lists himself as "artist" for the first time and is living with his father and brother at the Ormonde, 641 Huntington Avenue, Boston, where they will remain until the spring of 1898 (*Boston City Directory* and Hitchings 1989).

1898 Maurice applies for a U.S. passport on June 29.

1898-1899 Financed by Sarah Sears (Milliken 1926), Maurice travels to Italy and stays for about eighteen months. His itinerary probably included Venice, Padua, Florence, Siena, Orvieto, Rome, Naples, and Capri (Pepper 1910).
Maurice, Charles, and their father are listed as living at 27 Winthrop Street, Winchester (1899 *Woburn and Winchester City Directory*), where they have been since at least April 1898.

1899 While he is still in Italy, sixteen of Maurice's Italian watercolors are shown at the Eastman Chase Gallery in Boston, possibly constituting his first one-person exhibition. William Macbeth invites Maurice to exhibit in his New York gallery. In Maurice's absence, Charles responds positively on September 29 (Macbeth Gallery papers, Archives of American Art).
Maurice plans to leave Italy on November 16 (sketchbook, *Catalogue Raisonné*, no. 1479).

1900 Maurice shows watercolors and monotypes with Hermann Dudley Murphy at the Art Institute of Chicago, January 3-28.
The 1900 Census lists Maurice, Charles, and their father at 81 Walnut Street in Winchester.
Maurice has his first major one-person exhibition of watercolors and monotypes at the Gallery of William Macbeth, March 9-24.
Maurice mentions a sketching trip planned from July 18 until mid-September (letter from Maurice to William Macbeth, July 17, 1900, Archives of American Art).
By November Maurice has moved to 83 Walnut Street, Winchester, where he and his brother will continue to live at least until 1903 and their father until his death in 1901.

1901 Maurice Prendergast [Sr.] dies and is buried on September 23 (Family Bible).
Maurice wins a Bronze Medal at the Pan-American Exposition in Buffalo, NY.
Maurice's second major one-person show (watercolors and monotypes) is seen in Detroit and Cincinnati.

1902 During the summer Maurice and Charles visit the Oliver Williams family in Annisquam, Massachusetts, and Maurice paints a portrait of Esther Williams and her newborn son, Thomas (*Catalogue Raisonné*, no. 49).

1903 Charles and Hermann Dudley Murphy establish a framemaking business, Carrig-Rohane (Carrig-Rohane papers, Archives

of American Art), and Maurice works with Charles on Thomas Lawson's commission of two large frames (Derby 1989).
Although Maurice, Charles, and their father are not listed in the *Boston City Directory* from 1899 through 1904, Maurice maintained a studio at 56 Mount Vernon Street, Boston, for he gives that address in exhibition catalogues beginning in April 1903.

1904 Maurice exhibits at the National Arts Club and is first affiliated with Robert Henri, William Glackens, George Luks, John Sloan, and Arthur B. Davies, future members of The Eight. Maurice stays at 115 West 56th Street in New York during the spring and summer (letter from Maurice to Esther Williams, April 27, 1904, Williams Papers, Archives of American Art).

1905-1906 Maurice and Charles are living at 56 Mount Vernon Street, Boston, where they will remain until they move to New York in 1914 (*Boston City Directory*). Maurice, however, moves to "new lodging" at 65 Pinckney Street on October 19, 1905 (sketchbook, *Catalogue Raisonné*, no. 1483) and lists this address in the 1906 *Boston City Directory*. In the 1913 and 1914 *Boston City Directory* Maurice is listed as boarding at 60½ West Cedar Street, indicating that during these years he uses 56 Mount Vernon Street, where Charles continues to reside, only as a studio.
Maurice's work is interrupted in order to find a cure for his loss of hearing. Joining the "L Street Brownies" in Boston, he begins a regime of swimming and sunning to protect his health (sketchbook, *Catalogue Raisonné*, no. 1483, and letters from Maurice to Esther Williams, May 14 and November 10, 1905, Williams Papers, Archives of American Art).

1907 Maurice sails to France on May 19 and arrives in Le Havre on May 28.
Itinerary, according to letters from Maurice to Charles (Prendergast Archive, Williams College Museum of Art) and to Esther Williams (Archives of American Art), May-June 1907:
 Paris, by May 31
 Versailles, June 15
 St. Malo, June 31 to end of August
 Back to Paris in September.
Maurice plans to sail back to Boston on October 26 (letter from Maurice to Esther Williams, October 10, 1907, Williams Papers, Archives of American Art).

1908 Maurice participates in the exhibition of The Eight at Macbeth Galleries, February 3-15.
Maurice plans to spend the summer in Annisquam (letter from Maurice to Esther Williams, May 31, 1908, Williams Papers, Archives of American Art).

1910 Maurice takes part in the Exhibition of Independent Artists, April 1-27 in New York.
Charles Hovey Pepper publishes the first article on Maurice in *The World To-Day*.
Maurice travels to New Hampshire in the fall and exhibits watercolors of the trip at the Boston Water Color Club in February 1911.

1911 Charles travels to Italy from about June 15 through October.
Maurice follows him in August and during the autumn becomes ill and undergoes prostate surgery at the Cosmopolitan Hospital in Venice (letters from Maurice to Esther Williams, Williams Papers, Archives of American Art, and to Charles, Prendergast Archive, Williams College Museum of Art, September-December 1911).

1912 On January 31 Maurice sails home on White Star Line S. S. Canopic which stops in Palermo (Glavin 1976).

Maurice joins the Association of American Painters and Sculptors to organize the Armory Show and is appointed to the foreign and American selection committees (Brown 1963).

In April Maurice has a one-person exhibition at the Women's Cosmopolitan Club, New York.

Maurice spends the summer with the Glackens family in Bellport, Long Island (Glackens 1957).

Maurice paints in New Hampshire (Milliken 1926).

Sometime during this year Charles produces his first carved and painted panel (Basso 1946a and 1946b).

1913 The Armory Show, in which Maurice exhibits seven works, runs in New York from February 17 to March 15.

Maurice is listed in the 1913 and 1914 *Boston City Directory* as boarding at 60½ West Cedar Street, while Charles continues to reside at 56 Mount Vernon Street.

In June Maurice undergoes a second prostate surgery at City Hospital, Boston (letter from Maurice to Walter Pach, June 25, 1913, Pach Papers, Archives of American Art).

Maurice and Charles spend part of the summer in Brooksville, Maine (letters from Maurice to Walter Pach, July 11, 1913, Pach Papers, Archives of American Art, and to John Quinn, August 14, 1913, Quinn Papers, New York Public Library).

Maurice and Charles visit New York in early December and stay at the St. Denis Hotel (letter from Maurice to John Quinn, December 10, 1913, Quinn Papers, New York Public Library).

1914 Maurice travels to Paris and St. Malo in the spring and plans to return from France in mid-October (letter from Maurice to Esther Williams, May 2, 1914, Archives of American Art, and from Charles to John Quinn, June 24, 1914, New York Public Library).

Charles receives payment of $1800 for eighteen frames from an insurance company in Philadelphia, which enables the brothers to move from Boston to New York (Basso 1946b).

Maurice and Charles move to 50 Washington Square South in New York on November 1 (letter from Maurice to Edward Root, January 8, 1915, Root Papers, Archives of American Art).

Maurice is elected president of the Association of American Painters and Sculptors (Brown 1963).

1915 Maurice has a one-person show at the Carroll Galleries, New York, from February 15 to March 6.

Maurice and Charles exhibit together for the first time, March 23–April 24, at the Montross Gallery, New York.

In early July Charles visits the Williams family in Annisquam, and Maurice plans a trip there later in the month (letter from Maurice to Esther Williams, July 14, 1915, Williams Papers, Archives of American Art). Maurice and Charles are in Ogunquit, Maine, in early August and Maurice visits Walt Kuhn and his family in York Village, Maine. Maurice plans an autumn trip to the Catskills (letter from Maurice to John Quinn, September 7, 1915, Quinn Papers, New York Public Library).

Maurice is included in *Vanity Fair*'s "Hall of Fame" (vol. 5 [November 1915], p. 56).

1916 Maurice and Charles visit Boston in May (letter from Charles to John Quinn, May 10, 1916, Quinn Papers, New York Public Library). Maurice visits Boston in November with William Glackens (Glackens 1957).

1917 Maurice and Charles exhibit with the Society of Independent Artists, April 10–May 6. Charles is elected vice-president of this organization.

Maurice spends the summer in Annisquam and Gloucester, Massachusetts (Glackens 1957).

1921 A joint exhibition of the brothers' work is held at Brummer Galleries, New York, April 4–23.

1922 Walter Pach publishes "Maurice Prendergast" in *Shadowland* (vol. 66 [April 1922], pp. 10–11).

1923 In December Maurice is awarded a third place medal and $1000 in the Corcoran Gallery ninth biennial. He is in New York Hospital and is unable to receive the award in person (letter from Maurice to C. Powell Minnigerode, [December] 7, 1923, Corcoran Gallery Archives).

1924 Maurice dies on February 1 in New York City.

1925 Kraushaar Galleries arrange a memorial show for Maurice, February 16–March 4.

1926 The Cleveland Museum of Art mounts a memorial retrospective of Maurice's work, January 15–February 15.

Selected Bibliography

"Art Notes," *New York Evening Post,* February 20, 1915, Part I, p. 7.

Basso, Hamilton. "A Glimpse of Heaven—I," *New Yorker* 22 (July 27, 1946), pp. 24-28, 30.

Basso, Hamilton. "A Glimpse of Heaven—II," *New Yorker* 22 (August 3, 1946), pp. 28-32, 34, 36, 37.

Bolger, Doreen. "Modern Mural Decoration: Prendergast & His Circle." In *The Prendergasts & The Arts & Crafts Movement,* Williamstown, Massachusetts: Williams College Museum of Art, 1989.

"Boston Art Club Exhibition," *The Collector and Art Critic Weekly Calendar,* January 22, 1906.

Brady, Fred. "Anonymous Friend Reveals Prendergast's Love of Life," *Boston Herald,* Sunday, November 27, 1960.

Brooks, Van Wyck. "Anecdotes of Maurice Prendergast," *Magazine of Art* 31, no. 10 (October, 1938), pp. 564-569, 604. Reprinted from exhibition catalogue, *The Prendergasts: Retrospective Exhibition of the Work of Maurice and Charles Prendergast,* Addison Gallery of American Art, Phillips Academy, 1938. The same article was reprinted once again in Brooks, *Fenellosa and His Circle* (E. P. Dutton & Co., 1962).

Brooks, Van Wyck. *John Sloan: A Painter's Life.* New York: E. P. Dutton & Co., Inc., 1955.

Brown, Milton W. *The Story of the Armory Show.* New York: The Joseph H. Hirshhorn Foundation, 1963.

Buck, Stephanie Mary. "Sarah Choate Sears: Artist, Photographer, and Art Patron." Unpublished MFA thesis, Syracuse University, 1984.

The Buffalo Fine Arts Academy: The Albright Art Gallery, *Thirteenth Annual Exhibition of Selected Paintings by American Artists,* May 21 to September 8, 1919.

Caffin, Charles H. "American Studio Talk," *International Studio* 9, no. 34, Supplement (December 1899), pp. vii-viii.

Catalogue Raisonné. See under Clark, Mathews, and Owens.

Chamberlain, Arthur. "Boston Notes," *Art Interchange* 150, no. 4 (April 1898), pp. 88-89.

Chamberlin, Joseph E. "Two Significant Exhibitions," *New York Evening Mail,* February 4, 1908, p. 6.

Clark, Carol, Nancy Mowll Mathews, and Gwendolyn Owens. *Maurice Brazil Prendergast, Charles Prendergast: A Catalogue Raisonné.* Munich and Williamstown, Massachusetts: Prestel-Verlag and Williams College Museum of Art, 1990. (Referred to throughout the text as *Catalogue Raisonné.*)

Clark, T. J. *The Painting of Modern Life: Paris in the Art of Manet and His Followers.* Princeton: Princeton University Press, 1984.

Clement [Waters], Clara Erskine. *The Queen of the Adriatic or Venice, Mediæval and Modern.* Boston: Estes and Lauriat, 1893.

Cloutier, Nicole. *James Wilson Morrice 1865-1924,* exhibition catalogue. Montreal: The Montreal Museum of Fine Arts, 1986.

Cole, Robert J. "Maurice Prendergast Features One Woman," *New York Evening Sun,* February 26, 1915, p. 10.

"Collection of Decorative Drawings Shown at Hart & Watson's," *Boston Sunday Herald,* December 19, 1897, p. 30.

deKay, Charles, "Six Impressionists: Startling Work by Red Hot American Painters," *New York Times,* January 20, 1904, p. 9.

Derby, Carol. "Charles Prendergast's Frames: Reuniting Design & Craftsmanship." in *The Prendergasts & The Arts & Crafts Movement,* Williamstown, Massachusetts: Williams College Museum of Art, 1989.

Downes, William Howe. "Exhibition of the Water Color Club," *Boston Evening Transcript,* February 6, 1911, p. 11.

Edgerton, Giles [Mary Fanton Roberts], "The Younger American Painters: Are They Creating a National Art?," *Craftsman* 13 (February 1908), p. 523.

"'The Eight' Stir Up Many Emotions," *Newark Evening News,* May 8, 1909, II, p. 4.

"Exhibitions Now On," *American Art News* 6, no. 26 (April 11, 1908), p. 6.

"The Fine Arts: Gallery and Studio Notes," *Boston Evening Transcript,* April 24, 1897, p. 4.

"Four Boston Artists," *Boston Evening Transcript,* March 31, 1913, p. 11.

"Four Boston Painters," *Boston Evening Transcript,* January 8, 1913, p. 25.

Garland, Joseph E. *Boston's Gold Coast: The North Shore, 1890-1929.* Boston: Little, Brown and Company, 1981.

Glackens, Ira. *William Glackens and The Eight.* New York: Horizon Press, 1957.

Glavin, Ellen M. "Maurice Prendergast: The Boston Experience," *Art & Antiques* 5 (July-August, 1982), pp. 64-71.

Glavin, Ellen M., and Eleanor Green. "Chronology." In *Maurice Prendergast,* exhibition catalogue. College Park, Maryland: University of Maryland, 1976.

Gregg, Frederick James, introduction to the exhibition catalogue, *Maurice B. Prendergast: Paintings in Oil and Watercolors,* Carroll Galleries, February 15 to March 6, 1915.

Gregg, Frederick James. "'Expressionists' Presented as New Class of Artists," *New York Herald,* March 9, 1919, Third Section, p. 9.

Hitchings, Sinclair. "The Prendergasts' Boston." In *The Prendergasts & The Arts & Crafts Movement,* Williamstown, Massachusetts: Williams College Museum of Art, 1989.

Hoeber, Arthur. "Art and Artists," *Globe and Commercial Advertiser,* February 5, 1908, p. 9.

Homer, William I. *Alfred Stieglitz and the American Avant-Garde.* Boston: New York Graphic Society, 1977.

Huneker, James. "Eight Painters," *New York Sun,* February 9, 1908, p. 8.

Kandinsky, Wassily. "Extracts from 'The Spiritual in Art,'" *Camera Work* 39 (July 1912), p. 34.

Langdale, Cecily. *Charles Conder, Robert Henri, James Morrice, Maurice Prendergast,* exhibition catalogue. New York: Davis & Long Co., 1975.

Langdale, Cecily. *The Monotypes of Maurice Prendergast,* exhibition catalogue. New York: Davis & Long Co., 1979.

Langdale, Cecily. *Monotypes by Maurice Prendergast in the Terra Museum of American Art,* exhibition catalogue. Chicago: Terra Museum of American Art, 1984.

Levin, Gail. "Morgan Russell." In *The Advent of Modernism: Post-Impressionism and North American Art, 1900-1918.* Atlanta, Georgia: High Museum of Art, 1986.

Matisse, Henri. "Notes of a Painter" (1908) in Herschel B. Chipp, *Theories of Modern Art* (Berkeley: University of California Press, 1971), pp. 130-137. Originally published as "Notes d'un peintre" in *La Grande Revue* (Paris, December 25, 1908, pp. 731-745). Translation from *Matisse: His Art and His Public* by Alfred H. Barr, Jr. (New York: The Museum of Modern Art, 1951).

Milliken, William M. "Maurice Prendergast, American Artist," *The Arts* 9 (April, 1926), pp. 180-192.

Moffatt, Frederick C. *Arthur Wesley Dow (1857-1922),* exhibition catalogue. Washington, D. C.: Smithsonian Institution Press, 1977.

"The 'New Art' Applied to Decoration," *Vanity Fair* 4, no. 3 (May, 1915), p. 40.

"New Books," *New York Evening Sun,* January 2, 1896, p. 5.

Newspaper clipping, unknown source [May-June 1905] (Scrapbook 21, April 1905-March 1906, no. 24, Art Institute of Chicago Archives).

Pach, Walter. *Queer Thing, Painting.* New York: Harper & Brothers Publishing, 1938.

Pepper, Charles Hovey. "Is Drawing to Disappear in Artistic Individuality?" *The World To-Day* 19, no. 1 (July 1910), pp. 716-719.

Pepper, Charles Hovey. *Japanese Prints.* Boston: Walter Kimball and Company, n. d. [1905].

Perlman, Bennard B. *The Immortal Eight.* New York: Exposition Press, 1962.

Phillips, Sandra S. "The Art Criticism of Walter Pach," *Art Bulletin* 65, no. 1 (March, 1983), pp. 106-121.

"Prendergast's Paintings," *New York Times,* March 4, 1915, p. 8.

Reich, Sheldon. *Alfred H. Maurer 1868-1932,* exhibition catalogue. Washington, D. C.: National Collection of Fine Arts, 1973.

Rhys, Hedley H. "Maurice Prendergast: The Sources and Development of His Style." Unpublished dissertation, Harvard University, 1952.

Rhys, Hedley H. "Maurice B. Prendergast." In *Maurice Prendergast,* exhibition catalogue. Cambridge: Harvard University Press, 1960.

"A Significant Group of Paintings," *New York Evening Sun,* January 23, 1904, p. 4.

Smith, Joseph Coburn, *Charles Hovey Pepper.* Portland, Maine: The Southworth-Anthoensen Press, 1945.

"Striking Pictures by Eight 'Rebels,'" *New York Herald,* February 4, 1908, p. 9.

Troyon, Carol. *The Boston Tradition: American Paintings from the Museum of Fine Arts, Boston,* exhibition catalogue. Boston: Museum of Fine Arts, 1980.

Wright, Willard Huntington. "Impressionism to Synchromism," *Forum* 50 (December, 1913), pp. 757-770.

Wright, Willard Huntington. *Modern Painting: Its Tendency and Meaning.* New York: John Lane Company, 1915.

Catalogue of Works

Works will be shown at all four venues, except as indicated:

[A] Whitney Museum of American Art
[B] Williams College Museum of Art
[C] Los Angeles County Museum of Art
[D] The Phillips Collection

1 Evening Shower, Paris ca. 1892–94

Oil on panel (12¹/₂ x 8¹/₂ in.; 31.7 x 21.6 cm)
Private Collection

INSCRIPTIONS
l. l. in red: Prendergast

PROVENANCE
The artist; to Charles Prendergast, 1924; to Mrs. Charles Prendergast, 1948; to (Kraushaar); to present collection, 1952
verso: Untitled (carriage horse)
 Oil and pencil

2 Sketches in Paris ca. 1892–94

Girls in the Park; Paris Boulevards; Parisian Boulevards; Seven Genre Sketches; Seven Sketches in Paris
Frame by Charles Prendergast

Oil on panel (6¹/₄ x 3³/₄ in.; 17.1 x 9.5 cm; each panel)
Addison Gallery of American Art, Phillips Academy, Andover, Massachusetts (1939.2)

INSCRIPTIONS
a. l. l. vertically: Prendergast
b. l. r.: Prendergast
c. l. l.: Prendergast
d. l. l.: Prendergast
e. l. l.: Prendergast
f. l. l.: Prendergast
g. l. r. vertically: Prendergast

PROVENANCE
The artist; to Charles Prendergast, 1924; to (Macbeth), 1938; to present collection, 1939
Charles Prendergast framed together these seven small panels ca. 1933.

3 Along the Seine ca. 1892–94

Frame by Charles Prendergast

Oil on canvas (13 x 9¹/₂ in.; 33.0 x 24.1 cm)
Whitney Museum of American Art.
Purchase (39.27)

INSCRIPTIONS
l. l. in blue: Prendergast

PROVENANCE
The artist; to Charles Prendergast, 1924; to present collection, 1939

4 Dieppe ca. 1892–94

Oil on canvas (12³/₄ x 9¹/₂ in.; 32.4 x 24.1 cm)
Whitney Museum of American Art. Gift of Arthur G. Altschul (75.51)

INSCRIPTIONS
l. l. in black: Prendergast/Dieppe

PROVENANCE
The artist; to Charles Prendergast, 1924; to Mrs. Charles Prendergast, 1948; to (Kraushaar); to Raymond Chaffetz, 1949; (Kraushaar); to Arthur G. Altschul, 1956; to present collection, 1975

5 Paris Boulevard in Rain 1893

Champs-Elysées; Rainy Day, Paris; Wet Day, Paris

Watercolor and pencil on paper (13 x 10 in.; 33.0 x 25.4 cm)
Marcia Fuller French

INSCRIPTIONS
l. r. in black ink: To Mable Pelletier/Souvenir/Maurice B. Prendergast/Paris 93 [over same inscription in pencil]

PROVENANCE
The artist; to Mable Pelletier; (Goodman-Walker, Boston); to Donald B. Willson, 1941; to Caroline B. Willson (later Caroline B. Robie), 1948; to (Childs, Boston), 1952; to (Knoedler), 1952; to Mr. and Mrs. William Marshall Fuller, 1953; to present collection

6 South Boston Pier 1896

Atlantic City Pier; The Pier at Atlantic City; The Pier, Atlantic City; South Boston

Watercolor and pencil on paper (18¹/₄ x 14 in.; 46.4 x 35.6 cm)
Smith College Museum of Art, Northampton, Massachusetts. Purchased, Charles B. Hoyt Fund, 1950 (1950:43)

INSCRIPTIONS
l. l. in black ink: Maurice B. Prendergast
l. l. in blue and mauve: Prendergast/1896

PROVENANCE
Mr. and Mrs. J. Montgomery Sears; to Mrs. J.D. Cameron Bradley; to (Childs, Boston); to present collection, 1950
[A B]

7 South Boston Pier ca. 1895–97

Watercolor and pencil on paper (12¹/₄ x 19¹/₈ in.; 31.2 x 48.5 cm)
Gift of Annie Swan Coburn in memory of Olivia Shaler Swan, The Art Institute of Chicago (1948.208)

INSCRIPTIONS
l. r. in pencil: Prendergast
verso, u. c. in pencil: South Boston Pier

PROVENANCE
The artist; to Charles Prendergast, 1924; to (Kraushaar); to present collection, 1948
[B]

8 Revere Beach 1896

Watercolor and pencil on paper (14 x 10 in.; 35.6 x 25.4 cm)
Collection of Mr. and Mrs. Raymond J. Horowitz

INSCRIPTIONS
l. r. in black: Prendergast 1896

PROVENANCE
Edgar W. Hodgson; to Carolyn Holdtman, by 1949; (Sotheby's), 1972; to present collection, 1972
[A]

9 Children on a Raft 1896

Watercolor and pencil on paper (17¹/₂ x 13³/₈ in.; 44.5 x 34.0 cm)
Manoogian Collection

INSCRIPTIONS
l. r. in black ink: Maurice B. Prendergast/1896

PROVENANCE
The artist; to Charles Prendergast, 1924; to Mrs. Charles Prendergast, 1948; to (Coe Kerr), 1983; to present collection, 1983

This picture may appear in the back of a studio photograph of Maurice Prendergast taken at 83 Walnut Street, Winchester, MA, ca. 1900–03 (fig. 9) (Prendergast Archive, Williams College Museum of Art)

10 Float at Low Tide, Revere Beach ca. 1896–97

On the Float at Low Tide; People at the Beach

Watercolor and pencil on paper (13¹/₄ x 9¹/₄ in.; 33.7 x 23.5 cm; sight)
Addison Gallery of American Art, Phillips Academy, Andover, Massachusetts, Gift of Mrs. William C. Endicott (1942.2)

INSCRIPTIONS

l. r. in brown ink: Maurice B. Prendergast

PROVENANCE

Mrs. William C. Endicott; to present collection, 1942

[**B C D**]

11 Revere Beach 1896

Watercolor and pencil on paper
(13⅝ x 9⅞ in.; 34.6 x 25.1 cm)
The Saint Louis Art Museum, Purchase
(109.1947)

INSCRIPTIONS

l. l. in black ink: Maurice B. Prendergast/1896
l. r. in blue ink: Prendergast/1896

PROVENANCE

(Giovanni Castano, Boston); to present collection,
1947

[**A**]

12 Summer Visitors 1896

New England; Summer, Visitors Near the Shore

Watercolor and pencil on paper
(19 x 15 in.; 48.3 x 38.1 cm)
Private Collection

INSCRIPTIONS

l. r. in gray: M. B. Prendergast/'96

PROVENANCE

(Kraushaar); to (Margaret Brown, Boston); to Mr.
and Mrs. Walter Ross and estates, 1951; to (Hirschl &
Adler), 1985; to present collection, 1985

13 Ladies with Parasols ca. 1896–97

Watercolor and pencil on paper
(12¾ x 10 in.; 32.4 x 25.4 cm)
Collection of Kathyrn and Robert Steinberg

INSCRIPTIONS

l. l. in black: Prndergast

PROVENANCE

The artist; to Charles Prendergast, 1924; to Mrs.
Charles Prendergast, 1948; to (Coe Kerr), 1986; to
present collection, 1986

[**A**]

14 Low Tide, Nantasket
ca. 1896–97

Watercolor and pencil on paper
(20⅛ x 14 in.; 51.1 x 35.6 cm)
Williams College Museum of Art, Gift of
Mrs. Charles Prendergast (86.18.2)

INSCRIPTIONS

l. r. in blue: Prendergast

PROVENANCE

The artist; to Charles Prendergast, 1924; to Mrs.
Charles Prendergast, 1948; to present collection, 1986

[**C D**]

15 Low Tide ca. 1896–97

Watercolor and pencil on paper
(14 x 10 in.; 35.6 x 25.4 cm)
Williams College Museum of Art, Gift of
Mrs. Charles Prendergast (86.18.55)

INSCRIPTIONS

l. l. in red pencil: Prendergast

PROVENANCE

The artist; to Charles Prendergast, 1924; to Mrs.
Charles Prendergast, 1948; to present collection, 1986

verso: *Low Tide*

[**C D**]

16 Rocky Shore, Nantasket
ca. 1896–97

Frame by Charles Prendergast

Watercolor, pencil and ink on paper
(17 x 12½ in.; 43.2 x 31.7 cm)
Mr. and Mrs. Granville M. Brumbaugh

INSCRIPTIONS

l. l. in ink: Prendergast

PROVENANCE

The artist; to Charles Prendergast, 1924; to present
collection, 1938, from Mr. and Mrs. Charles Prender-
gast

17 Figures under the Flag
ca. 1900–05

Frame by Charles Prendergast

Watercolor and pencil on paper
(20½ x 10¼ in.; 52.1 x 26.0 cm)
Williams College Museum of Art, Gift of
Mrs. Charles Prendergast (86.18.70)

INSCRIPTIONS

l. l. in black: Prendergast

PROVENANCE

The artist; to Charles Prendergast, 1924; to Mrs.
Charles Prendergast, 1948; to present collection, 1986

[**C D**]

18 Low Tide ca. 1895–97

Oil on panel (13½ x 18 in.; 34.3 x 45.7 cm)
Williams College Museum of Art, Gift of
Mrs. Charles Prendergast (86.18.40)

INSCRIPTIONS

l. r. in brown over yellow: Prendergast

PROVENANCE

The artist; to Charles Prendergast, 1924; to Mrs.
Charles Prendergast, 1948; to present collection, 1986

19 Evening on a Pleasure Boat
ca. 1895–97

*Boston Harbor; A Summer Evening Excursion
on the Harbour*

Oil on canvas (14 x 22 in.; 35.6 x 55.9 cm)
Daniel J. Terra Collection, Terra Museum of
American Art, Chicago (28.1980)

INSCRIPTIONS

l. l., incised: Prendergast/Evening on a Pleasure Boat.

PROVENANCE

The artist; to Charles Prendergast, 1924; to Mrs.
Charles Prendergast, 1948; to (Kraushaar); to Mr. and
Mrs. John Koch, 1954; (ACA); to present collection,
1979

20 Splash of Sunshine and Rain 1899

*? After a [or the] Shower on the Piazza, Venice;
Church of St. Mark; ? Piazza San Marco;
Piazza, San Marco, Venice; Square of San
Marco, Venice; ? St. Mark's; Venice*

Frame by Charles Prendergast

Watercolor and pencil on paper
(19⅜ x 14¼ in.; 49.2 x 36.2 cm)
The collection of Alice M. Kaplan

INSCRIPTIONS

l. l. in pencil: Prendergast/Venice 1899

PROVENANCE

Private collection; to (Sotheby's), 1973; to Byron
Goldman, 1973; to (Berry-Hill), 1974; to present col-
lection, 1974

21 St. Mark's, Venice 1898

Frame by Charles Prendergast

Watercolor and pencil on paper
(14⅛ x 19½ in.; 35.9 x 49.5 cm)
National Gallery of Art, Washington, D. C.,
Gift of Eugénie Prendergast (1984.63.1)

INSCRIPTIONS

l. l. in black ink over pencil: Prendergast [in brown
ink] 1898
verso: l. r. in black crayon: 1898/Venice 192
u. r. in black crayon: St. Marks/150

PROVENANCE

The artist; to Charles Prendergast, 1924; to Mrs.
Charles Prendergast, 1948; to present collection, 1984

[**A B**]

22 Venice ca. 1898–99

Watercolor and pencil on paper
(14⅛ x 20¾ in.; 35.9 x 52.7 cm)
Williams College Museum of Art, Gift of
Mrs. Charles Prendergast (86.18.61)

INSCRIPTIONS

l. r. in ink: Prendergast
verso: l. c. in pencil: Venice 1898

PROVENANCE

The artist; to Charles Prendergast, 1924; to Mrs.
Charles Prendergast, 1948; to present collection, 1986

verso: *Nude Bathers in a Landscape*, ca. 1913–13
 Pencil

[**B C D**]

23 St. Mark's Square, Venice
(The Clock Tower) ca. 1898–99

St. Mark's, Venice

Frame by Charles Prendergast

Watercolor and pencil on paper
(26 x 6 in.; 66.0 x 15.2 cm)
Collection of the William A. Farnsworth
Library and Art Museum (44.316)

INSCRIPTIONS

l. l. in pencil: Prendergast

PROVENANCE

Mrs. J. Montgomery Sears; to Mrs. J. D. Cameron
Bradley; to (Childs, Boston), 1943; to present collec-
tion, 1944

[**A B**]

24 Easter Procession, St. Mark's

ca. 1898–99

? Interior of St. Marks; ? Interior, St. Mark's, Venice

Watercolor and pencil on paper
(18 x 14 in.; 45.7 x 35.6 cm; sight)
Collection of Erving and Joyce Wolf

INSCRIPTIONS

l. r. in brown ink: Maurice B. Prendergast
l. l. in pencil: Prendergast
verso, in pencil: Venice 1898

PROVENANCE

M. D. C. Crawford; to Morris Crawford, Jr.; (Kraushaar); to Mr. and Mrs. Walter Ross, 1956; to their estates, 1981; to (Hirschl & Adler), 1985; to present collection, 1985

[A]

25 Fiesta–Venice–S. Pietro in Volta

ca. 1898–99

Day Before the Festa; The Day Before a Festa, St. Pietro in Volte
Frame by Charles Prendergast

Watercolor and pencil on paper
(13³/₈ x 12¹/₂ in.; 34.0 x 31.7 cm)
Williams College Museum of Art, Gift of Mrs. Charles Prendergast (86.18.76)

INSCRIPTIONS

l. l. in pencil: The day before festa/St. Pietro in Volta/Prendergast
l. l. in ink: Maurice B. Prendergast

PROVENANCE

The artist; to Charles Prendergast, 1924; to Mrs. Charles Prendergast, 1948; to present collection, 1986

26 Venice ca. 1898–99

Watercolor and pencil on paper
(17¹/₄ x 15¹/₂ in.; 43.8 x 39.4 cm)
Addison Gallery of American Art, Phillips Academy, Andover, Massachusetts, Bequest of Miss L. P. Bliss (1931.96)

INSCRIPTIONS

l. l. in brown ink: Maurice Prendergast

PROVENANCE

The artist; to Charles Prendergast, 1924; (Macbeth); to Lillie P. Bliss, 1925; to present collection, 1931

verso: *Sketch of Gondolas*
Pencil

This is a view of Ponte Apostoli from Sotto Portico del Magazen.

[A B C]

27 Venetian Canal Scene ca. 1898–99

Grand Canal

Watercolor and pencil on paper
(13⁷/₈ x 20³/₈ in.; 35.2 x 51.8 cm)
Private Collection

INSCRIPTIONS

l. l. in black ink: Prendergast/[in pencil] Prendergast

PROVENANCE

Michael Naify, by ca. 1933; to Marshall Naify (his son), 1964; to Arthur G. Altschul, 1973; to (Edward L. Shein, Providence), 1981; to (Davis & Langdale), 1981; to present collection, 1981

This view of the Ponte Lion is from the Ponte dei Greci looking down the Rio dei Greci toward S. Lorenzo.

[B]

28 Grand Canal, Venice ca. 1898–99

Watercolor and pencil on paper
(9³/₄ x 13⁵/₈ in.; 24.8 x 34.6 cm; sight)
Collection of Mrs. Charles Prendergast

INSCRIPTIONS

l. l. in black ink: Prendergast

PROVENANCE

The artist; to Charles Prendergast, 1924; to present collection, 1948

This view from the steps of the Dogana shows the former Bucintoro Rowing Club to the right and buildings that are now hotels along the Grand Canal.

29 Festa del Redentore ca. 1899

Festa della Redentore

Watercolor and pencil on paper
(11 x 17 in.; 27.9 x 43.2 cm)
Collection of Mrs. Charles Prendergast

INSCRIPTIONS

l. r. in red: Prendergast

PROVENANCE

The artist; to Charles Prendergast, 1924; to present collection, 1948

The Festa del Redentore takes place on the Giudecca canal on the third Sunday of July. Because Prendergast did not apply for a passport until 29 June 1898, it is more likely that this is a scene of the 1899 Festa del Redentore.

[C D]

30 Assisi ca. 1898–99

Watercolor and pencil on paper
(15³/₈ x 11 in.; 39.1 x 28 cm)
Williams College Museum of Art, Gift of Mrs. Charles Prendergast (86.18.59)

INSCRIPTIONS

l. r. in pencil: Prendergast

PROVENANCE

The artist; to Charles Prendergast, 1924; to Mrs. Charles Prendergast, 1948; to present collection, 1986

[C D]

31 Afternoon, Pincian Hill

ca. 1898–99

The Pincian Hill, Rome

Watercolor and pencil on paper
(15¹/₈ x 10⁵/₈ in.; 38.4 x 26.4 cm)
Honolulu Academy of Arts, Gift of Mrs. Philip E. Spalding, 1940 (11,653)

INSCRIPTIONS

unsigned

PROVENANCE

Private collection, San Francisco; Mrs. Cressaty; to Mrs. Charles M. Cooke, Sr.; to Mrs. Phillip E. Spalding (her daughter); to present collection, 1940

verso: *Sketch of Venice*
Pencil and watercolor
This is a view along the Riva degli Schiavoni, Venice.

32 Pincian Hill, Rome 1898

Pincian Hill; Afternoon, Pincian Hill; The Pincian Hill

Watercolor and pencil on paper
(20³/₄ x 26⁷/₈ in.; 52.7 x 68.2 cm, sight)
The Phillips Collection, Washington, D.C. (1609)

INSCRIPTIONS

l. r. in black: Pincian Hill./Rome 1898/Prendergast.

PROVENANCE

(Montross); to Duncan Phillips, 1920; to present collection, 1920

[A D]

33 West Church, Boston ca. 1900–01

Red School House, Boston; Street Scene, Boston; West Church at Cambridge and Lynde Streets

Watercolor, pencil, and opaque white on paper
(10⁷/₈ x 15³/₈ in.; 27.6 x 39.0 cm)
Museum of Fine Arts, Boston, Charles Henry Hayden Fund (58.1199)

INSCRIPTIONS

l. r. in brown: Prendergast

PROVENANCE

Sheldon F. Wardwell; to (Macbeth), 1940; Robert Brackman, 1941; to (Hirschl & Adler), 1958; to present collection, 1958

At the turn of the century, West Church was temporarily used as a library. Prendergast did a series of views of the church-turned-library from the street or from the steps of the church, all of which show the courtyard and the fountain.

[A]

34 Madison Square 1901

Watercolor and pencil on paper
(15 x 16¹/₂ in.; 38.1 x 41.9 cm)
Whitney Museum of American Art.
Joan Whitney Payson Bequest (76.14)

INSCRIPTIONS

l. r. in black ink: Madison Square/New York/Maurice B. Prendergast/1901

PROVENANCE

The artist; to Charles Prendergast, 1924; to Mrs. Charles Prendergast, 1948; to Joan Whitney Payson; to present collection, 1976

The banner in this view of Madison Square is an advertisement for the Pan-American Exposition held in Buffalo, New York from May 1 to Nov. 2, 1901.

35 The Mall, Central Park

1901

Steps, Central Park; The Terrace; The Terrace Bridge, Central Park

Watercolor and pencil on paper
(15¹/₄ x 22¹/₂ in.; 38.7 x 56.9 cm)
The Olivia Shaler Swan Memorial Collection, The Art Institute of Chicago (1939.431)

INSCRIPTIONS

l. r. in pencil: Maurice B. Prendergast/The Terrace Bridge Central Park/1901 New York

PROVENANCE

(Kraushaar); to Cornelius J. Sullivan, 1926; to Mrs. Cornelius J. Sullivan; Olivia Shaler Swan; to present collection, 1939

[B]

36 Central Park 1900

Watercolor, pastel, charcoal and pencil on paper (14³/₈ x 21¹/₂ in.; 36.5 x 54.6 cm)
Whitney Museum of American Art. Purchase (32.41)

INSCRIPTIONS

l. l. in ink: Prendergast/1900

PROVENANCE

The artist; to Charles Prendergast, 1924; to present collection, 1932

[B C D]

37 Central Park ca. 1901

Central Park, New York City

Watercolor and pencil on paper (15¹/₄ x 22 in.; 38.7 x 55.9 cm)
Williams College Museum of Art, Gift of Mrs. Charles Prendergast (67.13)

INSCRIPTIONS

l. r. in ink: Prendergast
verso: Central Park/New York City

PROVENANCE

The artist; to Charles Prendergast, 1924; to Mrs. Charles Prendergast, 1948; to present collection, 1967

38 Central Park 1901

Watercolor, pencil, ink and pastel on paper (14³/₈ x 21¹/₂ in.; 36.5 x 54.9 cm; sight)
Whitney Museum of American Art. Purchase (32.42)

INSCRIPTIONS

l. r. in ink: Maurice B. Prendergast/Central Park/1901
l. l. in pencil: Prendergast

PROVENANCE

The artist; to Charles Prendergast, 1924; to present collection, 1932

39 In Central Park, New York

ca. 1900-03

Watercolor and pencil on paper (12¹/₄ x 20 in.; 31.3 x 50.8 cm)
Addison Gallery of American Art, Phillips Academy, Andover, Massachusetts, Gift of Anonymous Donor (1928.48)

INSCRIPTIONS

l. r. in brown ink: Prendergast
verso in ink: New York

PROVENANCE

The artist; to Charles Prendergast, 1924; to (Macbeth), 1928; to Thomas Cochran, 1928; to present collection, 1928

[B C D]

40 Merry-Go-Round, Nahant

ca. 1900-01

Carousel; Carrousel; Merry-Go-Round (Nahant)

Frame by Charles Prendergast

Watercolor and pencil on paper (13¹/₄ x 19 in.; 33.7 x 48.3 cm; sight)
Museum of Fine Arts, Springfield, Massachusetts (49.D02)

INSCRIPTIONS

l. l. in ink: Prendergast

PROVENANCE

The artist; to Charles Prendergast, 1924; to (Kraushaar); to present collection, 1949

verso: Carousel Horses and Riders
 Pencil

[A B]

41 May Day, Central Park

ca. 1900-03

Central Park

Watercolor and pencil on paper (14¹/₂ x 21⁵/₈ in.; 36.8 x 54.9 cm)
Whitney Museum of American Art. Exchange (48.19)

INSCRIPTIONS

l. r. in black: Prendergast

PROVENANCE

The artist; to Charles Prendergast, 1924; to (Kraushaar); to present collection, 1948

[A]

42 May Day, Central Park 1901

Maypole, Central Park

Frame by Charles Prendergast

Watercolor and pencil on paper (13⁷/₈ x 19⁷/₈ in.; 35.4 x 50.6 cm)
The Cleveland Museum of Art, Gift from J. H. Wade (26.17)

INSCRIPTIONS

l. c.: Maurice B. Prendergast/Central Park/1901/New York
verso, c. in pencil: May Day Central Park

PROVENANCE

(Kraushaar); to present collection, 1926

[A B]

43 The East River 1901

Watercolor and pencil on paper (13⁷/₈ x 20 in.; 35.2 x 50.8 cm)
The Museum of Modern Art, New York. Gift of Abby Aldrich Rockefeller (132.35)

INSCRIPTIONS

l. r. in ink: Maurice B. Prendergast/1901 The East River

PROVENANCE

The artist; to Charles Prendergast, 1924; to (Kraushaar); to Abby Aldrich Rockefeller, 1930; to present collection, 1935

verso: Untitled (East River park scene)
 Watercolor and pencil

44 Surf, Cohasset ca. 1900-05

Watercolor and pencil on paper (10⁵/₈ x 14⁷/₈ in.; 27.9 x 38.7 cm)
Collection of Mrs. Charles Prendergast

INSCRIPTIONS

l. r. in yellow pastel: Prendergast

PROVENANCE

The artist; to Charles Prendergast, 1924; to present collection, 1948

45 Surf, Nantasket ca. 1900-05

Watercolor and pencil on paper (15³/₈ x 11¹/₈ in.; 39.1 x 28.3 cm)
Williams College Museum of Art, Gift of Mrs. Charles Prendergast (86.18.60)

INSCRIPTIONS

l. r. in black ink: Prendergast

PROVENANCE

The artist; to Charles Prendergast, 1924; to Mrs. Charles Prendergast, 1948; to present collection, 1986

verso: Untitled sketch
 Watercolor and pencil

46 April Snow, Salem ca. 1905-07

Watercolor, pencil and colored pencil on paper (15¹/₄ x 22¹/₈ in.; 38.7 x 56.2 cm)
The Museum of Modern Art, New York. Gift of Abby Aldrich Rockefeller (129.35)

INSCRIPTIONS

l. l. in gray: Prendergast

PROVENANCE

The artist; to Charles Prendergast, 1924; to (Kraushaar); to Abby Aldrich Rockefeller, 1930; to present collection, 1935

47 Notre Dame, Paris ca. 1907

Watercolor and pencil on paper (13⁷/₈ x 20 in.; 35.2 x 50.8 cm)
Worcester Art Museum, Worcester, MA (1941.36)

INSCRIPTIONS

l. r. in black ink: Maurice Prendergast
verso in black chalk: Paris/19[09 or 07]

PROVENANCE

The artist; to Charles Prendergast, 1924; to (Kraushaar); to present collection, 1941

[A]

48 Paris ca. 1907

Nocturne; Place Vendome

Watercolor and gouache on blue paper (12¹/₄ x 9³/₄ in.; 31.1 x 24.8 cm; sight)
Collection of Mrs. Charles Prendergast

INSCRIPTIONS

l. l. in pencil: Prendergast

PROVENANCE

The artist; to Charles Prendergast, 1924; to present collection, 1948

49 Band Concert ca. 1907

? The Concert; In the Park; New England Village

Watercolor and pencil on paper
(13⁷/₈ x 19¹/₄ in.; 35.2 x 49.0 cm)
Mead Art Museum, Amherst College,
Museum Purchase (1951.336)

INSCRIPTIONS

l. r. in black ink: Maurice Prendergast
verso, l. r. in pencil: Paris 1909

PROVENANCE

The artist; to Charles Prendergast, 1924; to Mrs.
Charles Prendergast, 1948; to (Kraushaar); to (Macbeth), 1951; to present collection, 1951

Although later inscribed 1909, this work probably
dates from the artist's 1907 trip to St. Malo.

50 The Balloon ca. 1907

The Balloon, Paris

Watercolor and pencil on paper
(13⁷/₈ x 20 in.; 35.2 x 50.8 cm)
Addison Gallery of American Art, Phillips
Academy, Andover, Massachusetts, Gift of
Anonymous Donor (1928.50)

[B C D]

51 Paris Omnibus ca. 1907

Oil on panel (10¹/₄ x 13⁵/₈ in.; 26.0 x 34.6 cm)
Bucknell University

INSCRIPTIONS

l. l.: Prendergast

PROVENANCE

The artist; to Charles Prendergast, 1924; to Mrs.
Charles Prendergast, 1948; to (Kraushaar); to Ellen
Clarke Bertrand, 1947; to present collection

52 In Luxembourg Gardens ca. 1907

Oil on panel (10¹/₄ x 13³/₄ in.; 26.0 x 34.9 cm)
The Phillips Collection, Washington, D.C.
(1605)

INSCRIPTIONS

l. l.: Prendergast

PROVENANCE

The artist; to Duncan Phillips, early 1920s; to present
collection

53 Beach, St. Malo ca. 1907

On the Beach, St. Malo

Watercolor and charcoal on paper
(13³/₄ x 19⁷/₈ in.; 34.9 x 50.5 cm)
The Cleveland Museum of Art, Gift of
William Mathewson Milliken in memory of
H. Oothout Milliken (49.543)

INSCRIPTIONS

l. l. in charcoal: P
l. c. in black ink: Prendergast/Prendergast

PROVENANCE

(Kraushaar); to William M. Milliken, 1926; to present
collection, 1949

[C D]

54 St. Malo No. 2 ca. 1907

On the Beach; ? St. Malo; ? St. Malo Beach

Watercolor and crayon on paper
(12³/₄ x 19¹/₄ in.; 32.4 x 48.9 cm)
Columbus Museum of Art, Ohio: Gift of
Ferdinand Howald, 1931 (31.247)

INSCRIPTIONS

l. c. in blue: Prendergast

PROVENANCE

(Daniel); to Ferdinand Howald, 1916; to present collection, 1931

[A B]

55 On the Beach, St. Malo
ca. 1907

On the Beach

Watercolor and pencil on paper
(13¹/₂ x 19⁷/₈ in.; 34.3 x 50.5 cm)
Addison Gallery of American Art, Phillips
Academy, Andover, Massachusetts, Bequest of
Miss L. P. Bliss (1931.94)

INSCRIPTIONS

l. l. in ink: Prendergast

PROVENANCE

The artist; to Lillie P. Bliss; to present collection,
1931

[A B C]

56 Rising Tide, St. Malo
ca. 1907

St. Malo

Watercolor and pencil on paper
(18⁵/₈ x 13¹/₂ in.; 47.3 x 34.3 cm)
Yale University Art Gallery, Gift of
George Hopper Fitch, B.A., 1932
(1978.125.1)

INSCRIPTIONS

l. r. in ink: Prendergast/Rising Tide/St. Malo
l. r. in pencil: Prendergast

PROVENANCE

George Hopper Fitch; to present collection, 1978

57 Beach, St. Malo ca. 1907

St. Malo
Frame by Charles Prendergast

Watercolor and pencil on paper
(15 x 10³/₄ in.; 38.1 x 27.3 cm)
Private Collection

INSCRIPTIONS

l. r. center in black: Prendergast

PROVENANCE

The artist; to Charles Prendergast, 1924; to Mr. and
Mrs. Max Kuehne; to (Kraushaar); to present collection, 1953

[A B]

58 St. Malo ca. 1907

Watercolor, pencil and gouache on paper
(15¹/₄ x 11 in.; 38.7 x 27.9 cm)
Williams College Museum of Art, Gift of
Mrs. Charles Prendergast (86.18.74)

INSCRIPTIONS

l. r. in ink: Prendergast
verso in pencil: St Malo/1909

Although later inscribed 1909, this work more likely
dates from the artist's 1907 trip to St. Malo.

[C D]

59 St. Malo ca. 1907

Watercolor and pencil on paper
(11¹/₄ x 15¹/₄ in.; 28.6 x 38.7 cm)
Williams College Museum of Art, Gift of
Mrs. Charles Prendergast (86.18.75)

INSCRIPTIONS

l. r. in black: Prendergast

60 Lighthouse at St. Malo ca. 1907

Lighthouse, St. Malo

Oil on canvas (20¹/₈ x 24⁵/₈ in.; 51.1 x 62.6 cm)
The William Benton Museum of Art, The University of Connecticut. Gift of Mrs. Eugénie
Prendergast (72.31)

INSCRIPTIONS

l. r.: Prendergast

PROVENANCE

The artist; to Charles Prendergast, 1924; to Mrs.
Charles Prendergast, 1948; to present collection, 1972

61 Chateaubriand's Tomb, St. Malo
ca. 1907

St. Malo – Tomb of Chateaubriand

Oil on canvas (11¹/₂ x 14¹/₂ in.; 29.2 x 36.8 cm)
Mr. and Mrs. Bob London

INSCRIPTIONS

l. r. in red: Prendergast

62 St. Malo ca. 1903–06

Sketch, St. Malo

Oil on panel (10¹/₂ x 13³/₄ in.; 26.7 x 34.9 cm)
The Cleveland Museum of Art, Mr. and Mrs.
Charles G. Prasse Collection (82.162)

INSCRIPTIONS

Unsigned

PROVENANCE

(Kraushaar through Gage, Cleveland); to Leona E.
Prasse, by 1933; to present collection, 1982

Although this work has been titled *St. Malo*, it does
not have any of the standard items, such as French
flags, bathing tents or a coastline that can be specifically identified with France, which would mark it as a
work from Prendergast's 1907 trip abroad.

[A B]

63 Crescent Beach ca. 1907

Crescent Beach, St. Malo

Oil on panel (10¹/₄ x 13¹/₂ in.; 26 x 34.3 cm)
Bucknell University

INSCRIPTIONS

l. l.: Prendergast

PROVENANCE

The artist; to Charles Prendergast, 1924; to
(Kraushaar); to Ellen Clarke Bertrand, 1947; to present collection

64 Study St. Malo No. 11 ca. 1907

Studies, St. Malo

Oil on panel (10¹/₂ x 13³/₄ in.; 26.7 x 34.9 cm)
Private Collection

INSCRIPTIONS
l. l. in red: Prendergast

PROVENANCE
The artist; to Charles Prendergast, 1924; to Mrs.
Charles Prendergast, 1948; to present collection, 1984

65 Study St. Malo, No. 12 ca. 1907

Studies, St. Malo

Oil on panel (10¹/₂ x 13³/₄ in.; 26.7 x 34.9 cm)
Collection of Mrs. Charles Prendergast

INSCRIPTIONS
l. l. in black: Prendergast

PROVENANCE
The artist; to Charles Prendergast, 1924; to present
collection, 1948

66 Opal Sea ca. 1907–10

Promenade at City Point
Frame by Charles Prendergast

Oil on canvas (22 x 34 in.; 55.9 x 86.4 cm)
Daniel J. Terra Collection, Terra Museum of
American Art, Chicago (30.1980)

INSCRIPTIONS
l. r. in brown: Prendergast

PROVENANCE
Charles Hovey Pepper; to Mrs. F. Bradshaw Wood
(his granddaughter); Dr. William Winter?; to (Hunter,
San Francisco), 1975; to (Berry-Hill), 1976; to present
collection, 1976

This work was photographed in Prendergast's studio
by fellow-artist Charles Hovey Pepper around 1910.

67 Spring Promenade ca. 1910–11

Watercolor and pencil on paper
(21⁵/₈ x 14⁷/₈ in.; 54.9 x 37.8 cm; sight)
Williams College Museum of Art, Gift of
Mrs. Charles Prendergast (86.18.6)

INSCRIPTIONS
l. l. in pencil: Prendergast

PROVENANCE
The artist; to Charles Prendergast, 1924; to Mrs.
Charles Prendergast, 1948; to present collection, 1986

68 Children in the Tree ca. 1910–11

Watercolor and pencil on paper
(15¹/₈ x 22¹/₄ in.; 38.4 x 56.5 cm)
Collection of Mrs. Charles Prendergast

INSCRIPTIONS
l. r. in black ink: Prendergast

PROVENANCE
The artist; to Charles Prendergast, 1924; to present
collection, 1948

verso: Sketch for Children in the Tree
 Pencil

69 Santa Maria Formosa, Venice
ca. 1911–12

Church in Venice: Santa Maria Formosa

Watercolor and pencil on paper
(22 x 15¹/₄ in.; 55.8 x 38.9 cm)
Museum of Fine Arts, Boston,
Charles Henry Hayden Fund (59.58)

INSCRIPTIONS
l. r. in black ink: Maurice B. Prendergast/Venis 1912

PROVENANCE
Comtesse de Bellele; to (Wildenstein); to (Victor
D. Spark); to present collection, 1959
[A]

70 Venice ca. 1911–12

Watercolor and pencil on paper
(14⁵/₈ x 21¹/₄ in.; 37.5 x 34.5 cm)
Columbus Museum of Art, Ohio: Gift of
Ferdinand Howald, 1931 (31.251)

INSCRIPTIONS
l. r. in black ink: Prendergast

PROVENANCE
(Daniel); to Ferdinand Howald, 1915; to present col-
lection, 1931

This is a view of Ponte Nicolo Pasqualigo, showing
the campanile of S. Felice in the background.
[A B]

71 Canal ca. 1911–12

Canal, Venice

Watercolor and pencil on paper
(15³/₈ x 22 in.; 39.1 x 55.9 cm)
Munson-Williams-Proctor Institute Museum
of Art, Utica, New York, Edward W. Root
Bequest (57.213)

INSCRIPTIONS
l. r. in black ink: Maurice B. Prendergast/Venice 1912

PROVENANCE
The artist; to Edward W. Root, 1912; to present col-
lection, 1957

verso: *Rialto Bridge in Venice*

This is a view of Ponte Apostoli from Sotto Portico
del Magazen.
[B C]

72 Rialto, Venice
ca. 1911–12

Watercolor and pencil on paper
(14⁷/₈ x 21⁵/₈ in.; 38.1 x 55.9 cm)
Williams College Museum of Art, Gift of
Mrs. Charles Prendergast (86.18.79)

INSCRIPTIONS
l. r. in brown: Prendergast

PROVENANCE
The artist; to Charles Prendergast, 1924; to Mrs.
Charles Prendergast, 1948; to present collection, 1986

verso: *Rialto, Venice*

73 Still Life: Fruit and Flowers
ca. 1910–13

Oil on canvas (18¹/₂ x 21¹/₂ in.; 47.0 x 54.6 cm)
Collection of The Montclair Art Museum,
Museum Purchase, Florence O. R. Lang Fund
(54.20)

INSCRIPTIONS
u. l.: Prendergast

PROVENANCE
(Kraushaar); to Mr. and Mrs. Cornelius Sullivan,
1926; to (AAA/Anderson) 1937; C. L. Robertson, Jr.;
to (Macbeth); to present collection, 1954

74 Still Life ca. 1910–13

*Still Life with Bottle; Still Life with Geranium
and Bottle*

Oil on canvas (16 x 20¹/₄ in.; 40.6 x 51.4 cm)
Collection of Mrs. John W. Griffith

INSCRIPTIONS
l. r. in brown: Prendergast

PROVENANCE
The artist; to Charles Prendergast, 1924; to (Kraus-
haar); to Oliver James, 1940; (Kraushaar); to The
Toledo Museum of Art, 1953; to (Hirschl & Adler),
1957; sold to benefit American Friends of Hebrew
University, 1957; Dr. and Mrs. Ivan Gilbert; (private
gallery, Columbus, OH); to (Hirschl & Adler), 1981;
to present collection, 1983

**75 La Rouge: Portrait of
Miss Edith King ca. 1910–13**

Lady with the Rouge; The Rouge

Oil on canvas (28¹/₂ x 31¹/₂ in.; 72.4 x 80.0 cm)
Lehigh University Art Galleries-Museum Op-
eration, Bethlehem, Pennsylvania. The Anna
E. Wilson Memorial Collection (LUP56.1007)

INSCRIPTIONS
l. l. in red: Prendergast

PROVENANCE
The artist; to Charles Prendergast, 1924; to Mrs.
Charles Prendergast, 1948; to (Kraushaar); to Mr. and
Mrs. Ralph L. Wilson, 1955; to present collection,
1956

76 Landscape with Figures
ca. 1910–13

The Park
Frame by Charles Prendergast

Oil on canvas (29⁵/₈ x 42⁷/₈ in.; 75.2 x 108.9 cm)
Munson-Williams-Proctor Institute Museum
of Art, Utica, New York, Edward W. Root
Bequest (57.212)

INSCRIPTIONS
l. r. in black: Prendergast

PROVENANCE
The artist; to Edward W. Root, 1913; to present col-
lection, 1957

77 A Dark Day ca. 1910–13

Oil on canvas (21¹/₄ x 27³/₈ in.; 53.3 x 68.6 cm)
Hirshhorn Museum and Sculpture Garden,
Smithsonian Institution. Gift of the Joseph H.
Hirshhorn Foundation, 1966 (66.4129)

INSCRIPTIONS

l. l. in brown: Prendergast

PROVENANCE

The artist; to Charles Prendergast, 1924; to Mrs. Charles Prendergast, 1948; to (Kraushaar), 1954; to Joseph H. Hirshhorn, 1954; to present collection, 1966

78 Seashore ca. 1913

The Beach; Scene at Beach; Scene at Beach, No. 2; Seascape; Seashore No. 2
Frame by Charles Prendergast

Oil on canvas (24 x 32 in.; 61.0 x 81.3 cm)
The Saint Louis Art Museum, Purchase: Eliza McMillan Fund (33.1948)

INSCRIPTIONS

l. c. in black: Prendergast

PROVENANCE

Adolph Lewisohn, by 1928; (Knoedler); to present collection, 1948

Seashore No. 2 is dated 1913 in the catalogue of the Prendergast exhibition at Carroll Galleries in 1915.

79 Boat Landing, Dinard ca. 1914

Landing, Dinard
Frame by Charles Prendergast

Watercolor, gouache and charcoal on paper (15¹/₄ x 22¹/₄ in.; 38.7 x 57.1 cm)
Williams College Museum of Art, Gift of Mrs. Charles Prendergast (86.18.71)

INSCRIPTIONS

l. r.: Prendergast
verso in pencil: St. Malo/1909

PROVENANCE

The artist; to Charles Prendergast, 1924; to Mrs. Charles Prendergast, 1948; to present collection, 1986

80 Marblehead ca. 1914-15

Frame by Charles Prendergast

Watercolor, pencil, charcoal and pastel on paper (11¹/₂ x 18 in.; 29.2 x 45.7 cm)
Williams College Museum of Art, Gift of Mrs. Charles Prendergast (86.18.5)

INSCRIPTIONS

l. r. in black ink over pencil: Prendergast

PROVENANCE

The artist; to Charles Prendergast, 1924; to Mrs. Charles Prendergast, 1948; to present collection, 1986

81 New England Harbor ca. 1919-23

Landscape; New England Bay; New England Village
Frame by Charles Prendergast

Oil on canvas (24 x 28 in.; 61.0 x 71.1 cm)
Cincinnati Art Museum; the Edwin and Virginia Irwin Memorial (1959.51)

INSCRIPTIONS

l. c.: Prendergast

PROVENANCE

The artist; to Charles Prendergast, 1924; to (Kraushaar); to Mr. and Mrs. Edward G. Robinson, 1938; to Stavros Niarchos; to (Knoedler), 1958; to present collection, 1959

An old photograph marked "AIC" shows this painting at an earlier stage. In the final version, pointillistic color has been applied to the costumes in the foreground, the roof tops and trees. In addition, the seated male figure in the near foreground has been added, and the woman at center right with her arms reaching out to the seated figure has been changed from a woman with hands on hips.

82 Bathers ca. 1912-15

Watercolor and pastel on paper (14¹/₂ x 18¹/₂ in.; 36.8 x 47.0 cm)
Williams College Museum of Art, Gift of Mrs. Charles Prendergast (86.18.9)

INSCRIPTIONS

l. c. in pencil: Prendergast

PROVENANCE

The artist; to Charles Prendergast, 1924; to Mrs. Charles Prendergast, 1948; to present collection, 1986

verso: *Four Girls,* ca. 1900-03

83 The Promenade ca. 1913

Parade
Frame by Charles Prendergast

Oil on canvas (30 x 34 in.; 76.2 x 86.4 cm)
Whitney Museum of American Art. Alexander M. Bing Bequest (60.10)

INSCRIPTIONS

l. r.: Prendergast

PROVENANCE

The artist; to (Carroll), 1915; to John Quinn, 1915; to Alexander M. Bing; to present collection, 1960

84 Beach No. 3 ca. 1913

Bathers by a Waterfall; Beach
Frame by Charles Prendergast

Oil on canvas (18⁷/₈ x 29⁷/₈ in.; 47.9 x 75.9 cm)
The Metropolitan Museum of Art, Bequest of Miss Adelaide Milton de Groot, 1967 (67.187.135)

INSCRIPTIONS

l. r. in black: Prendergast

PROVENANCE

The artist; to (Carroll), 1915; to John Quinn, 1915; to (American Art Association), 1927; to (Kraushaar), 1927; Adelaide Milton de Groot, 1950; to present collection, 1967

[A B C]

85 Figures in Landscape ca. 1912-15

Watercolor, charcoal, pastel and pencil on paper (13¹/₂ x 19¹/₂ in.; 34.3 x 49.5 cm; sight)
Collection of Mrs. Charles Prendergast

INSCRIPTIONS

l. r. in pencil: Prendergast

PROVENANCE

The artist; to Charles Prendergast, 1924; to present collection, 1948

86 Women at Seashore ca. 1914-15

The Beach

Oil on panel (17 x 32 in.; 43.2 x 81.3 cm)
The Carnegie Museum of Art, Pittsburgh; Bequest of Edward Duff Balken, 1960 (60.42)

INSCRIPTIONS

l. l. in brown: Prendergast
l. r. in pencil: Maurice B. Prendergast

PROVENANCE

(Macbeth); to Edward Duff Balken, 1916; to present collection, 1960

87 The Picnic ca. 1914-15

Decoration, Picnic; Decoration – Summer
Frame by Charles Prendergast

Oil on canvas (37 x 57 in.; 94.0 x 144.8 cm)
National Gallery of Canada, Ottawa (4528)

INSCRIPTIONS

l. r.: Prendergast

PROVENANCE

The artist; to John Quinn, 1915; to Mr. and Mrs. Cornelius J. Sullivan, by 1927; to (Parke-Bernet), 1939; to (Kraushaar), 1939; to present collection, 1940

The frame is dated 1915 by a carved inscription on the back.

[A B]

88 The Swans ca. 1914-15

Entrance to the Harbor; Landscape with Figures
Frame by Charles Prendergast

Oil on canvas
(30¹/₄ x 43¹/₈ in.; 76.8 x 189.5 cm; sight)
Addison Gallery of American Art, Phillips Academy, Andover, Massachusetts, Bequest of Miss L. P. Bliss (1931.95)

INSCRIPTIONS

l. r. in blue: Prendergast

PROVENANCE

The artist; to (Daniel); to Duncan Phillips, 1921; to Phillips Memorial Gallery, by 1926; to (Kraushaar and Macbeth), 1928; to Lillie P. Bliss; to present collection, 1931

89 Sea Maidens ca. 1910-13

Watercolor, pencil and pastel on paper (13⁷/₈ x 19⁷/₈ in.; 35.2 x 50.5 cm)
Private Collection

INSCRIPTIONS

l. r. in black: Prendergast

PROVENANCE

The artist; to Charles Prendergast, 1924; to Mrs. Charles Prendergast, 1948; to present collection, 1985

90 Bathers ca. 1912-15

Watercolor and pencil on paper (11³/₈ x 17¹/₂ in.; 28.9 x 44.5 cm)
The William Benton Museum of Art, The University of Connecticut. Gift of the Eugénie Prendergast Foundation (74.8.2)

INSCRIPTIONS

l. l. in red pencil (in Charles Prendergast's hand): Prendergast/per CP

PROVENANCE

The artist; to Charles Prendergast, 1924; to Mrs. Charles Prendergast, 1948; to present collection, 1974

[A B]

91 Bathers ca. 1916-19

Watercolor, pencil, pastel and black chalk on paper (13⁷/₈ x 19⁷/₈ in.; 35.2 x 50.3 cm)
The Saint Louis Art Museum, Gift of Mr. and Mrs. G. Gordon Hertslet (55.1967)

INSCRIPTIONS

l. l. in pencil: Prendergast

PROVENANCE

The artist; to Charles Prendergast, 1924; to Mrs. Charles Prendergast, 1948; to (Kraushaar); to Mr. and Mrs. G. Gordon Hertslet, 1958; to present collection, 1967

verso: *Three Women*

[A]

92 Fantasy ca. 1914-15

Oil on panel (22 x 26 in.; 55.8 x 66.0 cm)
Williams College Museum of Art, Gift of Mrs. Charles Prendergast (85.45)

INSCRIPTIONS

l. r. in red: Prendergast

PROVENANCE

The artist; to Charles Prendergast, 1924; to Mrs. Charles Prendergast, 1948; to present collection, 1985

93 Blue Mountains ca. 1914-15

Oil on canvas (16¹/₄ x 25⁵/₈ in.; 41.3 x 65.1 cm)
Collection of Mrs. Charles Prendergast

INSCRIPTIONS

l. r. in red: Prendergast

PROVENANCE

The artist; to Charles Prendergast, 1924; to present collection, 1948

94 Rider Against Blue Hills
ca. 1914-15
Rider Against Blue Hills II

Oil on canvas (20 x 30¹/₄ in.; 50.8 x 76.8 cm)
Williams College Museum of Art, Gift of Mrs. Charles Prendergast (86.18.10)

INSCRIPTIONS

l. l. in brown: Prendergast

PROVENANCE

The artist; to Charles Prendergast, 1924; to Mrs. Charles Prendergast, 1948; to present collection, 1986

95 Sunset ca. 1915-18

Oil on canvas (21 x 32 in.; 53.3 x 81.3 cm)
Museum of Fine Arts, Boston, Purchased by Exchange (1989.228)

INSCRIPTIONS

l. r. in blue: Prendergast

PROVENANCE

The artist; to Charles Prendergast, 1924; to Mrs. Charles Prendergast, 1948; to (Kraushaar); to Alan H. Temple, 1957; to (Sotheby's), 1989; to present collection, 1989

[A B]

96 Sunset and Sea Fog ca. 1918-23

Oil on canvas (18 x 29 in.; 45.7 x 73.7 cm)
The Butler Institute of American Art, Youngstown, Ohio (955-O-128)

INSCRIPTIONS

l. r. in black: Prendergast

PROVENANCE

(Kraushaar); to Duncan Phillips, 1923; to (Kraushaar), 1945; to Oliver B. James, 1945; to (Parke-Bernet), 1955; to (Babcock and Milch), 1955; to present collection, 1956

[D]

97 Fantasy ca. 1912-15

Watercolor, pencil and ink on paper (13³/₄ x 19¹/₂ in.; 34.9 x 49.5 cm)
Williams College Museum of Art, Gift of Mrs. Charles Prendergast (83.20.2)

INSCRIPTIONS

Unsigned

PROVENANCE

The artist; to Charles Prendergast, 1924; to Mrs. Charles Prendergast, 1948; to present collection, 1983

98 Decorative Composition
ca. 1913-15

Watercolor and pencil on paper (13¹/₂ x 20 in.; 34.3 x 50.8 cm)
Los Angeles County Museum of Art, Mr. and Mrs. William Preston Harrison Collection (31.12.1)

INSCRIPTIONS

l. c. in ink: Prendergast

PROVENANCE

The artist; to (Carroll), 1915; to John Quinn, 1915; to (American Art Association), 1927; to (Kraushaar), 1927; to William Preston Harrison, 1927; to present collection, 1931

verso: Untitled (study of sea and rocky shore)
ca. 1907-10

99 Picnic ca. 1914-15
Decoration – Picnic

Oil on canvas (77 x 106¹/₂ in.; 195.6 x 270.6 cm)
The Carnegie Museum of Art, Pittsburgh; Gift of the people of Pittsburgh through the efforts of the Women's Committee, in honor of the Sarah M. Scaife Gallery, 1972 (1972.51)

INSCRIPTIONS

l. r. in brown: Prendergast

PROVENANCE

The artist; to John Quinn, 1915; to (American Art Association), 1927; to (Kraushaar); to Arthur F. Egner, 1927; Mrs. John Malone; (James Graham & Sons), by 1960; (Victor D. Spark); to present collection, 1972

[A]

100 Promenade ca. 1914-15
Decoration – Promenade; Mosaic

Oil on canvas (83³/₄ x 134 in.; 212.7 x 340.4 cm)
The Detroit Institute of Arts, City of Detroit Purchase (27.159)

INSCRIPTIONS

l. r. in brown/gray: Prendergast

PROVENANCE

The artist; to John Quinn, 1915; (American Art Association), 1927; to present collection, 1927

[B]

101 The Rider ca. 1912-15

Watercolor and pencil on paper (11¹/₂ x 16³/₈ in.; 29.3 x 41.6 cm)
Museum of Fine Arts, Boston, Anonymous Gift in Memory of John G. Pierce, Sr. (64.1604)

INSCRIPTIONS

l. r. in black ink: Prendergast

PROVENANCE

The artist; to (Carroll), 1915; to John Quinn, 1915; to (American Art Association), 1927; to (Kraushaar), 1927; to Mrs. Malcolm McBride; (Kraushaar); to Mr. and Mrs. John G. Pierce, 1956; to present collection, 1964

[A]

102 Elephant ca. 1912-15

Watercolor and pencil on paper (10³/₈ x 11¹/₂ in.; 26.4 x 29.2 cm)
Collection of Mrs. Charles Prendergast

INSCRIPTIONS

l. r. in pencil: tile from the Ceylon/Prendergast

PROVENANCE

The artist; to Charles Prendergast, 1924; to present collection, 1948

103 A Day in the Country ca. 1914-15

Oil on canvas (18¹/₄ x 27 in.; 46.4 x 68.6 cm)
Collection of Mrs. Charles Prendergast

INSCRIPTIONS

l. r. of center in black: Prendergast

PROVENANCE

The artist; to Charles Prendergast, 1924; to present collection, 1948

104 Fantasy ca. 1914-15
Landscape with Figures; Phantasy
Frame by Charles Prendergast

Oil on canvas (22⁵/₈ x 31⁵/₈ in.; 57.4 x 80.3 cm)
The Phillips Collection, Washington, D.C. (1604)

INSCRIPTIONS

l. r.: Prenderg

PROVENANCE

The artist to (Daniel); to Duncan Phillips, ca. 1917; to present collection, by 1921

105 Along the Shore ca. 1914-15
Beach Combers; On the Beach
Frame by Charles Prendergast

Oil on canvas (23¹/₄ x 34 in.; 59.1 x 86.4 cm)
Columbus Museum of Art, Ohio: Gift of
Ferdinand Howald, 1931 (31.252)

INSCRIPTIONS
l.l. in blue: Prendergast

PROVENANCE
(Daniel); Ferdinand Howald, 1917; to present collection, 1931

106 The Cove ca. 1918-23
Beach Scene No. 2
Frame by Charles Prendergast

Oil on canvas (28 x 39³/₄ in.; 71.1 x 101.0 cm)
Whitney Museum of American Art. Gift of
Gertrude Vanderbilt Whitney (31.322)

INSCRIPTIONS
Unsigned

PROVENANCE
(Kraushaar); to Gertrude Vanderbilt Whitney, 1930;
to present collection, 1931

107 Beach at Gloucester ca. 1918-21
The Beach; On the Beach
Frame by Charles Prendergast

Oil on canvas (30⁵/₈ x 43 in.; 77.8 x 109.2 cm)
Hirshhorn Museum and Sculpture Garden,
Smithsonian Institution. Gift of the Joseph H.
Hirshhorn Foundation, 1966 (66.4130)

INSCRIPTIONS
l. c.: Prendergast

PROVENANCE
The artist; to Charles Prendergast, 1924; to (Kraushaar), 1930; to Joseph H. Hirshhorn, 1954; to present collection, 1966

108 Girls in the Park ca. 1914-15

Oil on canvas (28¹/₄ x 39³/₄ in.; 71.8 x 101.0 cm)
Williams College Museum of Art, Gift of
Mrs. Charles Prendergast (86.18.7)

INSCRIPTIONS
l.l. in brown: Prendergast

PROVENANCE
The artist; to Charles Prendergast, 1924; to Mrs.
Charles Prendergast, 1948; to present collection, 1986

109 Acadia ca. 1918-23
Arcadia

Oil on canvas (31³/₄ x 37¹/₂ in.; 80.6 x 95.2 cm)
The Museum of Modern Art, New York.
Abby Aldrich Rockefeller Fund, 1945 (167.45)

INSCRIPTIONS
l. r.: Prendergast

PROVENANCE
The artist; to Charles Prendergast, 1924; to (Kraushaar), 1945; to present collection, 1945

110 Landscape with Figures 1921
? Landscape and Figures
Frame by Charles Prendergast

Oil on canvas (32⁵/₈ x 42⁵/₈ in.; 82.9 x 108.3 cm)
In the Collection of The Corcoran Gallery of
Art, Museum Purchase, William A. Clark Fund
(23.17)

INSCRIPTIONS
verso: Maurice B. Prendergast/1921

PROVENANCE
The artist; to present collection, 1923

111 Woman on Ship Deck, Looking
out to Sea ca. 1895
*Girl at Ship's Rail; Woman on Ship Deck,
Looking Out to Sea*
Monotype on paper
(6¹/₄ x 4¹/₈ in.; 15.9 x 10.5 cm; image)
Daniel J. Terra Collection, Terra Museum of
American Art, Chicago (20.1986)

INSCRIPTIONS
l. r. in plate: MBP [monogram]

PROVENANCE
Daphne Dunbar; to her great-niece, before 1975; to
(Margot Schab), 1986; to (Davis & Langdale), 1986;
to present collection, 1986
[A B]

112 The Ocean Palace ca. 1895
Monotype on paper
(7¹/₂ x 6¹/₄ in.; 19.1 x 16.5 cm; image)
Collection of The University of Iowa Museum
of Art, Gift of Robert E. Brady (1969.410)

INSCRIPTIONS
l.l. in plate: The Ocean Palace
l. r. in plate: M B P

PROVENANCE
The artist; to Charles Prendergast, 1924; to Mrs.
Charles Prendergast, 1948; to Robert E. Brady, by
1963; to present collection, 1969

113 Jumping Rope ca. 1895-97
? Skipping Rope
Monotype on paper
(6⁹/₁₆ x 5³/₁₆ in.; 16.7 x 13.2 cm; image)
Daniel J. Terra Collection, Terra Museum of
American Art, Chicago (35.1982)

INSCRIPTIONS
l.l. in red crayon (probably in another hand): M B P

PROVENANCE
The artist; to Charles Prendergast, 1924; to Mrs.
Charles Prendergast, 1948; to Mr. and Mrs. Matthew
Phillips, ca. 1965; to (William Zierler); private collection, New York, by ca. 1972; to (Davis & Long),
1978; to private collection, 1979; to (Davis & Langdale), 1982; to present collection, 1982
[A B]

114 The Three Little Girls in Red
1895
Children in Red
Monotype on paper
(5⁵/₈ x 6 in.; 14.3 x 15.2 cm; image)
Museum of Fine Arts, Boston,
George P. Gardner Fund (55.228)

INSCRIPTIONS
l.l. in plate: M/B/P 1895

PROVENANCE
Herman Dudley Murphy; to Carlene Murphy
Samoiloff; to present collection, 1955

The plate inscription might be read as 1897.
[A B C]

115 Horseback Riders ca. 1895-1900
Horse Riders
Monotype on paper with pencil additions
(9¹/₈ x 12¹/₄ in.; 23.2 x 31.1 cm; image)
Ball State University Art Gallery, Muncie,
Indiana, Permanent loan from the Elisabeth
Ball Collection, George and Frances Ball
Foundation (L83.026.25)

INSCRIPTIONS
l.l., in plate: M B P

PROVENANCE
The artist; to Charles Prendergast, 1924; to (Kraushaar); to Elisabeth Ball, 1936; to present collection,
1983

116 Lady with Red Cape and Muff
ca. 1900-02
Monotype on paper
(9¹⁵/₁₆ x 4⁷/₈ in.; 25.3 x 12.4 cm; image)
Williams College Museum of Art, Gift of
Mrs. Charles Prendergast (85.21.2)

INSCRIPTIONS
l.l. in plate: Prendergast

PROVENANCE
The artist; to Charles Prendergast, 1924; to Mrs.
Charles Prendergast, 1948; to present collection, 1985

117 Head of a Girl (with roses)
ca. 1898-99
? A Girl's Head
Monotype on paper
(6¹/₄ x 5³/₈ in.; 15.9 x 13.7 cm; sight)
Collection of Mrs. Suzanne Marache Geyer

INSCRIPTIONS
across top in plate: Maurice Brazil Prendergast
across bottom in plate: aurice Brazil Prendergast

PROVENANCE
The artist; to Charles Prendergast, 1924; to Mrs.
Charles Prendergast, 1948; to Mrs. Donald S. Granniss, 1967; to present collection, 1989

118 Seated Woman in Blue
ca. 1900-02
At the Cafe
Monotype on paper with pencil additions
(9⁹/₁₆ x 7¹/₁₆ in.; 24.3 x 18.0 cm; image)
Museum of Fine Arts, Boston, Lee M.
Friedman Fund (68.564)

INSCRIPTIONS

l. l. in plate: MBP [monogram]
l. l. below image in pencil (in another hand): At the cafe

PROVENANCE

The artist; to Charles Prendergast, 1924; to Mrs. Charles Prendergast, 1948; to present collection, 1968
[A B C]

119 Lady in Pink Skirt ca. 1895-97

Lady with Pink Skirt

Monotype on paper
(15 1/2 x 11 in.; 39.4 x 27.9 cm; sheet)
Williams College Museum of Art, Gift of Mrs. Charles Prendergast (86.18.78)

INSCRIPTIONS

l. l. in gold crayon (probably in another hand): M/B/P

PROVENANCE

The artist; to Charles Prendergast, 1924; to Mrs. Charles Prendergast, 1948; to present collection, 1986
[B C D]

120 The Spanish Steps ca. 1898-99

The Spanish Steps (Rome)

Monotype on paper
(11 11/16 x 7 1/2 in.; 29.7 x 19.1 cm; image)
The Cleveland Museum of Art,
Mr. and Mrs. Charles G. Prasse Collection (82.167)

INSCRIPTIONS

l. l. in plate: The Spanish Steps
l. r. in plate: MBP

PROVENANCE

Mrs. J. Montgomery Sears; to Mrs. J. D. Cameron Bradley; to (Childs, Boston); to Guy Mayer, 1951; Leona E. Prasse, by 1960; to present collection, 1982
[C D]

121 Market Scene ca. 1898-99

Monotype on paper with pencil additions
(7 5/8 x 9 3/8 in.; 19.4 x 25.1 cm; image)
Collection of the Prints and Photographs Division, Library of Congress, Washington, D.C. (540031)

INSCRIPTIONS

l. r. in green crayon (probably in another hand): M B P

PROVENANCE

The artist; to Charles Prendergast, 1924; to Mrs. Charles Prendergast, 1948; to (Kraushaar), 1954; to (Robert McDonald), 1954; to present collection, 1954
[A B C]

122 Orange Market ca. 1898-99

Monotype on paper with pencil additions
(12 7/16 x 9 1/8 in.; 31.6 x 23.2 cm; image)
The Museum of Modern Art, New York. Gift of Abby Aldrich Rockefeller (169.45)

INSCRIPTIONS

l. l. in pencil (probably in another hand): MBP [monogram]

PROVENANCE

The artist; to Charles Prendergast, 1924; to (Kraushaar), 1945; to present collection, 1945
[A B]

123 Roma: Flower Stall ca. 1898-99

Flower Stall; Roman Flower Stall

Monotype on paper with pencil additions
(9 3/8 x 7 1/2 in.; 23.8 x 19.0 cm; image)
Gift of the Friends of the McNay, Marion Koogler McNay Art Museum, San Antonio, Texas (1976.5)

INSCRIPTIONS

l. l. in pencil (probably in another hand): Prendergast Roma Flowor Stall

PROVENANCE

(Ruth O'Hara); to (Davis & Long), 1975; to present collection, 1976

124 Circus Band ca. 1895

Circus Band (Nouveau Cirque, Paris)

Monotype on paper with pencil additions
(12 3/8 x 9 3/8 in.; 31.4 x 23.6 cm; sight)
Collection of Rita and Daniel Fraad

INSCRIPTIONS

Unsigned

PROVENANCE

(Jan Streep); to (Spanierman), 1963; to (Davis), 1963; to present collection, 1963
[A B]

125 Picnic with Red Umbrella
ca. 1898-99

Monotype on paper with pencil additions
(9 1/4 x 7 1/2 in.; 23.5 x 19.0 cm; sheet)
Horatio Colony Museum

INSCRIPTIONS

l. l. in red crayon (probably in another hand): M B P

PROVENANCE

The artist; to Charles Prendergast, 1924; to Olive Whitman, from Mr. and Mrs. Charles Prendergast; to Mrs. Alfred Curtis; to Mary Curtis Colony (her daughter); to Horatio Colony (her husband); to present collection

126 Shipyard: Children Playing
ca. 1900-02

Monotype on paper
(7 7/8 x 10 in.; 20.0 x 25.3 cm; image)
The Cleveland Museum of Art, Mr. and Mrs. Charles G. Prasse Collection (82.166)

INSCRIPTIONS

l. l. in plate: MBP [monogram]

PROVENANCE

The artist; to Charles Prendergast, 1924; to Mrs. Charles Prendergast, 1948; to (Kraushaar); to (Margaret Brown, Boston), 1950; to R.V. Wood, Jr., 1950; Leona E. Prasse; to present collection, 1982
[A B]

127 Beach Scene with Lighthouse
ca. 1900-02

Children at the Seashore; Lighthouse

Monotype on paper
(9 7/16 x 13 7/8 in.; 24.0 x 35.2 cm; image)
The Metropolitan Museum of Art, Gift of Mr. and Mrs. Daniel H. Silberberg, 1964 (64.123.2)

INSCRIPTIONS

l. r. in red oil (probably in another hand): M/B/P

PROVENANCE

The artist; to Charles Prendergast?, 1924; to Mrs. Charles Prendergast?, 1948; to (Kraushaar)?; to William Lieberman?, 1955; to (E.V. Thaw)?; (Peter Deitsch)?; Mr. and Mrs. Daniel Silberberg; to present collection, 1964
[A B]

128 Lighthouse ca. 1900-02

Monotype on paper with watercolor and pencil additions
(9 1/4 x 15 in.; 23.5 x 35.6 cm; image)
Daniel J. Terra Collection, Terra Museum of American Art, Chicago (31.1980)

INSCRIPTIONS

l. r. in yellow oil (probably in another hand): M/B/P

PROVENANCE

The artist; to Charles Prendergast, 1924; to Mrs. Charles Prendergast, 1948; to (Davis & Long), 1978; to present collection, 1978
[C D]

129 Summer Day ca. 1900-02

Monotype on paper with pencil additions
(11 1/4 x 13 3/4 in.; 28.5 x 35.0 cm; image)
Daniel J. Terra Collection, Terra Museum of American Art, Chicago (10.1983)

INSCRIPTIONS

l. r. in red pencil (possibly in another hand): MBP 1901

PROVENANCE

The artist; to Charles Prendergast, 1924; to (Kraushaar); to Katharine Sturgis (Goodman), 1943; to (Davis & Langdale), 1982; to present collection, 1983
[C D]

Index of Names

Index of Works

Numerals in *italics* refer to pages with an illustration.

Photograph Credits

Photographs accompanying this text have been supplied, in the majority of cases, by the owners or custodians of the works, as cited in the captions. The following list applies to photographs for which an additional acknowledgment is due. E. Irving Blomstrann, cat. nos. 60, 79, 108; Lee Brian, fig. no. 22; Geoffrey Clements, cat. nos. 34, 36; Sheldon C. Collins, cat. nos. 3, 83; Jim Frank, cat. nos. 64, 89; Gamma One Conversions, cat. nos. 38, 41; Helga Photo Studios (Courtesy, Hirschl & Adler Galleries), cat. nos. 12, 24; Le Claire Custom Color, cat. no. 58; Lee Stalsworth, cat. no. 77; Joseph Szaszfai, cat. no. 56; M. Tropea, cat. no. 111.